L O V E

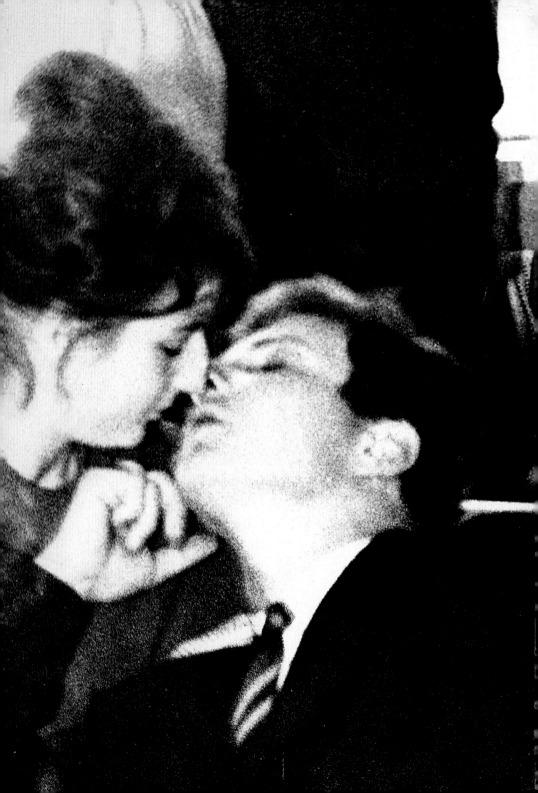

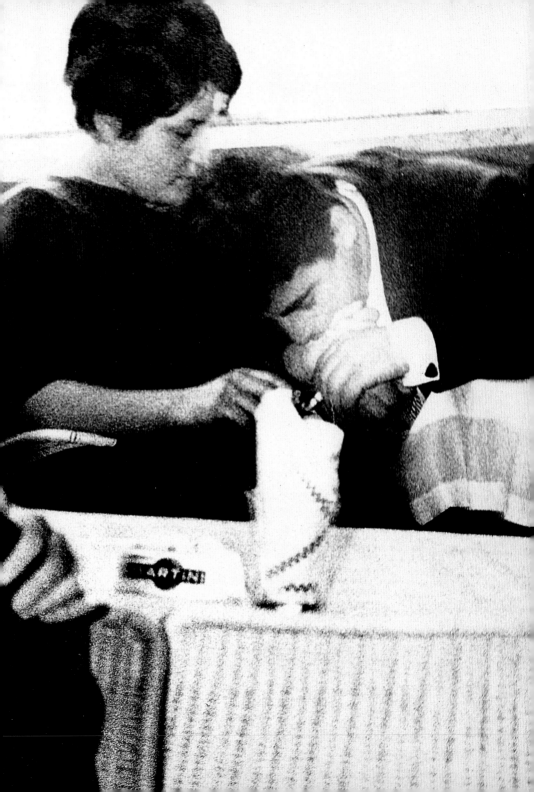

D E S I R E

A N D

CHRONICLE BOOKS

SAN FRANCISCO

WILLIAM A. EWING

LOVE
AND
DESIRE

photoworks

COVER

BERTRAM PARK
YVONNE GREGORY
Untitled, 1936
Gelatin silver print
Courtesy Uwe Scheid
Collection, Überherrn

BACK COVER

JOHN STEZAKER
Untitled, 1976
Collage (detail)
© 1976 John Stezaker;
courtesy the photographer

PAGE 2

MARIO GIACOMELLI
Un Uomo, Una Donna,
Un Amore (A Man,
A Woman, A Love), 1960–61
Gelatin silver print

PAGE 6

ERIC RONDPIERRE
L'Addition
From the series MOIRES, 1996–98
Reprinted deteriorated film still

FOR CLARE, FLORA, AND CRISPIN

First published in the United States in 1999 by Chronicle Books.

Copyright © 1999 by Thames and Hudson Ltd., London.

Pages 392–395 constitute a continuation of the copyright page.

Library of Congress Cataloging-in-Publication Data available.
ISBN 0-8118-2621-X

PRINTED AND BOUND BY
C.S. GRAPHICS (PTE), SINGAPORE

COVER DESIGN BY CONCRETE, CHICAGO

Distributed in Canada by Raincoast Books
8680 Cambie Street
Vancouver, British Columbia V6P 6M9

10 9 8 7 6 5 4 3 2 1

CHRONICLE BOOKS
85 SECOND STREET
SAN FRANCISCO, CALIFORNIA 94105

WWW.CHRONICLEBOOKS.COM

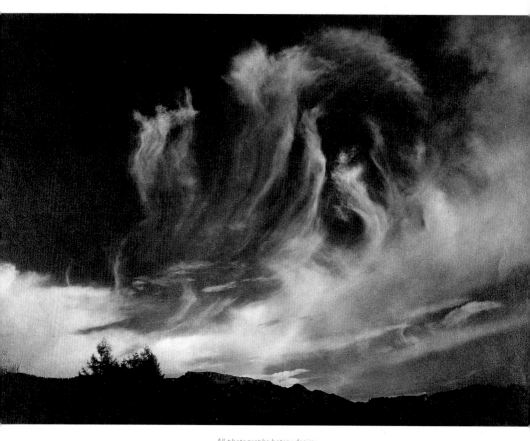

All photographs betray desire:
a haunting cloudscape from 1932.
Richard Wörsching
Untitled
Bromoil print

INTRODUCTION

Whoever you are, come forth! or man or woman come forth!...
Out of the dark confinement! out from behind the screen!
It is useless to protest, I know all and expose it.

–Walt Whitman, 'Song of the Open Road'[1]

'Today, Penthouse's Internet site, which diffuses images of willing female bodies,
is visited – daily – by five million people... Obscene photography, far from
being a marginal factor in the history of photography, is a condition
of its development – mysterious, no doubt, but crucial and fruitful –
and maybe even, deep down, its raison d'être.'

–Philippe Comar[2]

All photographs are, at some level, about love, and all photographs are triggered, to varying degrees, by desire. These human emotions may be well disguised, or expressed indirectly, but they are always there: either the person *behind* the camera wishes to seize and possess a moment, a mood, an object, a body, a place, a face; or the person in *front* of the lens asks, and often pays, to have a picture taken. Whoever instigates the event may wish to impress others, or honour them with a love token, or excite them sexually. Or they may simply want to preserve something for posterity. Whatever the intent, overt or covert, there is no denying the staggering volume of images produced in a mere one hundred and sixty years. In the aggregate, in their *billions*, the photographs of this world comprise a massive archive – testifying to the depth and immutability of human longings, lusts and affections.

How is it possible that in the short span of time since the arrival of photography in the mid-nineteenth century, such an immense repository could have been

accumulated? How is it that human beings (if not universally, at least wherever they had access to photographic imagery) found themselves so enamoured of this relatively novel medium – a means of picture-making which could produce only tiny, flat, fragmented, immobile, colourless (colour being essentially a post-World War II phenomenon) and mute images. Today, such is the craving that photographs are taken of human beings even before they are *born*: photographs of foetal scans, which started out as purely medical documents, are now routinely given to parents as mementos.

The universal appetite for photography is all the more impressive when we experience how callously it can betray our confidences: 'Surely that's not me!'...'I don't *really* look that old!'...'That's not my good profile!' And because we generally don't bother to date and caption our pictures, years later we find ourselves not even quite sure who the people are, and where, when and why the pictures were taken. Only then do we realize just how fragmentary, how vague, how untrustworthy, the photographic 'memory' actually is.

In the beginning – which in photographic terms means the Autumn of 1839 – people the world over read in their newspapers of a mirror that could render things in exquisite detail, and preserve them for posterity. The illustrator George Cruikshank captured the public excitement: 'Your image reversed will minutely appear/So delicate, forceful, brilliant and clear/So small, full and round, with a life so profound/As none ever wore/In a mirror before.'[3]

Louis Jacques Mandé Daguerre imagined that his 'mirror with a memory' would be used primarily to record beautiful things and places rather than people, but the latter had other ideas. As soon as refinements to the inventor's technique allowed for a reasonably short exposure time (and therefore a reasonable length of pose) professional portrait studios sprang up to accommodate an enthusiastic clientele, while well-heeled amateurs found no shortage of volunteers among families and friends.

At first, only the wealthy could afford to commission daguerreotype portraits. Examples were proudly displayed in opticians' or stationers' windows, where passers-by could marvel at the technological novelty, and especially the view it provided onto bourgeois intimacy. The poses of the sitters were usually stiff, it is true, owing to the long exposures required, but subtle gestures and body language could still poignantly communicate love and affection. Husbands and wives, parents and children, rested their hands tenderly on one another's shoulders or knees, and a father often stood

protectively behind his seated family. 'Love' was signified in various ways: a love of learning, for example, was indicated by a book held in the hands of the sitter, while flowers, displayed in vases, painted in on backdrops or even held in the hand, spoke of love in various forms: courtship, marriage, happy domesticity, idyllic childhood.

Such daguerreotype portraits, encased in stamped or embossed leather, became prized family possessions, treasured objects as well as icons. But, with the exception of the handful that were displayed publicly to encourage trade, there was no way they could be shared beyond the family circle, as they were one of a kind. Within a decade, however, ever-evolving technology, coupled with entrepreneurial acumen, would place photographic portraiture within the purview of the middle classes. The breakthrough was photographs on paper, printed from negatives, and replicated at will. And with the arrival in the early 1850s of the humble *carte-de-visite* – a small (5.7 x 9 cm) and inexpensive photographic portrait mounted on a card – portraiture became accessible to all but the poorest classes. Moreover, this relative cheapness meant that copies of the cards could be presented to family and friends. These were avidly

Marriage Portrait in the Studio After a Photograph
by Goupil of a Painting by Dagnan-Bouveret
The excitement of a19th-century photography studio is captured
by Auguste Lepère in this wood engraving of 1873.

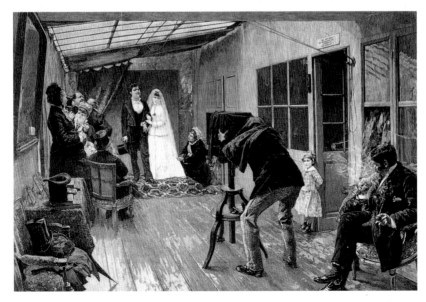

collected and mounted in family albums, where they were joined by other *cartes* of celebrities, which had been purchased inexpensively, or traded – a popular pastime.

Everyone, it seemed, wanted to be photographed. Even the dead were able to get in on the act. Families saw to it that loved ones, who had never had the opportunity of being photographed while alive, would be honoured in death. A commentator of the time noted the solace offered by photography: 'Thanks to the sublime art, much of the bitterness of separation amongst friends, and of that great and final separation which we have all at some time experienced, is greatly alleviated.'[4] Such was the dependence on photography as a spiritual liaison with the dear departed, that a virtual industry grew up around the production of 'spirit photographs', in which a widow would have her portrait taken only to discover, on seeing the print, a faint image of her dead husband hovering overhead. That his image bore an uncanny resemblance to his framed *carte-de-visite* on the widow's bedside table passed unperceived, such was the unquestioning belief in the veracity of the photographic image – not to mention a total ignorance, on the part of the naive client, of facile darkroom fakery.[5]

Cartes-de-visite were small, and features and expressions were therefore difficult to make out. Not surprisingly, the public's frustration with the tiny photographs grew, and professionals responded by developing more satisfying alternatives. 'Photography is governed by fashion,' noted Professor H. Vogel on a visit to London in 1875. *Cartes-de-visite* were giving way to varying sizes and shapes of portraits: 'cabinet, Victoria, Imperial, Promenade, and Boudoir' – some even bigger than anything we would see today. The same writer, observing the Parisian public, noted of anything that was less than life-size in shop windows: 'a passing glance is all they obtain'.[6]

It was not simply that an element of boredom with the human likeness had crept in – all fads eventually fade, and the magical aspect of photography was soon dissipated by sheer volume. Rather, there was a dawning awareness in the 1870s that the miraculous nature of photographic rendering exacted a price. 'One can hardly say that camera pictures were common household treasures before 1850,' noted one writer,

> A generation has now passed since photography came into general use, and an era has set in which may be fitly termed *an era of regrets*. We find, it is true, that photographs fade, but not as quickly, alas!, as

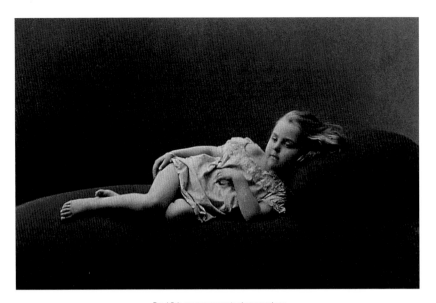

For 19th-century portrait photographers,
a child's natural innocence guaranteed
that no photograph could be seen as provocative.
Awit Szubert, Untitled, c. 1880, albumen silver print

the friends and acquaintances they represent. Grown-up men and women look curiously at their baby photographs, and grandfather and grandmother turn back with trembling hands to the first page of the album and see themselves once more in wedding garments, and muse on the times of years ago. More tender still are the thoughts called up by the pictures of those that are no more. The bright clever youth who stands before us so full of life energy – the radiant maiden, her warm lips and sunshine smile apparent still in the little brown picture – have left behind them no personal sign *save and except these shadows.*

After a while we shall grow accustomed to *the hard truths* the camera teaches us, but the present generation is the first to appreciate them to the full. That life is but a span is illustrated in every family album in the kingdom, and the adage was never so vividly and frequently brought home to us *as in these days of photography.*[7] (Author's italics)

Meanwhile, family albums were passing from the stage of being novelties and parlour ornaments to something bordering on the fetishistic: '...now albums are becoming sacred...a lock and key is fitted to the book, and it is treated with a reverence that day-to-day becomes more marked.'[8]

As in these days of photography... The die was cast, then, for better or for worse, just a few decades after the invention of photography – and this before a good part of the production of photographs had been wrested from the hands of the professionals and wealthy amateurs and made available to everyone by way of the mass-produced, hand-held camera which freed the image-maker from the constraints of the studio. The world eagerly accepted George Eastman's proposition of 1888 which came with the easy-to-use Kodak, 'You push the button, we do the rest.' From an art and craft of immense technical difficulty, the secrets of which had been jealously guarded by the few, photography became almost overnight a matter of facile visual recording prac-tised by a vast populace.

But photography exacted yet another price: a heightened self-consciousness. People were not necessarily ready to accept those 'hard truths'. Just as one's reflection in the bathroom mirror can bear terrifying witness to one's inevitable decline, prompting instant intervention (rouge, powders, paints, dyes and other ruses), the reflection in that other mirror, that permanent, photographic one, demanded its own special preparations. 'Next to getting married, we think there is more talk and more fussing and fixing "gone through with" to get one's self ready to have a photograph made than for anything else,' observed an American writer, who nevertheless defended the legitimacy of the preparations, '... because one desires to look well, especially when one is to be handed round, criticized and admired among his friends, and preserved for posterity.'[9]

Retouching was another form of obscuring hard truths. Hand-colouring was an element of *daguerréotypie* almost from the beginning, compensating for the hard, metallic aspect of the plate, and the practice was continued with paper prints. The same miniature painters who had lost their livelihoods to photographers now found their skills once more in demand, which explains the high quality and extraordinary sensitivity of much of this work. The added temptation, to 'improve' features, could not be resisted.

The idea of enhancing one's own photographic likeness had something to do with a new phenomenon: the rise of the modern celebrity. Previously, lithographs and

other kinds of prints had depicted the immensely talented or privileged, but these tended to idealize their subjects to the point of transforming them into mythic creatures, so providing far from accurate likenesses of their physiognomy. With photographic verisimilitude, on the other hand, it seemed that these gods and goddesses had descended to earth. Thanks primarily to millions of *cartes-de-visite*, the public satiated its appetite for its favourite dancers, actors and literary lions. But this verisimilitude was to some extent an illusion: the illustrious subjects of the portraits were learning rapidly how subtle retouching could transform an ordinary face into an icon of beauty. As it was only natural for ordinary folk to wish to look like the stars they worshipped, they likewise took to the retoucher's art, demanding that their features also appear 'as smooth and soft as a peach'.[10]

London's *Photographic News* was much less sanguine about a *new* species of celebrity that was famous only for being famous, what it called 'the advertising beauty' (and what we now call the model): 'We are afraid photographers are responsible for a good many of the vanities of the day… [They are] responsible, in a great measure, for that objectionable person – the professional beauty. A lady whose profession it is to be a beauty, and to appear in that character at fancy fairs, would scarcely, one would think, hold a very exalted position; but thanks to photographers, she has become a very grand personage indeed. This purposeless creature at once takes rank with other notables, with rogues, with royalty, scientists and distinguished murderers…'[11] The account also noted how the public was being taken in by 'before-and-after photographs', which were proof of accomplished retouching rather than the claimed-for efficacy of some fabulous freckle-remover.[12]

There had always been those who loved the medium *itself*, rather than what it was good for. The very first photographers, who had yet even to find a word to describe what they were doing – making 'sun pictures', or 'photogenic drawings' (Why not 'photography', meaning drawing with light, suggested the polymath Sir John Herschel) – focused on what they loved. William Henry Fox Talbot felt the urge to give permanence to aspects of his genteel country life: small flowers from the garden, a venerable oak tree on his estate, his treasured books (which he had to lug into the garden for sufficient illumination); for Daguerre, it was objects collected over the years: plaster casts of artworks (including nudes, the first timid appearance of Eros in photography!), fossils, a framed drawing; for Bayard, it was his garden – a broad sun hat, an old rake, a vase of flowers, arranged in imitation of a Dutch flower piece.

Those who came after the pioneers, thrilled with the newfound precision recording device, also turned their lenses on what they loved. For some, it was escape from 'civilization', or at least from polite society: the pleasures of voyages to exotic lands where savage women went bare-breasted without shame, and were willing to 'share' their bodies with the camera artist. For others, it was the discovery of ancient sites and decaying monuments, though passions and prejudices coloured what they thought their lenses saw purely objectively. As photohistorian Maria Morris Hambourg notes, '[These] supposedly faithful "documents" were rife with subjective impressions and inflections of European culture... So much so that it would be fair to say that the archaeology and geography of the photographers' imaginations had the upper hand on objective science.'[13]

For still others, like the Bisson *frères*, romance was to be found on the summit of Mont Blanc, cumbersome wet plates and all. Romance of a kind also lay on the battleground. 'Like Euphorion, I felt I had to go,' explained Matthew Brady of his great American Civil War photography, 'A spirit in my feet said "Go", and I went.'[14] But not all that many photographers were willing to follow a muse onto perilous terrain. The majority were more level-headed about photography's potential, less likely to cast it in the role of petulant, demanding mistress. Instead, they stayed home and offered their services to *others* who had been smitten: the avid, narcissistic public who would suffer any indignity (heads clamped, eyes unblinking in harsh sunlight or dangerous artificial rays) to see their reflections captured on plaques of metal or sheets of paper. Photography offered virtually everyone, at least a partial realization of their dreams.

□　□　□

With *agape* so universally worshipped, would Eros wait patiently in the wings? Hardly! He had been seeding the terrain from the very moment of photography's unveiling, restrained only by technical limitations. Eros wondered what that prim young lady, sitting ever so demurely for her daguerreotype portrait, would look like divested of her crinolines, her chemise and her whalebone corset... Erotic daguerreotypes, with varying degrees of explicitness, would soon be found in the luxury brothels of Paris, or under the counter at certain opticians' shops (which also often housed daguerreotype studios). Here, binoculars, microscopes, compasses and other instruments signified an exclusively male preserve, and photography, with

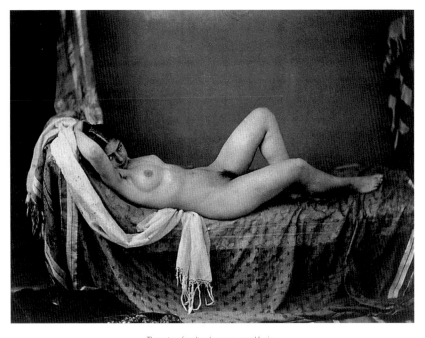

There is a fine line between académies --
nudes ostensibly produced as aids for artists -- and explicit erotic imagery.
Louis-Camille d'Olivier, *Étude No. 535,* 1855,
salted paper print

its technical paraphernalia, slipped comfortably into this fraternity.[15] Such daguerreo-
types were expensive, and often exquisitely hand-coloured. The majority were
stereographic, requiring special viewers which enhanced the voyeuristic 'keyhole'
experience. The settings were often exotic: occasionally forest glades and sylvan land-
scapes, sometimes a maid's boudoir, usually simply a bed, adorned with rich fabrics.
Mirrors were also stock-in-trade, enabling the voyeur to see simultaneously the full
catalogue of female charms.[16]

Today, we view such objects as quaint, but they were electrifying to voyeurs at the
time.[17] Imagine, if you will, two gentlemen at dinner. The Parisian host can hardly
conceal his impatience; over port and cigars, with the ladies safely retired, he beckons
to his American nephew with a wink, unlocks a drawer, and withdraws with exagger-
ated care a small, leather case, beautifully embroidered; inside, matted in a silk or
velvet surround (not unlike sheets on a bed), lies a voluptuous woman, her limbs in
positions of abandon, her gaze direct, her cheeks pink with excitement... The young

21

visitor recalls certain *risqué* pictures he has just seen at the Louvre, almost scandalous in their thinly veiled nudity, but this…*this woman is alive*! He feels a surge of excitement… Abruptly, his host snaps the case shut, and puts his treasure back, taking care to turn the key with a flourish. She is, after all, he is saying, *his* possession, *his* property… Nevertheless, the young man is racked with desire…

The American's encounter would probably have been extremely unsettling (as it would very likely have been for most of his European and British counterparts). Consider, for example, what an ordinary middle-class male of the time would have known of his fiancée's body. According to the cultural historian Stephen Kern,

> He has had no opportunity to see his fiancé's body… He has seen only her face and hands in the flesh, though perhaps he has had a glimpse of her bosom pushed out of a corset under a low cut evening dress. He does not know what her legs or her torso look like, and since he has never seen her doing any vigorous athletic activity, probably has little idea of how her body moves freely, unencumbered by a welter of clothing… Their physical contact has been limited to an occasional embrace during a waltz, formal kisses on the hand, and perhaps a daring touch of the knees under the table… If he has read Sylanus Stall, he has learned…that [once married] they should never undress in front of each other in order to avoid excessive stimulation of the sexual appetite.[18]

The body was a minefield in the nineteenth century, and harboured numerous anxieties. Darwin had perturbed many with his evolutionary theories. Many were not happy with the clear outlines of the ape beneath the noble human form. Animals were equated with nakedness, as were the 'lower' orders and 'inferior' races of mankind. To be clothed was to be civilized. The body hardly existed on the plane of social discourse. Physicians counselled women without ever looking at or – God forbid! – touching their bodies. Bathers entered the water in cabins, while sport was considered too disturbing (the danger was sexual arousal!) for women to follow. Impulsive, animal sexuality was something educated peoples had left behind. They had a duty to be vigilant. The head, face and hands – the only parts of the body that were permitted to be displayed – therefore had to carry the body's full symbolic charge.[19]

Is it any wonder, then, that public reaction to such imagery (whether in the form of daguerreotypes, or, later, paper prints) was so often one of outrage? The press, both popular and specialized, was full of anecdotal evidence of the rot threatening society. 'Should art be deployed for debasement?', thundered one moralist,

> The office of true art is to exalt the mind, refine the manners, and purify the passions: but here it is employed to corrupt youth and enflame the lowest feelings of human nature. The contemplation of the photographs generally to be seen has been the ruin of many young men and women... *I am told* that the sale of these photographs to young men and used-up voluptuaries for the very purpose of contamination is enormous.[20] (Author's italics)

With such attitudes in the majority, it should not surprise us, then, that virtually any naked body depicted photographically – for whatever purpose – could elicit condemnation for 'lewdness', 'lasciviousness', 'pruriency' and 'revolting indecency', to name a few of the more common charges. Even a photograph of a naked Zulu tribesman, shown in the context of ethnographic documentation, could be described in a photography journal as 'a rather nasty object to look at'.[21] And nudes made expressly for artists' use (but called '*académies*' to underscore serious intent and avoid undue attention) also received their fair share of reprobation.

But it was difficult to explain to one's readers just what it was that made photographs 'indecent' when even the word 'body' was considered too vulgar to mention. Instead of condemning 'photographs of naked women', it was a matter rather of 'photographs of women in voluptuous attitudes, with lascivious countenances, in the costume of Mother Eve'.[22] Those who felt obliged to defend the public good in print often tied themselves in verbal knots: 'There is hardly a street in London which does not contain shops in which photographs, and especially stereoscopic photographs, are exposed for sale, which *are certainly not positively indecent*, but which it is equally clear *are expressly intended for the gratification of the pruriency* which Parliament tried to deprive of its coarser stimulus' (Author's italics).[23]

One thing is abundantly clear: if the material was intended to arouse lust, it often succeeded, judging by this leering account:

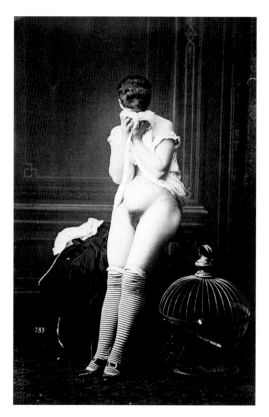

The women who posed for pornographic imagery were often the same models who sat for the respectable académies, *but for the erotic images they insisted on preserving their anonymity.* Unidentified photographer, Untitled, c. 1880, albumen silver print

Not a print sellers' or fancy stationers' in London can you now look in but what are exhibited photographs of young ladies at their toilette, some lacing their corsets, some exposing their legs while lacing their boots and arranging their garters, some stooping just to exhibit their bosoms, others reclining on couches in exciting postures, some again in their robes de chambre sitting on the edge of a bed withdrawing their stockings; in brief, woman may be seen in every conceivable attitude that a lewd image could suggest, *with every conceivable sin pictured in her face.*[24] (Author's italics)

Lest we think that the problem was one of English prudery, let us recall the famous diatribe of Baudelaire: '…a thousand hungry eyes are bending over the peepholes of the stereoscope as though they were the attic windows of the infinite…everyone was infatuated with them.'[25]

Then, as now, battles raged over the terrain of art, as distinguished from pornography. We know from early accounts that daguerreotype *académies*, in which nude men, women and children (overwhelmingly women) posed as they would have in an artist's studio or a live drawing-class, were in great demand by artists from the early 1840s.[26] Delaroche, Ingres and Delacroix were among the many painters and sculptors who found the images useful, either as a record of a fixed position held by a model or as a corrective to artistic conventions which deviated from reality. These *académies*, as opposed to the intentionally erotic images described earlier, usually featured a model in repose or seated on a simple divan covered with a sheet. Occasionally models stood, leaning against a wall or prop for support during the long exposure. Body language and gesture could seldom be construed as provocative or even flirtatious.

Ironically, at first glance, these *académies* look much less like 'art' then their erotic daguerreotype cousins. Producers of the latter made every attempt to mimic respectable art, down to the imitation of painters' styles and even specific paintings or sculptures. There was much truth in the grumblings of the critics who maintained that pornographers were 'hiding behind the beautiful shield of art'.[27] This could be true as well of ethnographic images. Photographs of natives belonging to cultures where nakedness was the norm could be defended as objective science. Thus, the photographs of naked Zulus which landed a British dealer in court also had defenders, among them the prestigious newspaper *The Times*, which opined that 'the prurient mind will see indecency in a marble Venus.'[28] Herein lies the irony: there is much evidence that pruriency was *exactly* what was intended in many instances.

Erotic daguerreotypes posed little problem from the authorities, however, because they were produced in such small numbers. But when photographs on paper were introduced in the early 1850s, their cheapness and reproducibility resulted in an explosion of salacious and titillating material. In France, 'polkas' was the popular term for photographs of group sex. In England, 'Stanhopes' delighted connoisseurs of eroticism: the Stanhope was a microscopic image which required a tiny magnifying lens which could itself be hidden in a brooch or a ring, and sexual subjects were

among those that found an eager clientele, quick to grasp a route around the censors. Another shrewd French device was a transparent playing card which when held up to the light showed figures engaged in sex. Though much of this imagery has disappeared, we have police reports as evidence of the trade's vigour: seizures of tens, or even hundreds of thousands of prints are not uncommon. Much material evidently crossed borders. The Parisian police went after the distributors of Stanhopes in 1863, and succeeded in putting an end to the trade.

Distinguishing material which was clearly intended as an aid for artists from material which was intended clearly to stimulate sexual appetites was not a simple matter. Everyone 'knew' from painting that the nude body was perfectly acceptable, indeed *ennobled*, when encoded in heroic, biblical or mythological motifs. Greek gods and goddesses, for example, were often portrayed erotically, if heroically, their sexuality thinly veiled. But photography upset the apple cart by either refusing or being unable to provide the proper encoding. The bodies were too personalized, too rooted in the real, as was evident in complaints that models in photographs had dirty feet (whereas in Bouguereau's paintings women's feet hardly ever touched the ground!). Obscenity was the charge, but it seems that the real crime was offending bourgeois taste.[29] Just how confused the authorities were is evident in the case of the eminently respectable French photographer Adolphe Braun, who fell foul of the law not because he had photographed nudes (he had not), but because he had photographed *paintings* of nudes.

Some photographs which to modern eyes do have a sexually provocative aspect escaped censure. For example, between the late 1850s and late 1870s the author Lewis Carroll, who is loved today for his marvellous *Alice's Adventures in Wonderland,* published in 1865, took hundreds of photographs of young girls, including his muse, Alice Liddell, and some of these images involve full or partial nudity.[30] But because the poses were always decorous, which is to say that they followed artistic convention, the Victorians were not perturbed. Yet at least one contemporary writer considers Carroll's preoccupation with girls 'at the very least, extreme',[31] and adds, 'Carroll's photographs tapped into Victorian conventions ranging all the way from pedophilia through innocence and back again.'[32] What accounts for the discrepancy in moral judgment between then and now?

For the Victorians and Edwardians, 'childhood innocence' was taken for granted (though we now realize that this was a social construct dating from the eighteenth

century).[33] Therefore, a child's naked body seen in a photograph was by definition a sign of total innocence, and it would be perverted even to *suggest* otherwise. Carroll's work was therefore in a sense inoculated against charges of sexual provocation. Additionally, his photographs were masterfully contrived to appear spontaneous and natural, as if the little girls behaved this way as a matter of course. To his contemporaries, who had not yet realized that all photographs are staged to some degree, the pictures would have appeared to be simply documents of a charming reality.[34]

Comparison of Carroll's photography with that of another great Victorian photographer of children is illuminating. Julia Margaret Cameron's stature seems to be growing while Carroll's has been called into question. Self-taught, Cameron was not intimidated by technique and in fact had pioneered indistinct focus to capture 'the greatness of the inner as well as the features of the outer man';[35] indeed, she was dismissive of anything that did not help her to express her poetic allegories, which called for the enactment of myths and legends with family and friends standing in for King Arthur, Sir Lancelot or the Furies. 'What is focus – and who has the right to say what is the legitimate focus?', she demanded of her numerous critics.[36] She herself played a role in a number of Madonna and Child tableaux. These pictures were much

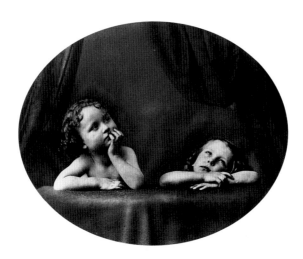

Victorian photographers proposed a childhood world of fantasy far removed from the materialist sphere of adulthood. Oscar Gustave Rejlander, *Non Angeli sed Angli,* 1857, albumen silver print

admired, and it is not difficult to see why: the Madonna/Child motif was common-place in art of the time, and had long ago been drained of its Catholic iconography, signifying rather the unconditional devotion of motherhood. Cupids had also ceased to be regarded as embodiments of Eros – pagan god of sexual love – and were now seen as innocent, impish children. Cameron's *Venus Chiding Cupid and Removing His Wings* therefore conveys a subtle message. Not only does it reinforce the Victorian cult of domesticity, which anchored the married woman at the centre of family life, thus celebrating the sacred love of family over the profane form located outside the family's citadel, but the very clipping of Cupid's wings stands as a cautionary tale: that sexual temptation will arrive is never in doubt, but it must be kept in check, and put off as long as possible.

With the invention of photomechanical methods of reproduction, erotic imagery tapped vast new markets. Revues flourished, their names showing how the sacred (art) and the profane (pornography) were inseparably linked: *Le Nu décoratif*, *En costume d'Eve*, *Le Nu esthétique*, *Vénus moderne*, *Le Déshabillé au stéréoscope*, *Le Nu académique*. The postcard also provided a very public, and therefore usually restrained, view of eroticism, as subjects had to be acceptable to postal authorities as well as to those on the receiving end.

Photographers trafficking in anything remotely erotic knew the risks were real, and kept their heads below the parapet. Sylvie Aubenas, a specialist of nineteenth-century material who has looked at photographers' statements, notes how silence reigned supreme when it came to writings about the nude, whereas the same men were prolix when it came to '…the problems of technique, lighting, the speed of exposure, the exploits of photographers in the Alps, the conquests of artificial light-ing, the subtleties of portraiture.'[37] Astonishingly, the nude remained almost entirely absent from nineteenth-century exhibitions and was explicitly forbidden in the shows of the prestigious Société Française de Photographie until the end of the century.

The essence of photographic expression, however, was about to change, and with it not only the status of that construct we still so politely call 'the nude', but also its understanding and treatment. Those late-nineteenth-century practitioners who championed photography's claim to be (or at least to have the potential to be) a bona fide art form, were appalled by the medium's condition: photography, in their eyes, was either being practised by professionals, which at the time meant both portrait photographers and those who were offering their services to medicine, botany,

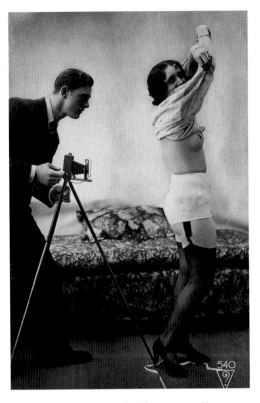

*An amateur photographer's fantasy, as staged by
a professional photographer.* Unidentified photographer,
Untitled, c. 1920, gelatin silver print

anthropology, or – the unmentionable – pornography; or it was being taken up with untutored enthusiasm by hordes of amateurs, gluttons for wholly artless family snapshots. The well-educated, craft-oriented, true gentleman *amateur*, who wished for photography to aspire to a fine art, therefore felt besieged on all sides.

It was high time for a rescue operation. Inspired by the fierce polemics of Peter Henry Emerson, who lectured that dedicated practitioners were indeed capable of producing high art (and had his own highly accomplished imagery to prove it), and the haunting portraiture of Julia Margaret Cameron, a new generation of camera artists (for that is *exactly* how they saw themselves) undertook to pick photography up from the gutter and set it firmly on the path to rectitude and its noble, rightful destiny as a fine art.

29

The Pictorialists, as they came to be called, believed that a photograph was a work of art when it was *composed* just as any other work of art was composed. They had only disdain for documentation of the real world, which was judged vulgar and mechanical. *Inner vision*, rather than *sight*, was the means of achieving the goal of Truth and Beauty. They took their cue particularly from the work of Whistler, suppressing detail in favour of the broad effect.[38] They were, however, far more timid than he was with subject matter, refusing to abandon the genre scenes and anecdotal approach which had already fallen out of fashion in the fine arts.

'Love' was fundamental to the Pictorialist quest for Truth and Beauty, though the treatment was high-minded and spiritual as opposed to carnal and erotic. Fundamental to these *visions*, for they were visions rather than *observations*, is woman, who in the Pictorialist universe holds the keys to domestic happiness and societal well-being. She is often seen reading to her children in an orchard, or walking alone through a forest glade in flowing robes, holding a glass globe through which she presumably

The Pictorialists took a high-minded approach to the theme of 'woman',
but their imagery nonetheless contained deep currents of eroticism.
Frank Eugene, *Slumbering Vestal Virgins, c.* 1914, gelatin silver print

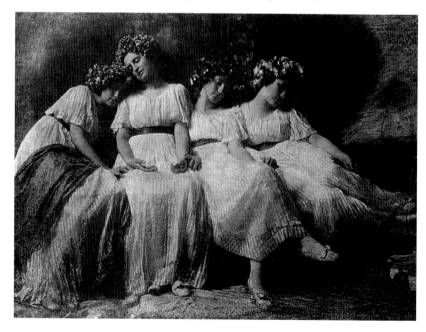

divines the future. She is either depicted as Mother Earth, or she is elevated and ethe-real. Nevertheless, currents of sensuality are evident in many Pictorialist images, though they are handled metaphorically, through conventional symbols such as flowers, and 'safe' motifs borrowed from painting and sculpture, such as angels, cupids and cherubs. Keeping the physical aspect at bay was paramount for these pho-tographers, if female purity of soul and maternal selflessness were to be worshipped. Nudity (exclusively of women and children) *could* be associated with the spiritual domain of love and affection, provided it was handled with extreme discretion. Geni-tals simply did not exist, and a generalized soft-focus ensured that flesh was never too evident. It is clear that the nude was an artistic genre which nevertheless ran the risk of scandal and censure.

The British solution was simply to avoid it. The female body was declared to be beyond the photographer's capacity to idealize; the sensual and profane inevitably tri-umphed. Moreover, as the Victorian conception of womanhood required her to be *the* pillar of domestic virtue – a wife and mother (or one who was preparing for these roles), the nude was too closely associated with the role of mistress, and with bohemian Parisian *ateliers*. The French Pictorialists, on the other hand, thought the nude perfectly acceptable, if rules and conventions were followed. Some ventured into the countryside with their models, posing them classically, as they would have in the studio. Or the models would be seen wandering through flowery meadows, as if lost in reverie. A few photographers composed decorous nudes in the studio. Occa-sionally, certain photographers succumbed to the lure of Eros, and staged mildly provocative imagery, but such digressions from the norm were well hidden from view.

In short, love and desire in the Pictorialist ethos were, with such rare exceptions, defined as sacred or familial, and tied to the Church and the family – another reason why Julia Margaret Cameron's work was treated so reverentially by this generation of art photographers.

Nineteenth-century photography experimented with the whole gamut of human affections to one degree or another, but for most of the period its production was limited to manual, or at best, quasi-industrial methods. Even at their most efficient, the biggest nineteenth-century firms could not produce copies of any *particular* image in numbers competitive with the sentimental lithographs and engravings in vogue at the time. Nevertheless, the public's craving for the verisimilitude that was particular to photography stimulated efforts towards an efficient means of mass production and **31**

distribution. The breakthrough came in the 1880s with the invention of the halftone screen, which allowed for a reasonable ink facsimile to be made of the finely toned photograph (though so inferior to it as to disappoint greatly those who loved the rich nuances of a silver print). By the turn of the century, photographs could be reproduced rapidly, inexpensively, and in large numbers, and for the first time since the invention of moveable type some four hundred years earlier, printers now had a simple means of marrying pictures with words. There was a downside, however: fewer *individual* photographs would be put into circulation, though these would be disseminated in much larger numbers and much more widely. Standardization of a world-view had begun, and at the expense of cultural diversity.

Nevertheless, new forms of commerce and communication which addressed human emotions were created. Illustrated greetings cards had emerged in the 1840s. Now *photographically* illustrated, they delighted their recipients with tableaux of romantic courtship, flower-strewn marriages and blissful parenthood. Though theatrically staged, the photographic imagery still seemed more *real* than its engraved or lithographed counterparts because it featured evidently real people. Postcards performed a similar function, and proved even more popular. With people communicating over greater distances as a consequence of growing emigration and urbanization, the photographic postcard could be, in addition to a message or a memento, an *alter ego* bearing a 'virtual gift'. However, the postcard, which had begun its life in 1870 in Germany before being universally adopted in the space of a few short years, parted company with the more sedate greetings card when it came to sex. There were plenty of gently *risqué* nudes which would not cause a censor undue concern (bare-breasted bathing beauties, for example, or next-to-naked African women were popular subjects, as were nudes posing as classical sculpture), but there were others of decidedly lascivious intent whose buyers could not risk sending them in the mail: priests seducing nuns (preferably in church), headmistresses caning the bare buttocks of their adolescent charges, lesbians undressing one another, enactments of bondage, mild fetishism, and so on – scenes usually so awkwardly staged that doubts arise as to whether the actors had any first-hand experience at all. Nevertheless, it was understood by all parties concerned that such pictures were never really intended to serve as postal communications, but were destined instead to be collected and traded; the postcard was simply the cheapest means of printing and distributing such imagery.[39] Meanwhile, magazines specializing in eroticism catering to every taste

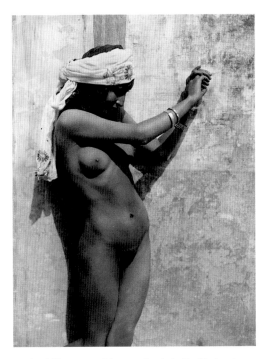

Late-19th-century erotic imagery often cloaked itself in the guise of ethnography. Lehnert & Landrock (Rudolf Lehnert and Ernst Landrock), Untitled, c. 1910, gelatin siver print

were printed in ever-increasing numbers as machinery was improved and mass distribution systems put into place.

Simultaneously, ordinary citizens were discovering the joys of making their own 'snapshots'. Here, the familial/platonic accounted for the bulk of image production, at least as long as the Kodak system held sway. Sending film away to be developed risked its being observed by prying eyes, which discouraged amateurs of erotica.[40] Parents lavished film on themselves and their children, recording birthdays, christenings and confirmations, anniversaries and family vacations. And not always their own affairs: 'The sedate citizen can't indulge in any hilariousness without incurring the risk of being caught in the act…,' reported one New England newspaper, evidence that there would be a price to pay for the new toy: a serious erosion of privacy.[41] Nonetheless, for most parents, it seemed that technology had put in their hands a way of miraculously preserving – forever, it was assumed – the otherwise fleeting, but magical, phase of childhood. 'I look at these pictures of my family every day,' wrote a **33**

friend to George Eastman, '... Do you imagine that anybody could take them away from me at any price?' [42]

In 1900 the children *themselves* were targeted by the manufacturers of the Kodak. The idea was to provide them with their own version of the camera, the 'Brownie'. 'The main feature of the Brownie camera was its calculated averageness,' Elizabeth Brayer, Eastman's biographer, tells us: 'Designed to make average pictures in average light at average speed with film of average sensibility, it was deemed perfect for starting children on a lifetime of shooting pictures, and, therefore, using film.'[43] This long-term sales strategy was brilliantly effective; 'Brownie acorns' have indeed grown into 'Kodak oaks', as trade circulars of the time put it. Today, observes the cultural historian Anne Higonnet, 'Adults make pictures of children almost as much as they look at them.' Her evidence? The 12½ billion photographs of children taken each year in the United States alone.[44]

Coached and cajoled as often as they are by parents (*Smile! Sit still!*), it is not surprising that children have developed an extreme self-consciousness in the presence of the camera. At a raucous birthday party some years ago, I observed one mother trying to take, unobserved, a picture of her five-year-old son. Sensing what she was after, he adopted a kind of performance mode, laughing and gesticulating and turning his head this way and that for a full minute, giving her the chance to make a *series* of 'spontaneous' snapshots. Then, when he judged she had had ample time for a number of pictures, be broke off the photo opportunity, extinguishing the smile abruptly. Clearly, the prying eye of the camera has made childhood innocence a thing of the past.

George Eastman's genius lay in having colonized the territory of the home, having seduced both parents and children with his invention. At the same time, however, one communal family rite involving photography was lost: before snapshots became commonplace, families gathered around the magic lantern, where they delighted in views, often in stereo, of exotic peoples and life in foreign lands. Millions of glass and cardboard slides were sold for home entertainment. Not all of it was for the entire family, however. Once the children were in bed, guests might be offered more titillating entertainment, hinting at adulterous relationships and broken hearts – the precursor of the televised soap opera.

In the late twentieth century, most social rites are photographed. Indeed, photography has *become* the social rite! Weddings in particular are inconceivable without

photography, and couples whose photographs fail to turn out have been known to restage the event just for the camera. With such a heavy responsibility demanded of marriage photography, the amateur made way long ago for the professional. Marriage was simply too important a rite to risk the 'wrong' profiles, unsmiling faces at important moments (or worse, grimaces), or a bridesmaid appearing prettier or happier than the bride.

Professionalism was also required in the lucrative domain of advertising photography, which required elaborate stagings and complex apparatus, despite the seeming simplicity and spontaneity of the results. By the 1930s photography was

The photography of weddings has become an indispensable aspect of the rite. Rafael Goldchain, *Wedding On The Plain, Cuilapam De Juarez, Oaxaca, Mexico*, 1985–87, chromogenic print, original in colour

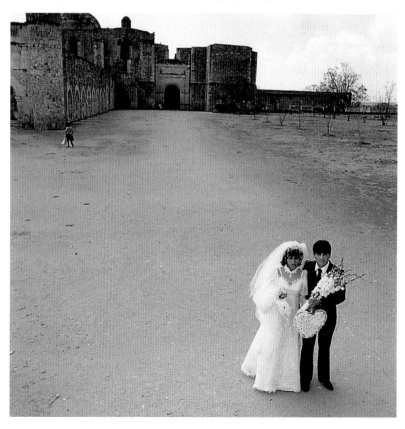

acknowledged as the most effective means of encouraging people to consume, particularly if the image-makers managed to tap into deep-seated desires (or, as one prescient observer put it as far back as 1934, 'to bind the goods and the customer in the indissoluble bonds of matrimony'[45]). The extraordinary success of American advertising photography in marrying the consumer to a product was soon emulated elsewhere in the world, though foreign advertisers soon discovered that their own countrymen were often impervious to the imported, American brand of visual persuasion. The associations an object or a gesture might trigger varied according to cultures and subcultures, and it was therefore difficult or impossible to present *universal* objects of desire.

Be that as it may, *no* culture could resist the onslaught of photographic imagery: 'Make no mistake', said an influential American art director in 1969, referring to the status of European and Japanese commercial photography, 'their advertising is almost entirely photographic.'[46] And photohistorian Robert Sobieszek adds, 'Modern advertising places far more emphasis on the photographic image than ever before, and expects that image to carry most if not all of the ad's message.'[47] By the late twentieth century, advertising images (to speak only of still photography) had invaded most public spaces in the form of billboards and packaging, and reached into private spaces via magazines, newspapers and the circulars which spill unrequested through the front door.

Every genre of advertising imagery, whether clothes, cars or cat food, crafts its own language of seduction. Every product is transformed into an object of desire. Goods are associated with the most unlikely objects or environments or bodies in order to provoke an emotional attachment or even to simply capture the viewer's attention. In the 1950s, car advertising imagery linked bikini-clad women with the metal hulks themselves, gendered male; purchase of the car, it was implied, would lead to sexual conquest. By the 1990s, the cars themselves were 'feminized'; taking possession of one meant sexual consummation in itself.

Advertising images are complex amalgams of word and image rather than straight 'photographs'. Art directors design these constructs, and photographers execute the photographic components, which may then be further enhanced by manual retouching or electronic manipulation. Consider, for example, a 1990s advertisement for a manufacturer of aeroplanes. A photograph of a jet engine is 'collaged' with that of a flower, directly equating the *blades* of the engine with the *petals* of the flower: this sug-

In the hands of a skilled photographer,
the most banal object can be
transformed into an object of desire.
François Kollar, untitled publicity photograph, 1934,
gelatin silver print

gests to potential air travellers that they will be transported gently and lovingly across the world thanks to these machines, the structural complexity (and beauty!) of which approaches that of nature, that is to say, it suggests *that flying is natural*. Or, consider an advertisement for a computer, featuring its photograph. An impressive tableau of facts and figures purports to sell the machine by virtue of its technical wizardry, but the image on the computer's screen shows a Tahitian beach, all palm trees, emerald seas and dazzling sand. The text of the advertisement appeals to the head, the image to the heart. Ironically (and this illustrates marvellously our ambiguous

Modern fashion photography is suffused with eroticism.
Unidentified photographer, untitled fashion photograph,
c. 1950, gelatin silver print

relationship to machines), the photograph evokes not the work the machine is intended to actually perform, but the means of escape from it!

Fashion photography is another commercial genre of desire-infused imagery worthy of special mention. Note, indeed, how seduction begins with the name: what is being sold is not lowly *clothing*, but *fashion*, which connotes desirability and exclusivity. The practice of photographing clothes began in the early twentieth century, once illustrated magazines had developed mass markets, and passed rapidly from a descriptive or documentary approach to one based on dream and fantasy. Glamorous surroundings, and bodies made impossibly beautiful by the retoucher's brush, transported the viewer to a land of eternal youth and material pleasure. From time to time the pendulum has swung back in favour of realism, but that has always proved a clever ploy: the realist genre of fashion photography turns out to be just as fabricated. The contemporary fashion photographer knows that, no matter which market is intended (youth, the bride, young men), it is not clothes he is selling, but

an ideology – of eternal youth, physical and material well-being, and sensual and sexual fulfilment.

Like film and television, commercial photography has contributed to the creation of a virtual world, prettier, cleaner, brighter, more perfect, more desirable than the grey world our bodies inhabit. The people who come from that other world to talk to us are more beautiful, cleverer and more accomplished. They are never tired, never sick and never unhappy. And they remind us every day of our failings…

In short, the twentieth century has seen every genre of love- and desire-related photography produced and disseminated on a scale which would have defied the nineteenth-century imagination. Photographs went from being rare and treasured curiosities in the 1850s, to being as common as leaves on trees by 1950, and probably more common thereafter. Like a rapacious plant, photography has invaded every niche of public and private life.

□ □ □

Where all forms of love and desire are concerned, the body is the prime signifier, whether naked or clothed. And of all the manifestations of the body in photography, what we call 'the nude' is by far the most common, the most important and the most complex.

Just what 'the nude' encompasses, however, is difficult to pin down. 'Beauty is our escape from the murky flesh-envelope that imprisons us,' suggests Camille Paglia,[48] reiterating the distinction Kenneth Clark famously made between *naked* and *nude* which stresses the transformative and elevating role of art. There are many kinds of photographic nudes which seem, on the surface, almost indistinguishable, but in fact encode very different messages. There are many, many books by art photographers with *Nudes* as their titles, in which the individual models are depersonalized in favour of a distanced abstraction. There are the provocative nudes of heterosexual men's magazines and calenders, which often mimic some of the art-genre conventions while making every effort, via sign and symbol, to evoke the erotic. There are the nudes of women's fashion magazines, which draw on the language of romantic childhood inno-cence (the body adorned with flowers, hairless, desexed, childlike, posing shyly). There are the nudes of gay men's magazines, which use similar motifs (sport being the favoured one) to present the well-developed male physique as an object of desire. **39**

And there are the nudes of nudist or naturalist magazines, full of imagery of healthy bodies exerting themselves in sport, dance and play, while carefully avoiding the expressions, gestures and poses we automatically associate with sexual titillation. In short, the term 'nude' is a kind of shorthand we employ to lump together photographs of the naked human body which have been taken for pleasure *of one sort or another*. Beyond this simple fact lie widely divergent agendas that nonetheless share common threads.

Take the nude in art photography, the richest vein in terms of experimentation and innovation, and a wellspring from which the other genres take nourishment. Thanks to the pioneering efforts of the nineteenth-century Pictorialists – who though admittedly timid in their subject matter, relative to progressive painting at the time, were nonetheless bold in terms of their willingness to confront taboos restricting photographic art – the nude would rapidly come to occupy a respectable niche in photography exhibitions, revues and books. By the 1920s, it had become a *central* motif of the newly acclaimed art, a position it has never relinquished. And because photographers of the nude have had relatively good access to past accomplishments through reams of publications and exhibitions, the twentieth-century nude can rightly be said to constitute a *tradition*, indeed, one of the richest and most coherent traditions within the domain of art photography.

For photographers, the nude offers the possibility of addressing thoughts and desires both platonic and spiritual, and on the plane of both the particular (a spouse or a lover) and the universal ('Man' and 'Woman'). In cultural terms, the nude has long been a respectable means of addressing concepts of love and desire, overtly or covertly. Photographers and their models feel comfortable in the studio; the public feels comfortable with nudes on the walls of galleries and museums; and readers feel comfortable with books of nudes openly displayed on their coffee tables – we see ourselves as *connoisseurs*, rather than as *voyeurs*.

In recent decades feminism has effectively exposed the one-sided nature of much nude photography, where men do the 'taking' and women submit to their demands. This has encouraged more women photographers to take up the nude, though it would be misleading to suggest that there is anything like parity today. But beyond satiating our sexual appetites and our *scopophilia* (the sheer pleasure of looking at beautiful pictures), the nude seems also to offer us something more intangible, a kind of *virtual* terrain, both communal (in that many look at the same pictures) and

private (we look at the images alone), where we can all observe and appreciate one another's bodies naked and without shame. We turn-of-the-century humans *know* the body in all its variety due largely to photography rather than to our necessarily limited experience.

In one sense or another, the nude is always an object of desire, and for most of photography's history, the 'object' has been overwhelmingly female. Furthermore: young female, and within narrow bands – postadolescent, premarried (I say *pre*married rather than *un*married because the implicit language of the nude stresses her youth, vitality and desirability, hence in our culture, her marriageability); the lovely young woman languidly posed on rumpled sheets (a perennial motif) or shown removing her underwear (another favourite) is 'available' in different guises depending on the viewer's fantasies – as a mistress for some, as a potential mate for others; conversely, once married she will no longer be 'available', that is, a legitimate object of desire. The implicit understanding is that the model stands for one more variation on the timeless theme: 'woman'.

The male nude has had a far more chequered history. It first emerges as an aid to artists rather than as a bona fide subject of its own. To a very limited extent, the Pictorialists took up the challenge, but treatments of the body were constrained by all kinds of prejudices and taboos. Young boys were considered acceptable subjects when shown within groups of nude girls, provided the genitalia were entirely absent (rather than simply hidden) and provided the implicit reading of the ensemble suggested a family group. Men were allowed to pose nude if they were willing to strum lyres or play panpipes, or even hang on the Cross (with a suffering countenance cast to heaven), and as long as *their* genitalia were hidden in deep shadow (which corresponded well with the Christian sense of shame). For a homosexual clientele, the sun-drenched, flower-bedecked reveries of the Sicilian-based Baron Wilhelm von Gloeden and his cousin, Guglielmo Plüschow, were much in demand. These photographs of entirely nude young men, their genitals *much* on display, tapped into the ancient Greek concept of an older man enjoying sexual relations with a younger one in return for helping the latter establish himself in society.[49] Not that the older men appeared in the photographs; their participation was sublimated in their roles as collectors and guardians of the images.

If certain critics wondered wryly 'to what end the young gentlemen are taking in the fresh air',[50] many were those who admired Von Gloeden's work independently of

the homoerotic undertones, Alfred Stieglitz among them. The boys' total or near-total nudity, being outdoors, was proposed as a 'natural' state of Mediterranean peoples, who were less spoiled by civilization and more in tune with the simple wisdom of the ancients. Back in northern Europe, his fantasy found an eager public, who were attracted by the Arcadian vision, an earthly paradise of the here and now. Von Gloeden's work appeared in Stieglitz's *Camera Notes* and other photographic periodicals, medico-ethnographic and anthropological publications, and family journals and magazines, as well as in publications of the burgeoning nudist movement. His photographs warn us how unfruitful it is to think of the various genres of photography as separate and distinct. [51]

There have been other kinds of male nudes that have enjoyed respectability over the years, though, like the Von Gloedens, they carry a homoerotic charge for those so attuned: photographs of athletes and bodybuilders are a classic example. A heterosexual viewer could appreciate the finely tuned bodies as living proof of *mens sana in corpore sano*, while a homosexual viewer might read the images very differently. Thus, a nude archer with bow drawn shows off the body at the peak of its prowess, while evoking the act of penetration. Wrestling is also a motif which has allowed males to 'couple' legitimately in front of the camera. Magazines with names like *Male Model Monthly* and *Physique Pictorial* were ostensibly focused on physical culture, but, as David Leddick has observed in his survey of the male nude, 'Their product was clearly meant for the homosexual market and no other. It was aimed neither at health enthusiasts nor at those in the actual business of building their bodies.'[52] As these motifs have effectively confounded censors over the years, they have remained common currency in homoerotic imagery.

The debate over eroticism versus pornography is a perennial one. It is fruitless for anyone to declare with absolute conviction what constitutes photographic erotica as it is so clearly a matter of individual judgment. Take one obvious example: what an adolescent male and an adolescent female would consider erotic, which are as different as chalk and cheese; the boy chooses to peep at his father's *Penthouse*s, which he describes as 'a real turn-on', while the girl pins up on her bedroom wall her latter-day Prince Charming, Leonardo DiCaprio, whom she describes simply as 'really sexy'.

Looking on, most people would not contest the fact that both kinds of pictures fall under the term 'erotic', even though, as adults, we may well have outgrown the allure of either. While one can argue that it is equally misguided to be as dogmatic in one's

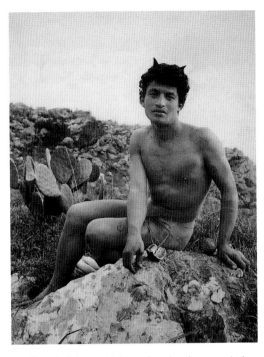

For much of photography's history, the male nude was conceived in homoerotic terms. Wilhelm von Gloeden, *Faun,* c. 1900, gelatin silver print

assertions about what constitutes pornography, there is another way of defining the issue which avoids the subjective and helps us to understand what is at stake (and for photographers, *plenty* is at stake when issues erupt – lawsuits, seizures of negatives and prints, the maligning of reputations, and so on). We may simply ask: what is the intention of the producer, and is that intent realized? After all, a sexually explicit image of which there is only one copy, hidden in someone's drawer, can hardly be thought to constitute a risk to society, whereas an image which is reproduced in great numbers and is expressly marketed in order to gratify the impulses of sadists or paedophiles most certainly can.

One taboo that has an influence on both male and female nudes relates to age. As already noted, naked infants and children appear very often in nineteenth-century photography, as a celebration of both their sexual and social innocence. The trend continued into the twentieth century, with little controversy until recently, when **43**

concerns were voiced over the true meaning of these pictures. The motives of photographers have been called into question: are the photographs taken to celebrate childhood or to excite paedophiles? Are they art or pornography? Defenders of the genre have had to go to great lengths to deny *any* sexual significance in the pictures, as if sexuality and childhood were mutually exclusive. Convoluted legal arguments worthy of Kafka have been invoked to attack or defend the practice, but the risks at least are real: in the last decade of the century, a parent can run the risk of prosecution for having taken a simple snapshot of a child in its bath, and a professional photographer – even armed with parental permission – can risk career, livelihood and reputation.

At the other end of the spectrum – the aged body – photographers of the nude can also provoke extreme displeasure, though without the severe legal penalties. Most people, it seems, cannot tolerate the sight of naked bodies that are not youthful and in perfect health – hardly surprising, when the billboard, the magazine and the pharmacy window present a unified vision of the perfectly toned, bronzed ideal, implying that the aged body, with its sagging, worn flesh, is shameful (and certainly unfit for photographic commemoration).

The most important taboo concerning the artistic nude is perhaps the most surprising: overt sex. This is because every nude represents an accord between two parties: the body in the picture, and the body outside it – the observer or voyeur. The nude suggests the possibility of a conquest, of physical possession. Thus a third party would strip the image of this implicit agreement.

Observe how the nude evolved in the twentieth century. The nineteenth-century photographic nude was, with very few, if notable, exceptions, a pale reflection – or worse, an uninspired imitation – of the nude encountered in the so-called fine arts: full figure, generally in repose on a bed or divan. There was little understanding that the nude might be reconceived on photography's own terms. In fairness, the cumbersome apparatus and slow film militated against the kind of 'what if' experimentation that was a precondition of such a rebirth. Indeed, the breakthrough came early in the new century when photographers were armed with small, hand-held cameras, which allowed for a more intimate scrutiny of the body – from any distance and angle. The nineteenth-century photographer had carefully posed his model, and, once satisfied, recorded the static result. The twentieth-century photographer went at the task without preconceptions, and used his or her camera to investigate or discover a

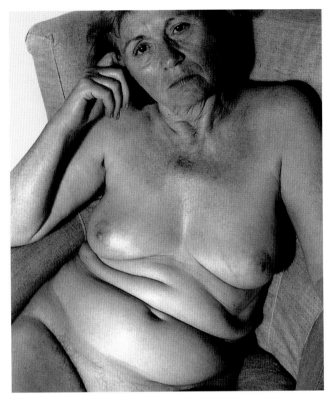

For certain contemporary photographers, the aged body,
especially if it is that of a loved one, is worthy of commemoration.
Melanie Manchot, *looking at you,* from the series
look at you loving me, 1998, gelatin silver print

'terrain'. Classical perspective and the standard poses known from art seemed more and more irrelevant, as photographers 'danced' around the model's bodies (which could also be encouraged to move) looking for the new and unexpected. With ever increasing confidence in their own medium, photographers proposed nudes which looked less and less like Goyas, Moreaus, Ingres and Bouguereaus and more like a wholly new genre. The real innovation, and the real excitement, arose from the disorienting fragmentation that grew out of this new approach, which was a peculiar mix of realism and abstraction, a mix that had the effect of reinvesting the body with mystery. This allowed for a tension between what was concealed and what was revealed – a fundamental requirement of eroticism. The body, seen up close with all **45**

its pores and fine hairs visible – was no longer the coherent 'figure' known from art. Fragments could reveal unexpected beauty, or suggest that the whole from whence they derived was something other than a body – perhaps an animal, an inanimate object, or even a magical being. Now the realism of photography, which had been seen for so long as a drawback, was valued as an asset. Photography had finally found an expressive terrain which distinguished itself from painting.

This is not to say that the photographic nude has evolved no further since the era of modernist invention in the first half of the twentieth century, nor that it has come to the end of its creative evolution. Since the 1980s there has been a distinct trend to depict the flesh of the body in all its peculiarities and imperfections, previously glossed over in pursuit of exquisite form. The homoerotic nude has also moved boldly into the mainstream, and no longer hides itself behind euphemisms. Women, too, are far less reticent to take up the nude – male and female – and they show no reserve when it comes to frank sexuality. Lastly, as we have seen, the aged body is also being slowly accepted as a valid subject.

Nudes – in whatever guise – by no means account for all the manifestations of love and desire in photography; far from it, as the plethora of styles and strategies presented in this book suggest. Collage; reportage and other forms of documentary photography; artworks which rework imagery appropriated from commercial sources; staged and fabricated photographs – each genre contributes its share. But all the genres and sub-genres of photography relating to love and desire can still be reduced to three key strategies:

– A photographer may propose a body or a thing or a place as an object of desire, with the express intention of *exciting* the viewer (page 190).

– A photographer may present something he or she has observed (and certainly not directed) with the hope of *informing* the viewer or stimulating the intellect (page148).

– A photographer may fabricate an image in order to *attack* or even *subvert* conventional notions of respectability, prudery, hypocrisy and the like (page 361).

Very different modes of working characterize these approaches: a commercial studio which turns out advertising and fashion work has immense technical and human resources to put into the task (expensive cameras, lighting, stylists, make-up artists, assistants), whereas the documentary photographer prowling the streets has little to fall back on except his or her own wits. And the artists who sit in their studios weaving their spells may rely on no equipment at all, save for scissors and paste. These

are not insignificant differences, and it is helpful to keep them in mind when thinking about the meaning of each image.

What follows are some 320 creative, informative, exciting and provocative images drawn from across the history of photography – its art and its commerce – from industrially produced postcards, pumped out by the millions, to unique, lovingly handworked prints destined for a museum collection or an ardent collector. There are classic, utterly respectable nudes, and photographs of naked bodies which purposely defy artistic and moral convention. There are straight, unadulterated photographs and those that have been subject to complex manual and electronic manipulation.

I have ignored such distinctions in the juxtaposition of images on the pages of this book in the hope that the different strategies and intentions will be all the *more* evident as a result. Moreover, a single photographer's work may be featured in different sections, underlining the varied functions of an image. I believe that it is impossible – or at the very least unfruitful – to talk of a single meaning of a photograph. Each viewer brings to each image his or her personal experience (including the experience of viewing previous images), his or her preconceptions about art and representation, and his or her emotional needs. Thus, the choice of images in this book, their juxtaposition and their assignment to a specific section betrays its author's point of view, insights and prejudices.

Following pages
Duane Michals, *What is Love? What is Desire?*, 1999, gelatin silver prints

What is Love?

Love is a jubilant fountain of affection, that floods the hollow heart with happiness and overflows with joy. Like wind, fire and air, it is a natural element, an instinct to share, the caring heart laid bare. Lovers fill with fascination for each other, and see in the other's eyes what their lives have been denied, and where their futures lie. Infatuation is the adolescence of true love. Romance is the fluttering of the heart, when the other departs. I cannot tame my orphaned heart's remorse, or claim myself to be my very own, since you have roamed, and love has changed its course. You are true north to my heart.

What is Desire?

Desire is a coveting need, an urgent greedy appetite to acquire and consume to satisfaction. Unlike love, which seeks to serve, desire is self-serving and seeks its own reward. Lust is sired by a panicked yearning that erupts in passion and good sense and logic are dispensed. It is a spectre in the skin that leads the hand to sin. Desire dies when satisfied; Desire denied multiplies. I can still remember even today the way your shirt was torn and how I glimpsed a treasured hint of your perfect form. And with that quick glance desire was born

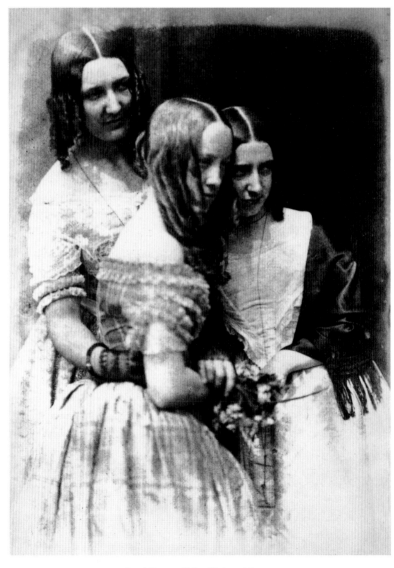

David Octavius Hill and Robert Adamson
Misses Binney and Miss Justine Monroe (later Mrs Justin Gallie), c. 1843–47
Salted paper print

BONDS

For the Victorians, the celebration of family bonds needed discipline. They posed stiffly for daguerreotypists [54] and calotypists [Hill and Adamson *opposite*], their gestures and expressions carefully orchestrated. In fairness, this rigidity was in good part a consequence of the long exposures required – subjects had to remain absolutely still for as long as several minutes, often with their heads held in clamps. The result, however, was worth the ordeal: a portrait of mirror-like fidelity beautifully encased in velvet and leather, or a delicately rendered print that could outshine the finest engraving. Either would find a place among a family's most valued possessions.

By Edwardian times, people were far more relaxed in front of the camera, and photographers were much more comfortable with their craft. As a result, pictures from this era have an easy informality about them, though one should not be misled by appearances. What looks like casualness was often staged: the portrait of Sarah Bernhardt [59] is actually every bit as posed as its more formal counterparts, but the touching gesture whereby she reaches down lovingly to pat her dog strikes us as authentic, as if we were witnessing a relaxed 'off-camera' moment.

It is possible that commercial photography of the period was beginning to absorb – admittedly to a very limited degree – the influences of amateur photographers, whose lack of understanding of, or even disdain for, the rules and conventions made for less wooden imagery [Cameron 57]. In the hands of gifted amateurs, family portraiture could achieve great eloquence [Myers 60].

Once freed from the confines of the studio, the photographer's domain knew no bounds. Professionals and amateurs travelled the world in search of the exotic – and what was more exotic than distant peoples and their customs, particularly those that touched on love and desire [62, 65]? Those less adventurous amateurs who elected to remain at home commemorated the *rites de passage* of their loved ones with the help of the ingenious Kodak [64]. Newlyweds, however, have never entirely trusted their amateur friends to convey the solemnity of the marriage ceremony itself: to this day, the 'official' picture-taking is entrusted to professionals [Sullivan Studio 80].

Amateurs, at least those with a keen sensitivity, have one advantage over professionals which is evident in the work: they are close to their subjects and recognize

the subtle gestures and expressions that betray emotional states. *Contemporary* photographers – and here we must stress that the old amateur/professional dichotomy is no longer accurate since many artists (amateurs in the strict sense) manage *very* professional careers – have found their own families to be a rich vein indeed [Lüthi 67; Sultan 83; Mann 85; etc.]. Their intimacy brings them in close [Gall 75; Nixon 76] and allows them to observe moments that would never be exposed to the gaze of a stranger [Carucci 82].

Photographers of our day tend to be far more frank and much less sentimental than their early-twentieth-century predecessors, as a comparison of 'mother and child' images from both periods makes clear [Coburn 61; Dijkstra 91]. Nevertheless, one should be careful not to exaggerate such distinctions, as if the two eras had nothing in common: the Pictorialist ethos remains a powerful undercurrent in contemporary photography, even if its accent is on realism rather than idealization [Fellman 74].

Today's pictures also tend to be a good deal more sensual, which carries great risks when the subjects are children – from the evidence, it would appear that the Victorians were far more comfortable with depictions of naked children than we are. What *is* new in the representation of familial bonds, however, is a willingness to depict the emotional tensions of family life [Mann 68], together with a sense of social critique leavened by gentle irony [Paradeis 86, 87].

(opposite) **Phil Bergerson**
Brides and Grooms, 1978
Original in colour/Ektacolor print

(following pages) **Edward Monson Studio**, Ipswich
Untitled, c. 1850
Daguerreotype

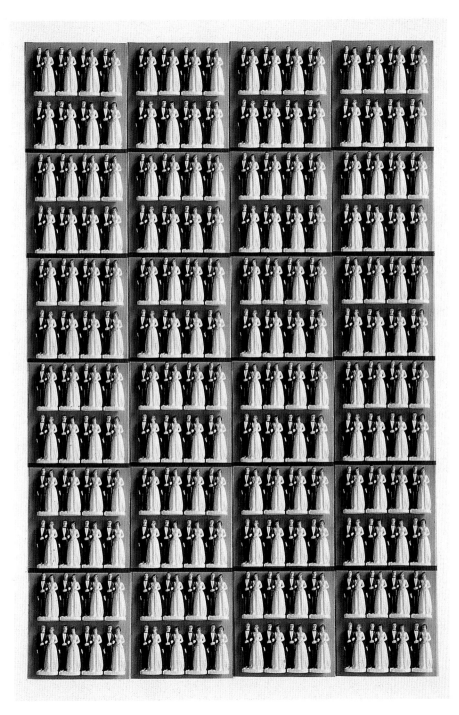

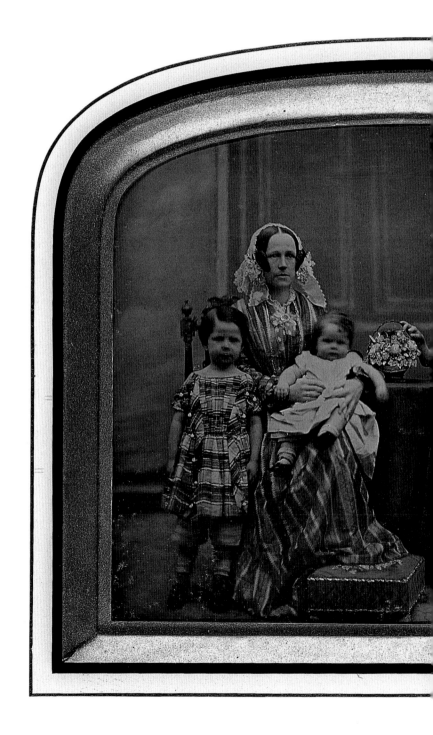

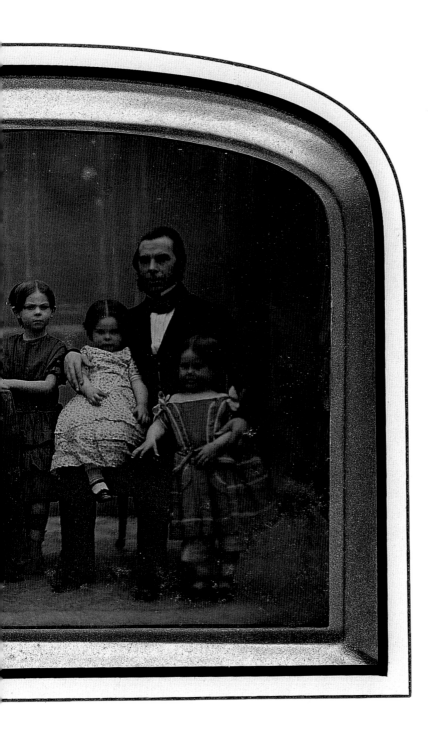

František Drtikol
Untitled, c. 1905
Gelatin silver print

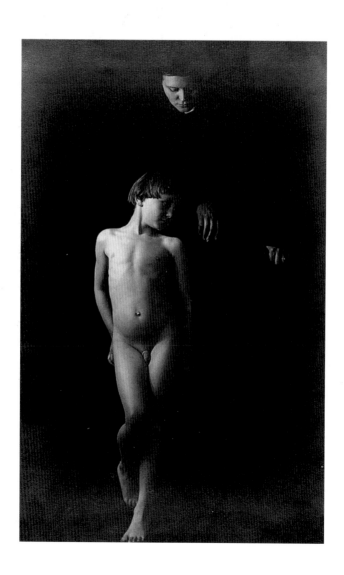

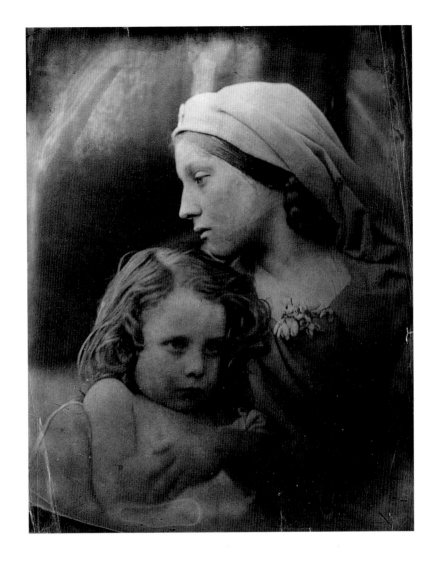

Julia Margaret Cameron
La Madonna Aspettante, Yet a Little While, c. 1865
Albumen silver print

Unidentified photographer
Untitled (Eastern Europe), 1926
Postcard

(opposite) **Unidentified photographer**
Sarah Bernhardt, c. 1895
Gelatin silver print

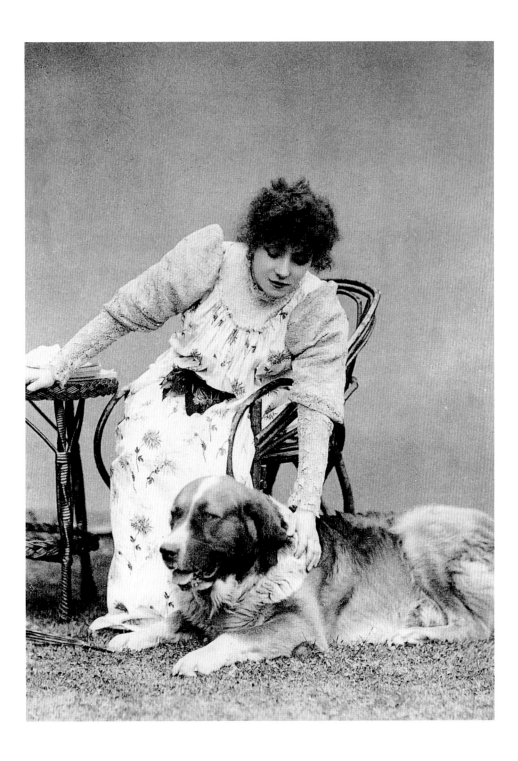

Eveleen Myers
Frederic W. H. Myers,
the photographer's husband, and their son, c. 1890
Platinum print

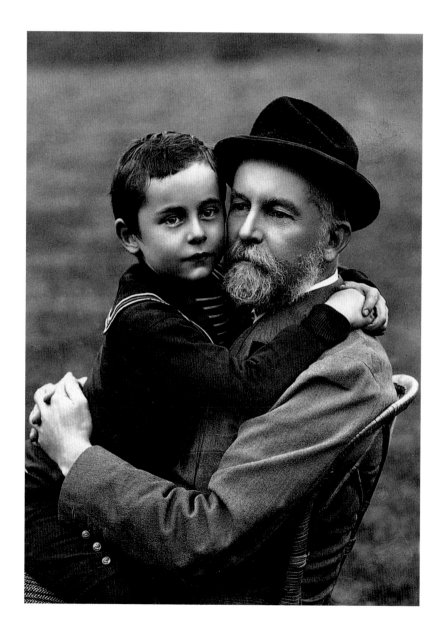

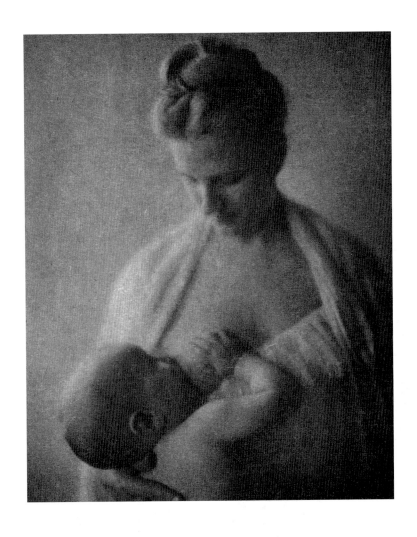

Alvin Langdon Coburn
Mother and Child, A Study, before 1904
Photogravure

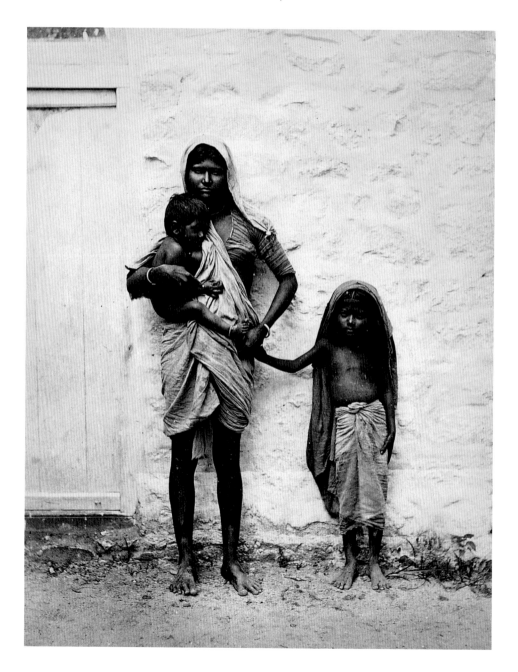

Imogen Cunningham
Family on the Beach, c. 1910
Gelatin silver print

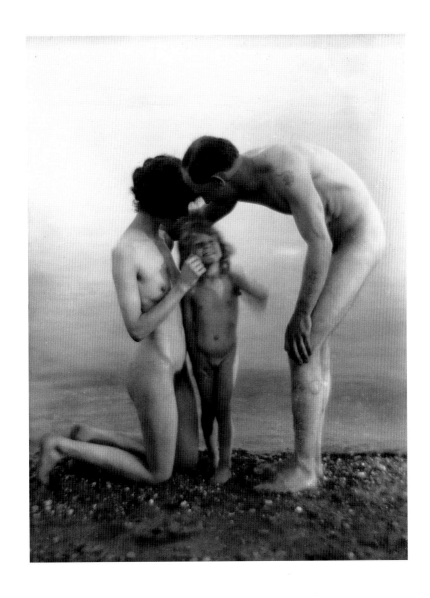

(opposite) **Unidentified photographer**
Untitled, 1888
Gelatin silver print

Unidentified photographer
Untitled, c. 1870
Albumen silver print

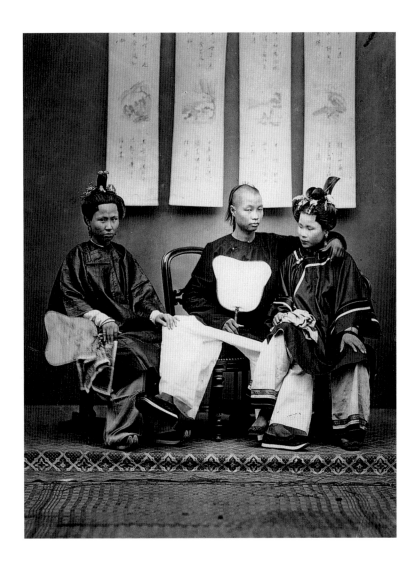

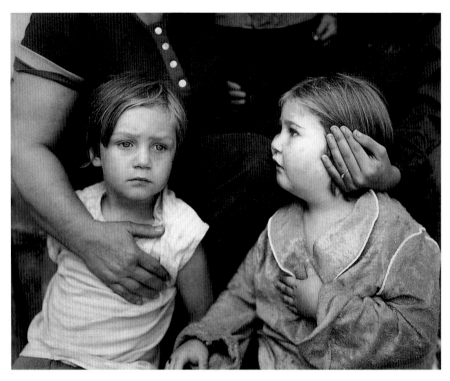

Andrea Modica
Treadwell, New York, 1986
Palladium print

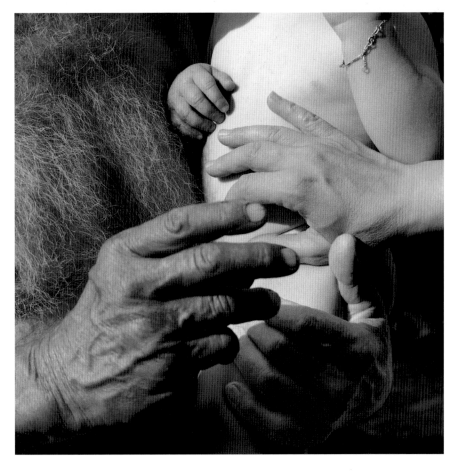

Gérard Lüthi
*Le Temps réconcilié (Three Generations of Hands:
Those of My Daughter, My Wife and Her Father)*, 1990
Gelatin silver print

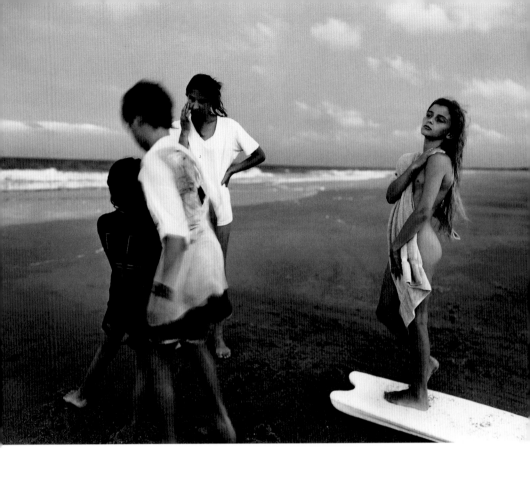

Sally Mann
Venus Ignored, 1992
Gelatin silver print

Leon Levenstein
Coney Island, 1957
Gelatin silver print

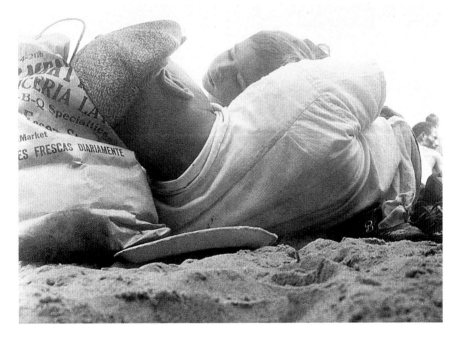

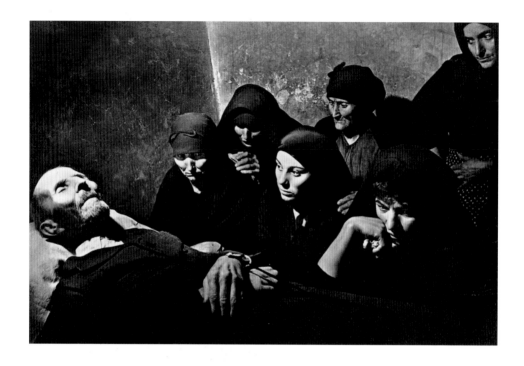

W. Eugene Smith
The Wake, 1951
Gelatin silver print

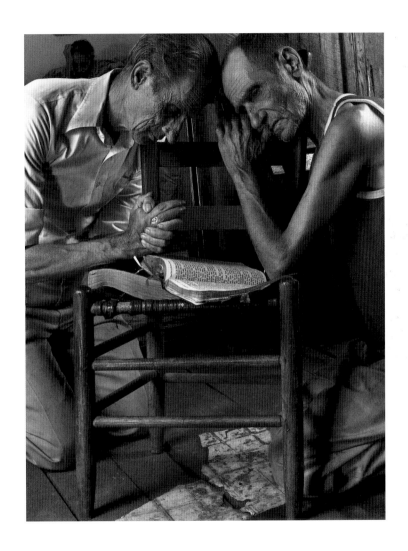

Shelby Lee Adams
Brothers Praying, Hooterville, Kentucky, 1993
Gelatin silver print

Nicholas Nixon
Bebe and I, Lexington, 1997
Gelatin silver print

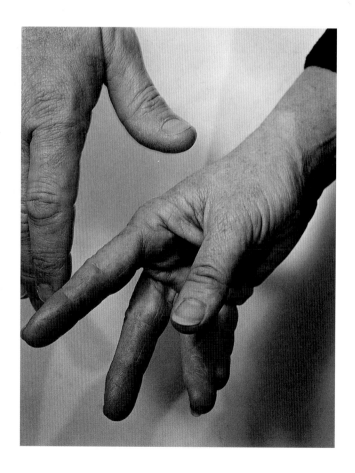

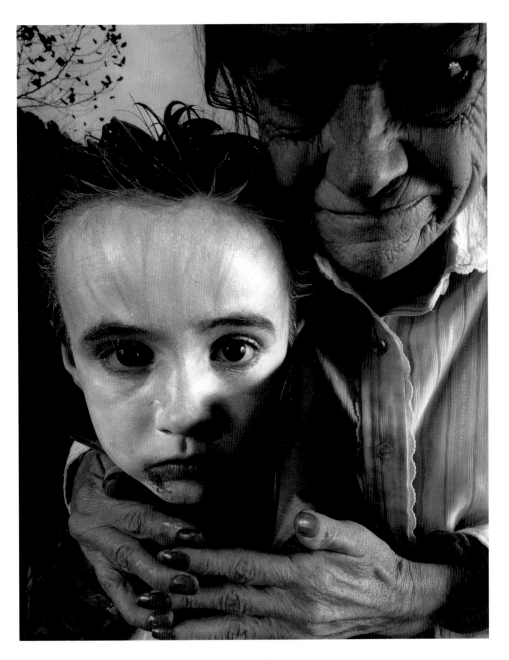

Shelby Lee Adams
Appalachian Dracula with Granny,
Leatherwood, Kentucky, 1993
Gelatin silver print

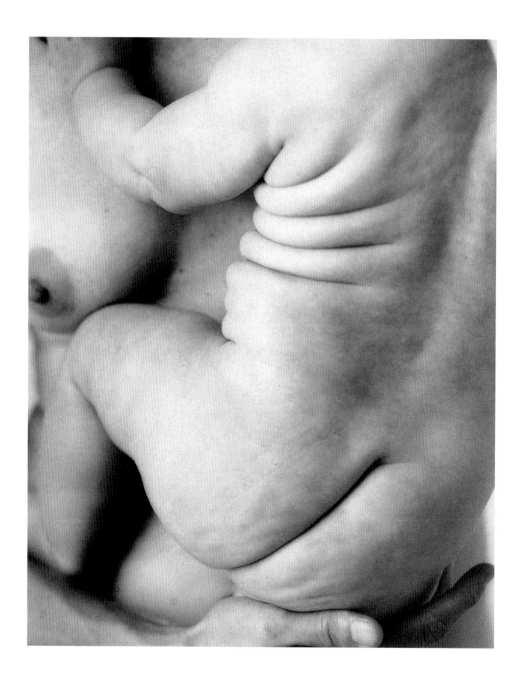

(opposite) **Sandi Fellman**
Untitled, 1994
Platinum print

Sally Gall
Re-entry, 1997
Gelatin silver print

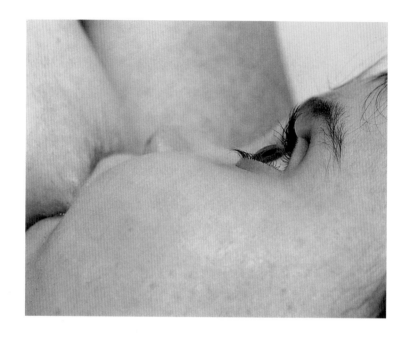

Nicholas Nixon
Clementine, Cambridge, 1986
Gelatin silver print

(opposite) **André Kertész**
Elizabeth and I, Paris, 1931
Gelatin silver print

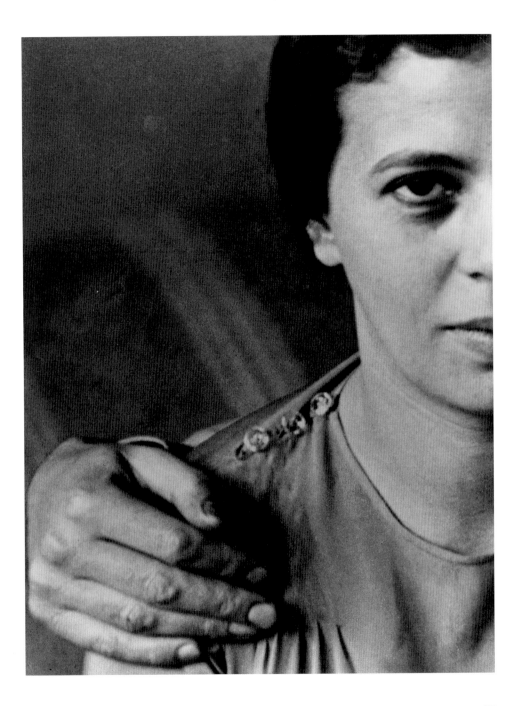

Bill Jacobson
From the series, *Song of Sentient Beings*, 1994
Ektacolor print

(opposite) **Ed van der Elsken**
L'Amour, n. d.
Gelatin silver print

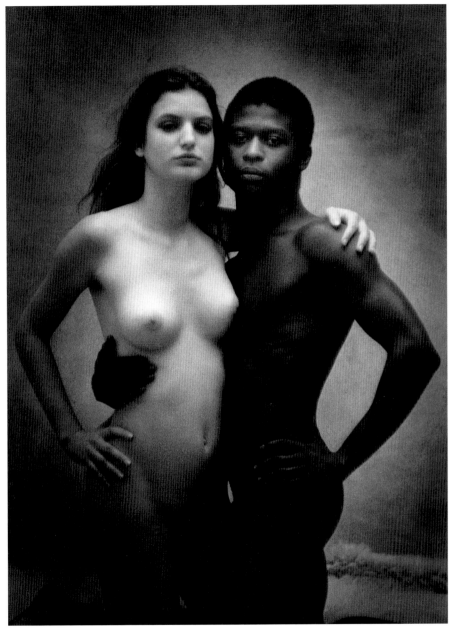

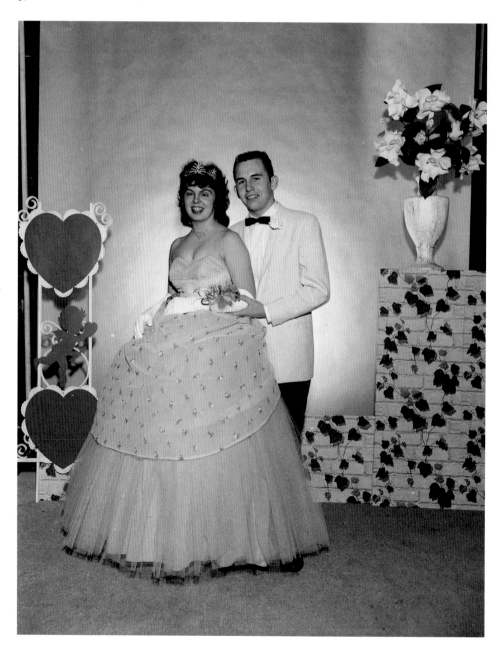

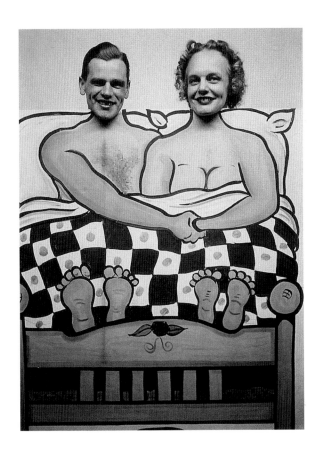

(opposite) **Francis Sullivan Studio**
Derry, New Hampshire, 1959
Gelatin silver print

Unidentified photographer
Untitled (Fairground cut-out), c. 1940
Gelatin silver print

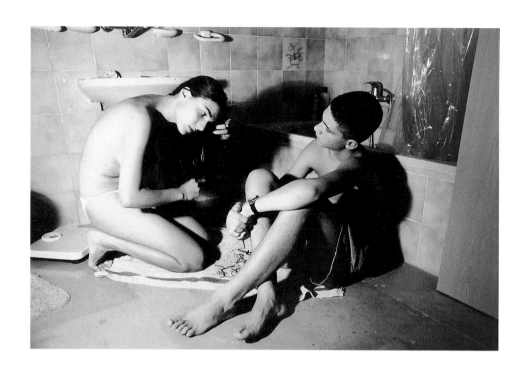

Elinor Carucci
Haircut, 1994
Chromogenic print

Larry Sultan
My Mom Posing at Home, 1987–89
Chromogenic print

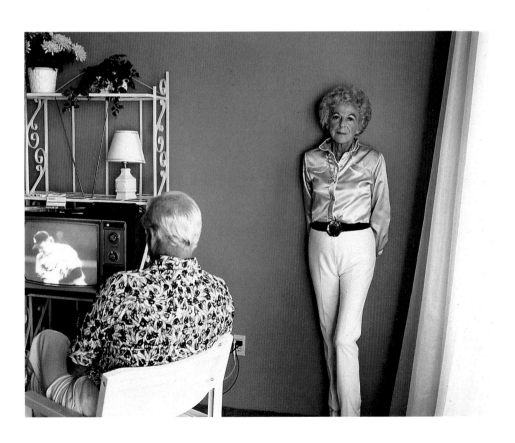

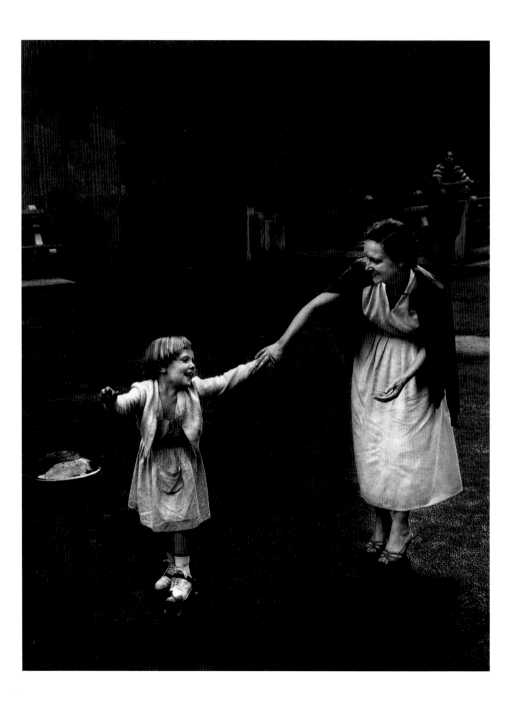

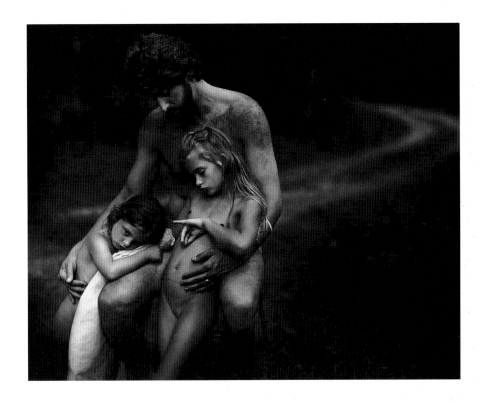

(opposite) **David Heath**
New York, 1958
Gelatin silver print

Sally Mann
The Good Father, 1990
Gelatin silver print

Florence Paradeis
Les Deux Oreilles (The Two Ears),
11 May 1996; diptych
Chromogenic print

Florence Paradeis
Les Deux Oreilles (The Two Ears),
11 May 1996; diptych
Chromogenic print

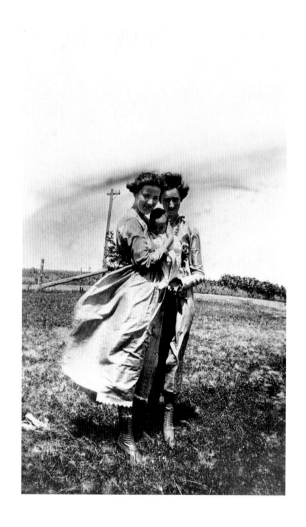

Unidentified photographer
Untitled, c. 1935
Gelatin silver print

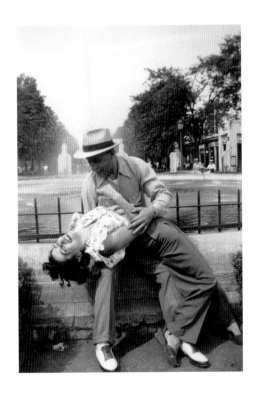

Unidentified photographer
Untitled, c. 1945
Gelatin silver print

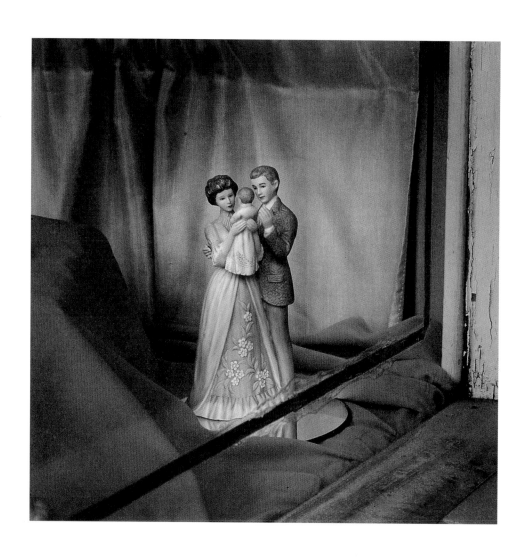

Phil Bergerson
Ceramic Nuclear Family,
Strathroy, Ontario, 1994
Ektacolor print

Rineke Dijkstra
Tecla, Amsterdam, 16 May 1994
Chromogenic print

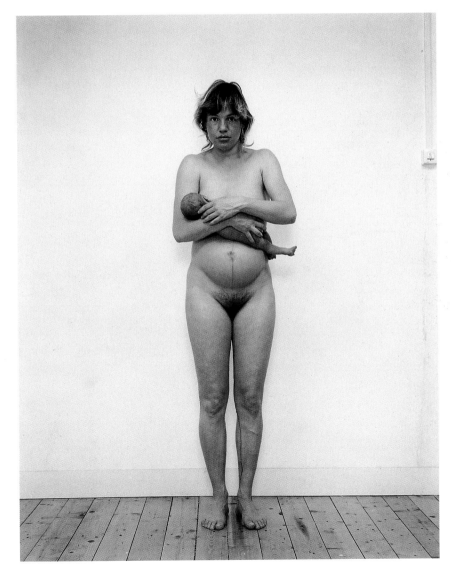

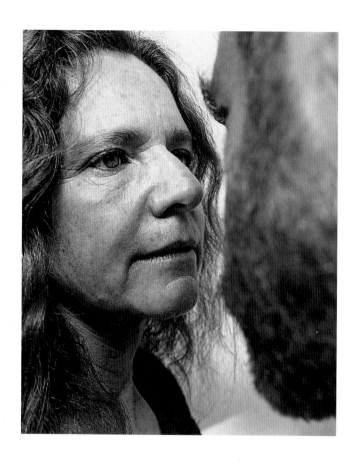

Nicholas Nixon
Bebe and I, Lexington, 1998
Gelatin silver print

(opposite) **John Dugdale**
Carlos and Darrel, 1993
Cyanotype

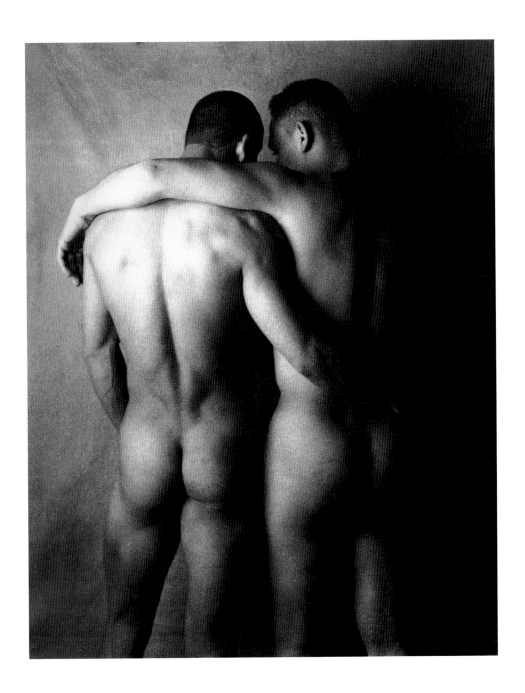

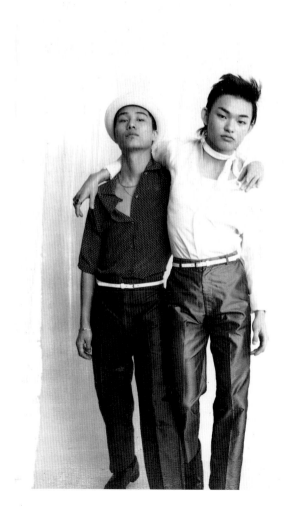

(opposite) **Unidentified photographer**
Untitled, c. 1950
Gelatin silver print

Sandi Fellman
Horiyoshi III and His Son, 1984
Polacolor ER print

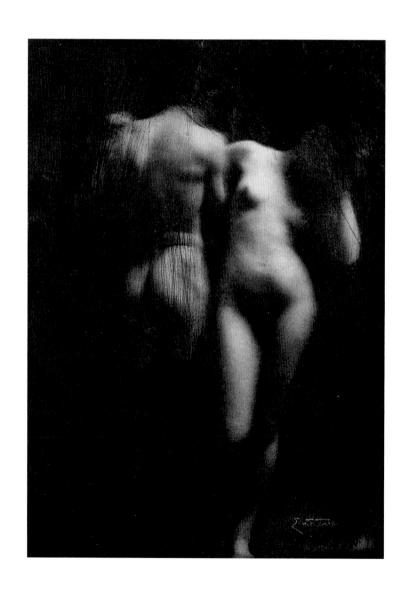

Frank Eugene
Adam and Eve, 1898
Photogravure 1910

ICONS

In the era which preceded the arrival of photography, people were accustomed to highly idealized portrayals of their heroes and heroines in paintings, sculpture, engravings, lithographs and the like. Photography held out the possibility of an unprecedented form of intimacy: an almost physical and psychological proximity with the admired subjects themselves. This made for a new sense of community, far more extensive than that offered by one's family, friends and acquaintances – though 'virtual', that is, disembodied.

While the public wanted 'real people' in photographs, these real people might in fact be playing well-defined roles [Silvester 102]. And if role-playing was required, it stood to reason that young, physically attractive bodies would be preferred. Furthermore, these youthful bodies would be far more appealing if couched in fantasy [103, 104], especially that which conjured up or showed exotic settings [105].

Photography offers the viewer a choice: either to possess – at least in the imagination – the object of desire; or – by following a regime – to *become* it. The late-nineteenth-century practice of bodybuilding, for example, made effective use of photography in regard to the latter proposition. Before-and-after photographs comparing a weakling with a latter-day Atlas were held up as proof of this-or-that method's efficacy, while portraits of those who had accomplished this transformation lined the walls of gymnasia [118].

Since then, male physique photography has proved a durable genre [106, 109], on the one hand catering to a powerful male urge to display the body in heroic fashion, at the peak of its physical strength and prowess, on the other hand responding to a homosexual desire to see the body (sometimes with the aid of phallic symbolism [111]) as an object of lust.

Myth has often served photographers as a vehicle for high-minded sentiments, and the young and the beautiful, often scantily clad, figure prominently in such imagery. The late-nineteenth-century art photographers known as the Pictorialists were particularly fond of this allegorical genre: Adams and Eves [Eugene *opposite*], Madonnas sacred and secular, and gods and goddesses pagan and Christian [Yevonde 122, 123] people the Pictorialist landscape. But the overpowering realism –

the here-and-now aspect of photography – seems ill-suited to religion's pictorial needs. Attempts to stage tableaux such as the Crucifixion or the Stations of the Cross have met with anger and disdain. Religious themes seem better suited to documentary photography, which does not rule out a certain irony [Gutsche 142, 143].

There are many ways of treating the iconic, idealizing aspect in photography. Sometimes the challenge is to construct, or at least reinforce, an ideal of physical perfection – one is tempted to say, the industry standard – as in Herb Ritts's clubbish supermodels [127]. Other photographers prefer to observe and record the phenomenon of adulation in its varied forms: a ticker-tape parade for the astronauts who set foot on the moon [De Biasi 138–39]; a rapturous crowd intent on physical contact with a living legend [Capa 140–41].

Photographers who help to create the icons of today and those who are content to witness the phenomenon do not have the field entirely to themselves. Certain photographers use the medium to analyse and critique. Vanessa Beecroft uses her own mute models in performances which parody the vapid if glamorous lives of their high-fashion counterparts [130], while Nancy Burson's composites of film stars reveal the cultural biases of different eras and force us to question conventional notions of unique, individual beauty [136, 137].

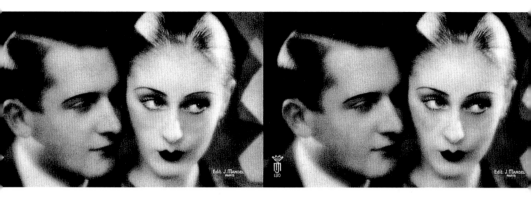

Giannetto Bravi
Cercando la tua piccola bocca scarlatta
(Looking for Your Little Scarlet Mouth), 1996
From original postcard published by J. Mandel, Paris
Photographic glaze transferred to canvas
(202 × 64 cm) and plasticized

Guilmer
Etude d'homme drapé
(Study of Man with Drape) 1870
Albumen silver print

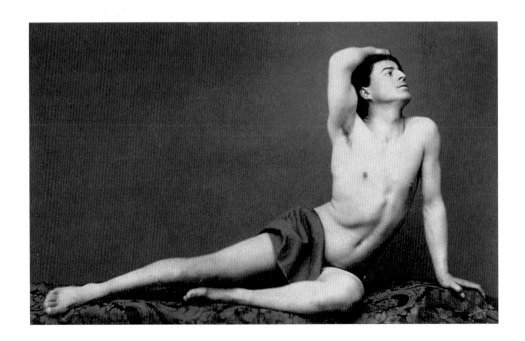

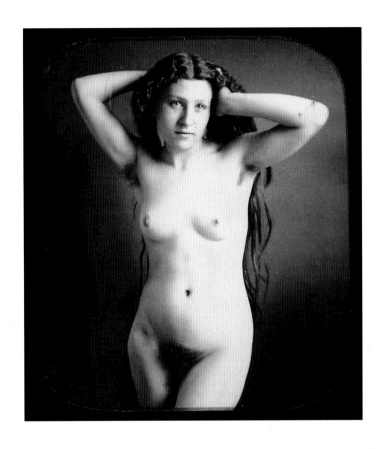

Unidentified photographer
Untitled, c. 1855
Stereoscopic daguerreotype

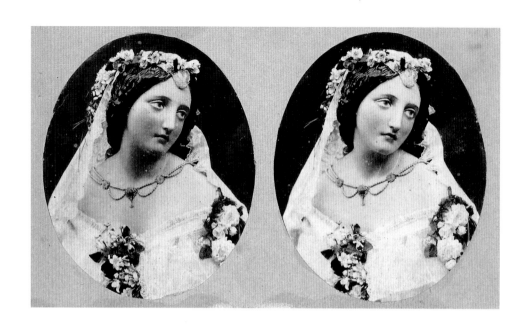

A. Silvester
The Bride, c. 1860–65
Stereoscopic albumen silver
print on card

Unidentified photographer
Untitled, *c.* 1855
Daguerreotype

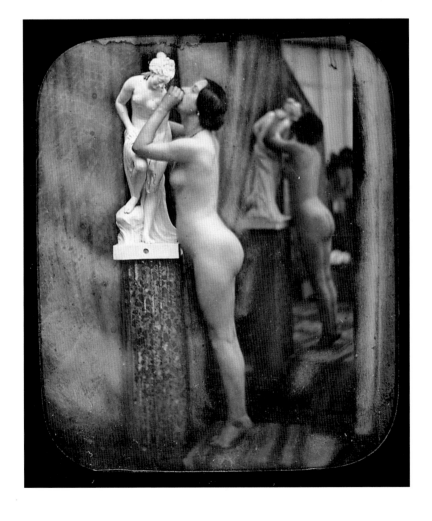

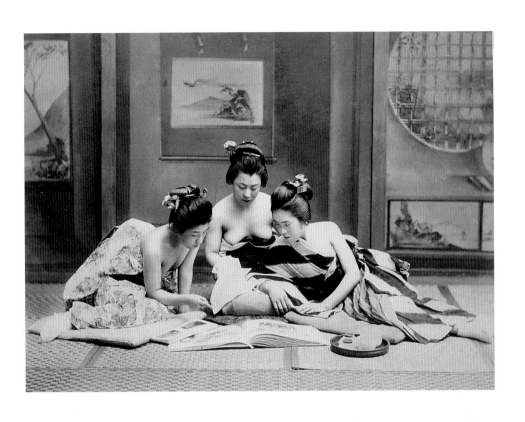

(opposite) **Unidentified photographer**
Untitled, c. 1900
Gelatin silver print

Unidentified photographer
Teahouse Women, c. 1890s
Hand-coloured albumen silver print

Unidentified photographer
Western Photography Guild
Untitled, c. 1950
Gelatin silver print

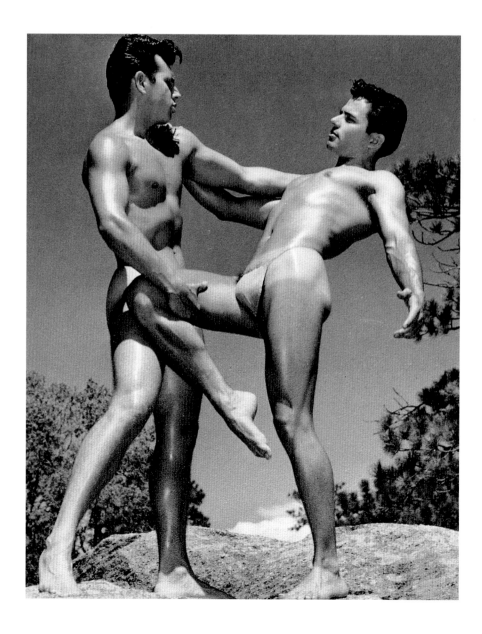

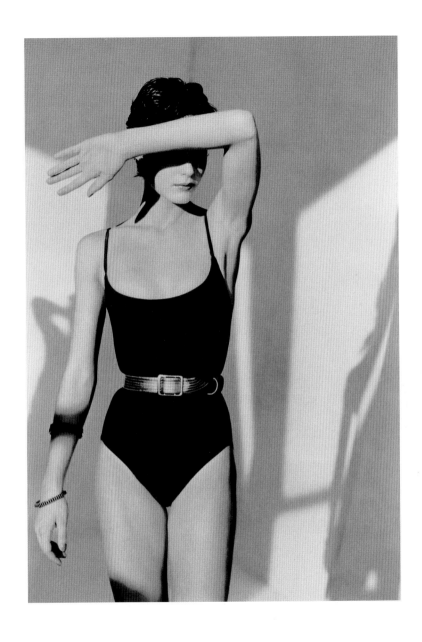

Arthur Elgort
Esmé for Vogue, 1979
Toned gelatin silver print

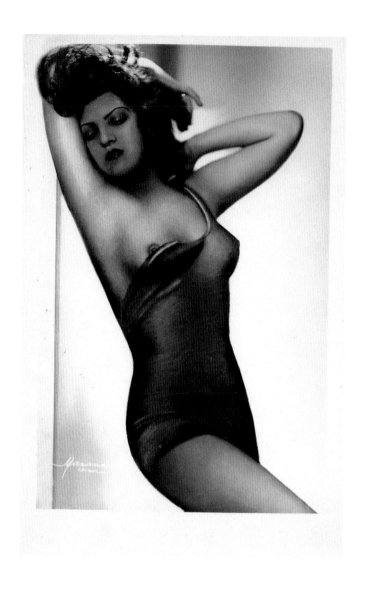

Studio Manassé, Vienna
Untitled, c. 1940
Postcard

Unidentified photographer
Untitled, c. 1950
Gelatin silver print

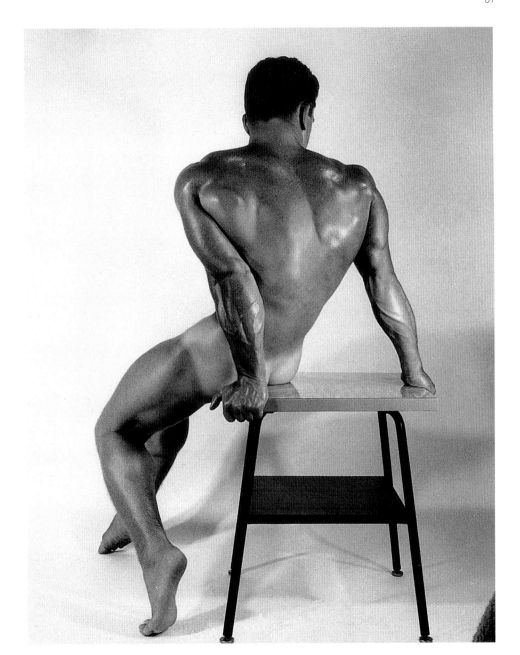

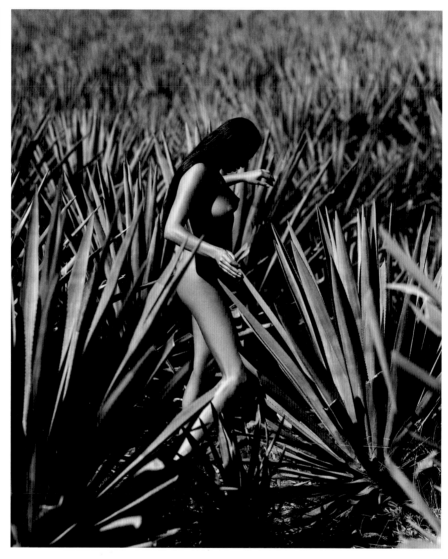

George Holz
Woman, Garden of Agave, Tequilla, Mexico, 1996
Retouched gelatin silver print

Unidentified photographer
Untitled, c. 1940
Gelatin silver print

(overleaf) **Harry Annas Studio**, Lockhart, Texas
Untitled, 1930
Gelatin silver print

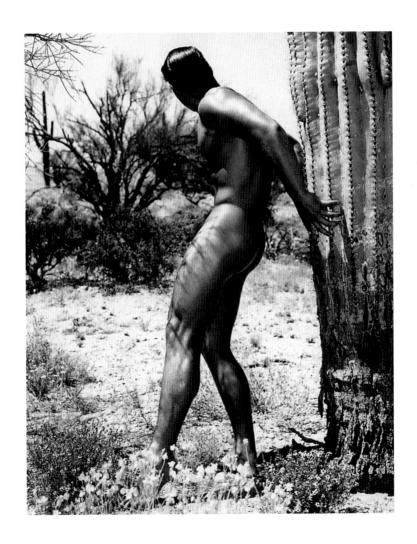

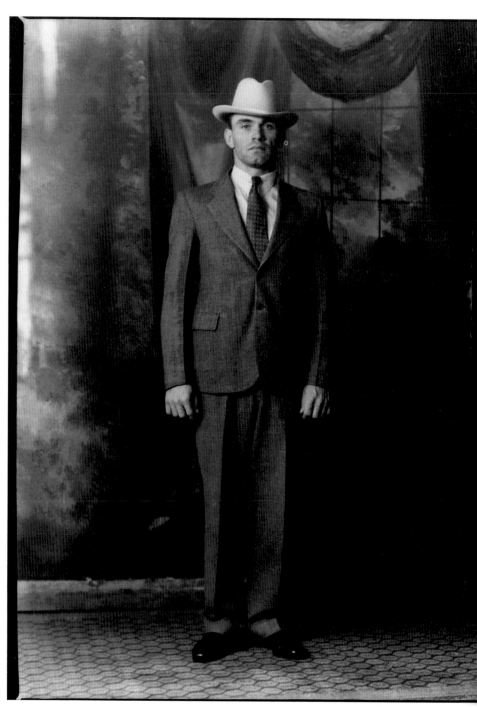

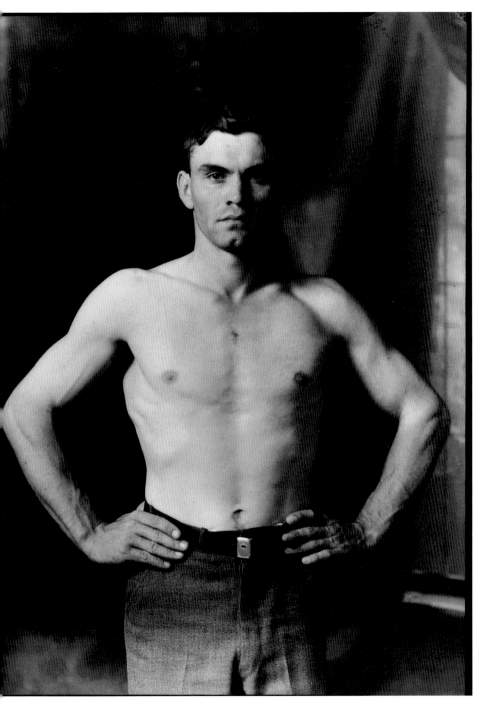

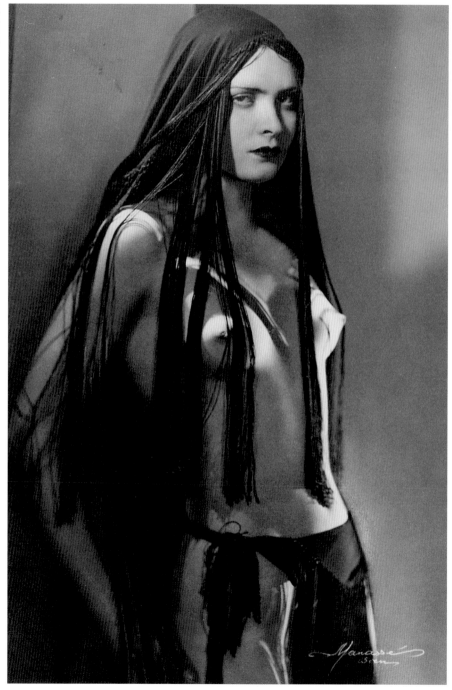

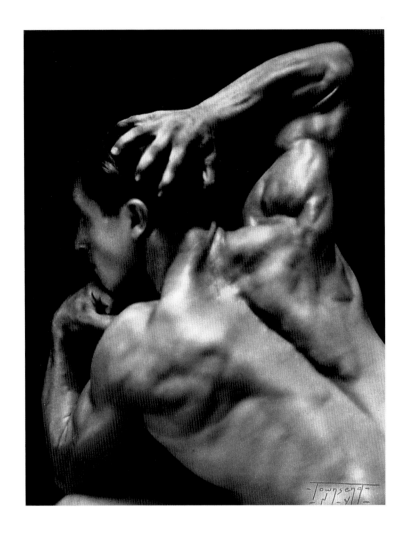

(opposite) **Studio Manassé**, Vienna
Untitled, c. 1935
Gelatin silver print

Townsend, New York
Untitled, c. 1940
Gelatin silver print

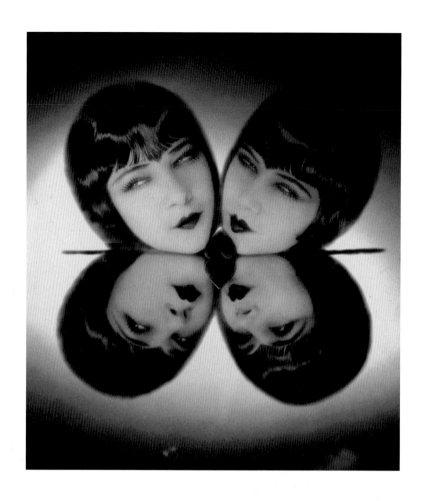

Studio Manassé, Vienna
Untitled, c. 1930
Photomontage; gelatin silver print

(opposite) Albert Rudomine
The Legs of Suzy Solidor, 1924
Bromoil print

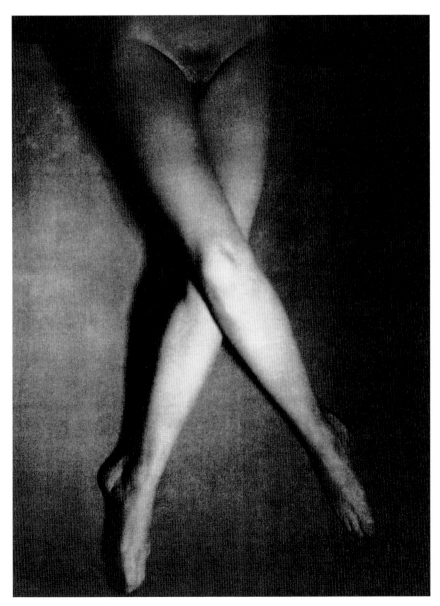

Unidentified photographer
Untitled, c. 1920
Gelatin silver print

(opposite) **Unidentified photographer**
Untitled, c. 1940
Gelatin silver print

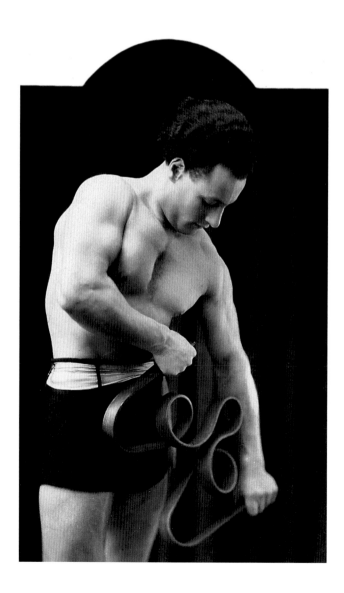

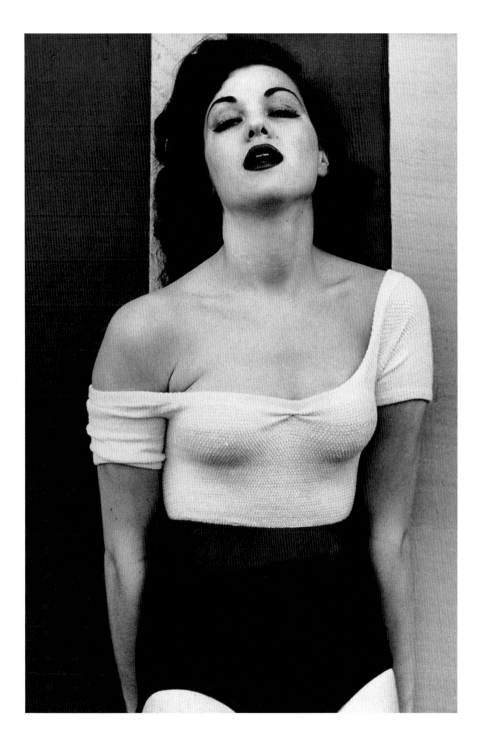

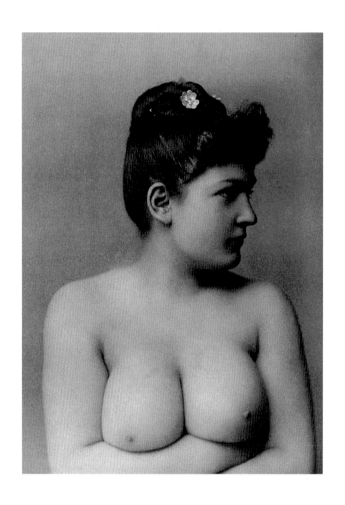

Unidentified photographer
Untitled, c. 1890
Albumen silver print

(opposite) **Alejandra Figueroa**
Untitled, 1998
Gelatin silver print

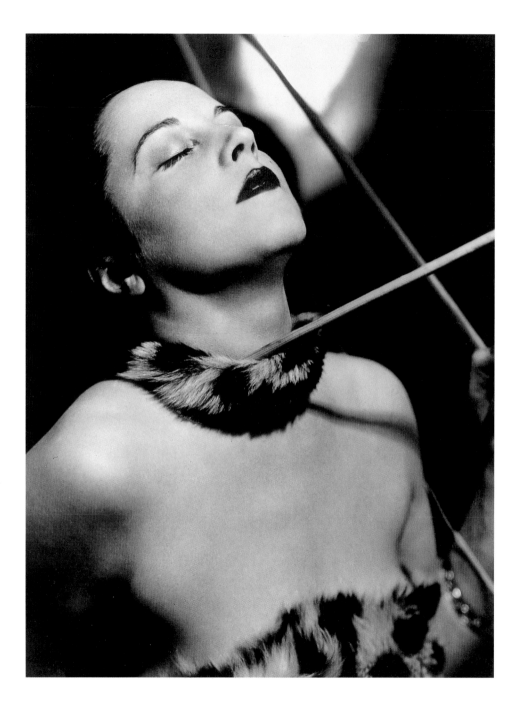

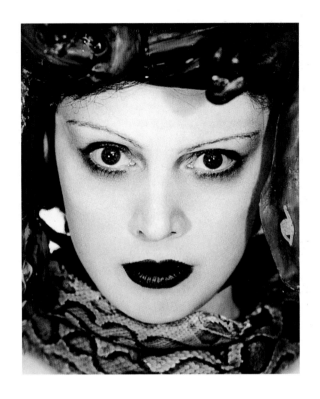

(opposite) **Madame Yevonde** (Yevonde Cumbers)
Lady Milbanke as Queen of the Amazons *(Penthesilea),*
from the Goddesses *Series,* 1935
Vivex colour print

(above) **Madame Yevonde** (Yevonde Cumbers)
Mrs Edward Mayer as Medusa,
from the Goddesses *Series,* 1935
Vivex colour print

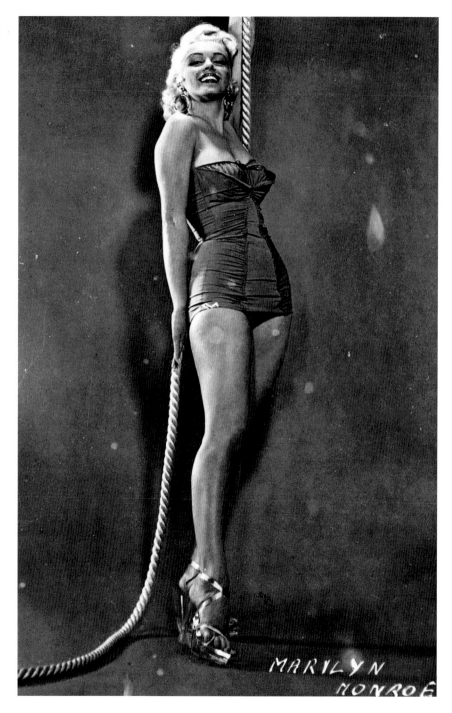

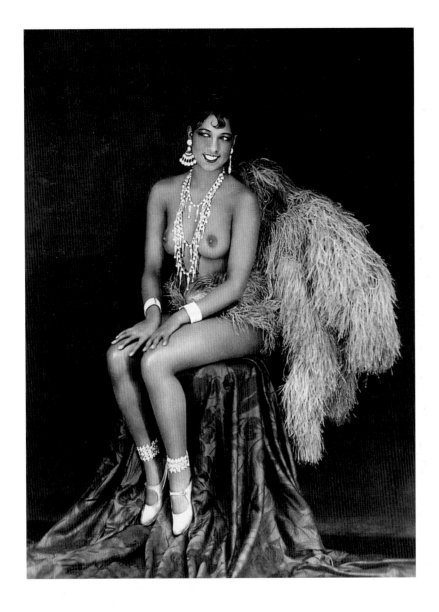

(opposite) **Unidentified photographer**.
Marilyn Monroe, n.d.
Postcard

Studio Waléry, Paris
Josephine Baker, c. 1925
Gelatin silver print

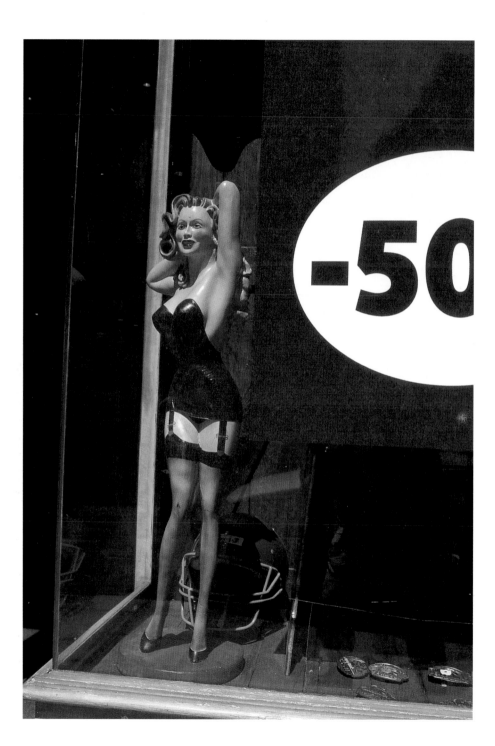

(opposite) **Robert Walker**
Shop Window, Paris, 1995
Cibachrome print

(below) **Herb Ritts**
Stephanie, Cindy, Christie, Tatjana, Naomi;
Hollywood, 1989
Gelatin silver print

(overleaf) **Unidentified photographer**
Jane Fonda as Barbarella, 1967
Front-of-house publicity still

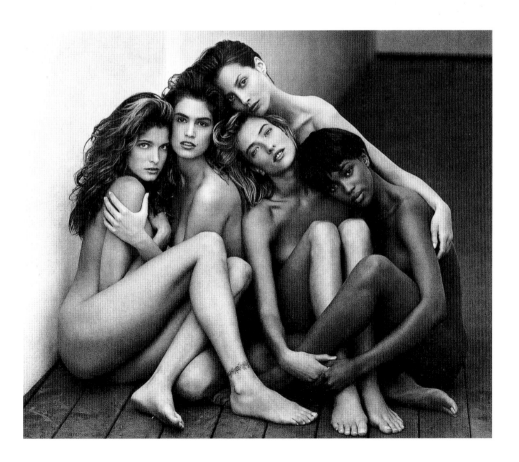

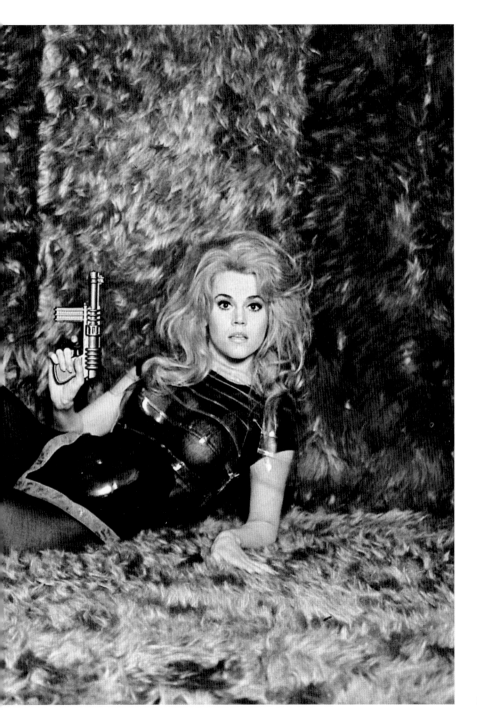

Vanessa Beecroft
UB 25 Performance 1996
Stedelijk Van Abbemuseum, Eindhoven,
the Netherlands
Cibachrome print

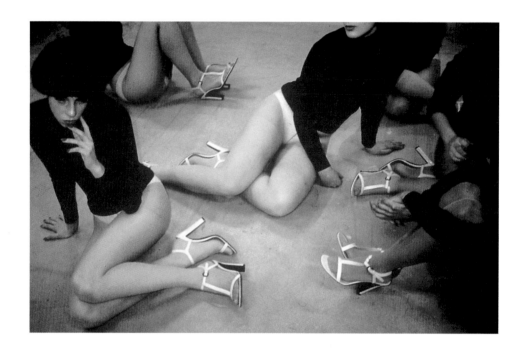

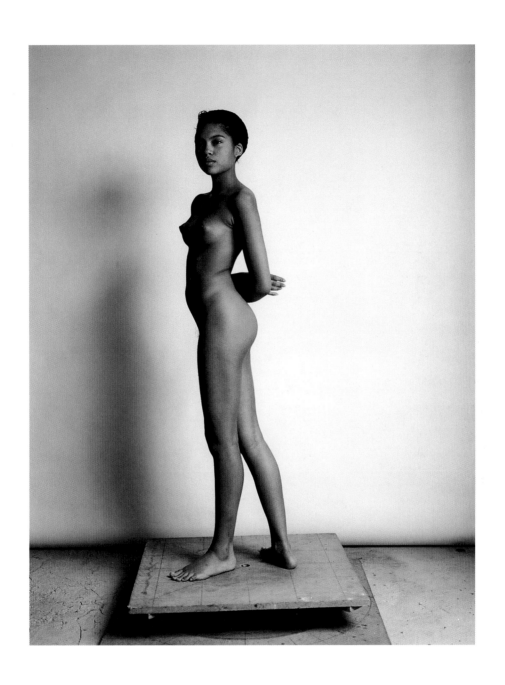

Robert Graham
LAC 1, Los Angeles, 1985
Unique Polaroid photograph

Paul L. Facchetti
From the review *Nus exotique, c.* 1940
Photogravure

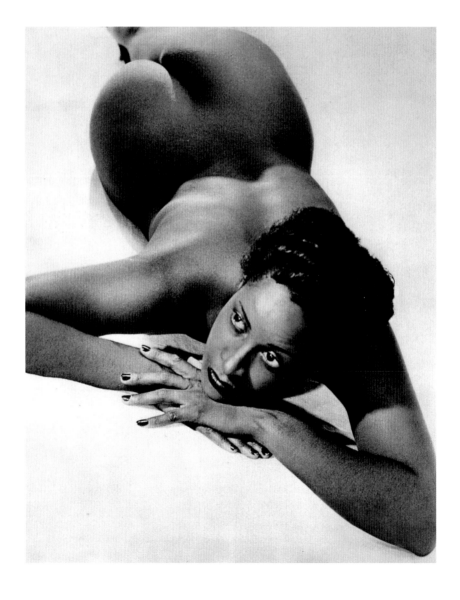

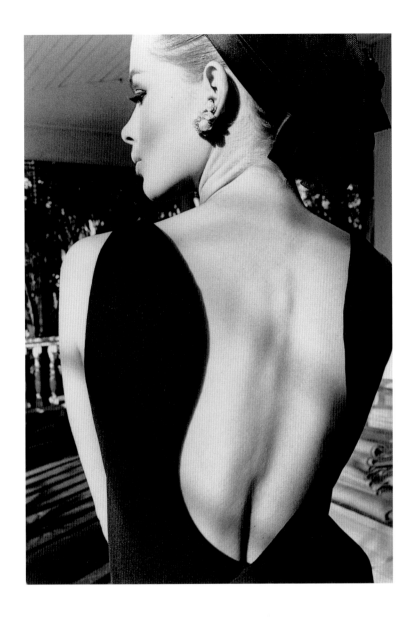

Jeanloup Sieff
Le Dos d'Astrid (Astrid's Back),
Palm Beach, 1964
Gelatin silver print

133

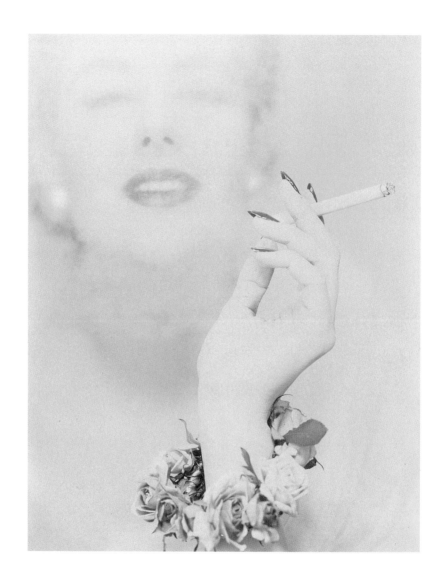

Erwin Blumenfeld
Untitled, New York, 1955
Kodachrome

Royé, England
Untitled, *c.* 1940
Kodachrome

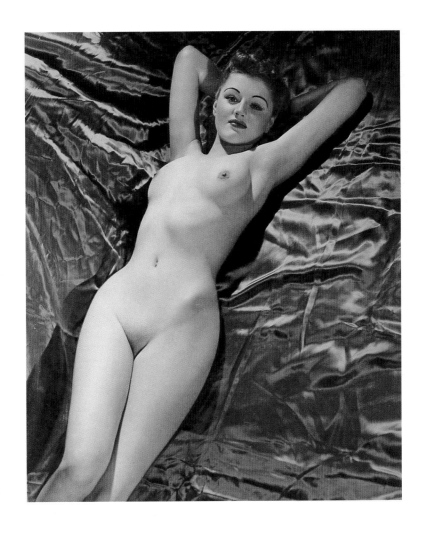

Nancy Burson
with David Kramlich and Richard Carling
Beauty Composite: Bette Davis, Audrey Hepburn, Grace Kelly,
Sophia Loren, Marilyn Monroe, 1982
Computer-generated
composite/gelatin silver print

Nancy Burson
with David Kramlich and Richard Carling
Beauty Composite: Jane Fonda, Jacqueline Bisset, Diane Keaton,
Brooke Shields, Meryl Streep, 1982
Computer-generated
composite/gelatin silver print

(overleaf) **Mario de Biasi**
The Heroes of Apollo II Celebrate the
Conquest of the Moon,
Broadway, New York, 1969
Chromogenic print

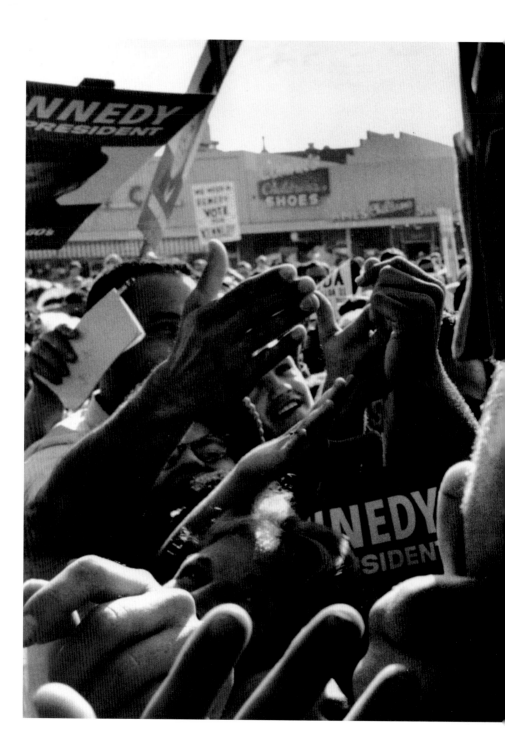

(preceding pages) **Cornell Capa**
The Hands of John F. Kennedy, as He
Campaigns in.California, 1960
Gelatin silver print

(above) **Clara Gutsche**
Pointe du Lac, Québec, 1993
From the *High School* Series
Chromogenic print

Clara Gutsche
Hull, Québec, 1993
From the *Convent* Series
Chromogenic print

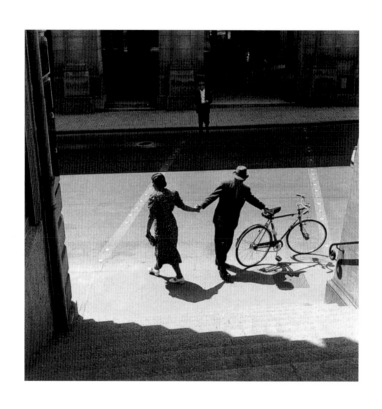

Hans Baumgartner
Limmatquai in Zürich, 1938
Gelatin silver print

OBSERVATIONS

Themes of love and desire seem to permeate photography, but being interior, emotional states they are impossible to photograph directly: they must always be *inferred* from actions and gestures, signs and symbols. Of course we automatically associate certain kinds of behaviour – kisses, embraces, held hands, and so on – with loving and desirous behaviour, but passion may also be feigned, and much deeply felt emotion between people passes unnoticed by all but the keenest observer. Happily, though, many of these observers are also photographers. And as a bonus for those of us who delight in photography's surreal capacity, they are often equipped with a wry sense of humour [Faurer 147; Walker 181].

While many of the photographers represented in this book prefer to orchestrate or stage pictures of love and desire, others prefer the challenge of finding 'the real thing', and the *additional* challenge of capturing it on film. For the roving photographer always on the lookout for a telling moment [Mermelstein 169], or the photojournalist out for a scoop [Lotti 148], speed is of the essence, or the split-second opportunity is lost [Brassaï 151; Dille 182].

Such photographers naturally gravitate to sites where erotic love is overtly on the agenda: the street, the park bench (a perennial favourite!) [Horvat 174], a red-light district [van der Elsken 164], bars and dancehalls [Zimbel 158, 159], cabarets, parties and balls [Tuggener 154], the beach in summer [Ishimoto 167]. They observe the rituals of courtship and love: young men and women 'on the make' [Greenfield 180; Musy 185], and middle-aged men who have long abandoned their pursuit of the opposite sex and are content to buy momentarily into a ritualized sexual fantasy [Horvat 160–61].

Some photographers manage to penetrate the most private of spaces: a working prostitute's apartment [Iuncker 162–63], a Wall Street brothel [Merry Alpern 165] or a plastic surgeon's operating theatre where breasts are reduced to conform to the norms of beauty [Gollob 168]. And two photographers have chosen to observe the activity – on and off stage – on pornographic film sets, though their styles are poles apart: the first approaches the subject in deadpan fashion, as if the hard work being performed by actors and crew were like any other [Probst 170, 171]; his fellow

photographer prefers an oblique, distanced approach – his images recall the orgiastic scenes depicted on ancient Greek pottery [Burton 172, 173].

Documentary photographers (or street photographers as they are sometimes called) are also keen observers of all the *ephemera* of desire – a store window forlornly displaying sexy shoes in a drab urban environment [Nozolino 156], obscene graffiti on the wall of an abandoned apartment [Kolar 186] or the side of a truck [Plachy 189], a beguiling image appearing fleetingly on a television screen in a less than glamorous apartment [Reggiardo 184].

Photographs of this nature invite storytelling and speculation and encourage our natural human tendency to fill in, to elaborate. Is the word 'love' found on a Cape Cod highway a plea or an affirmation [Atwood 188]? Is the young man at a Czech market, evidently captivated by the naked body of a beautiful young woman, destined to stray from the control of his partner, or merely experiencing a momentary rush of hormones [Kolar 175]? This is the pleasure of photography for those who take the time to appreciate it – the realization that the image is not just a dumb reflection of the world, but an intelligent and often lively commentary on it.

Louis Faurer
Freudian Hand Clasp, 1948
Gelatin silver print

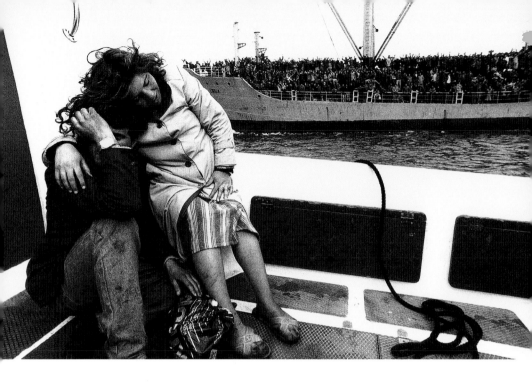

Giorgio Lotti
Albanian Refugees, Brindisi: Linda Halilay and her husband
have arrived in Italy clandestinely from Albania. She is in labour.
A boat is taking her to the hospital. In the background
is the ship Lirija *full of Albanian people*, 1993
Gelatin silver print

Uldis Braun
*Un Mariage campagnard
(Rustic Wedding)*, c. 1955
Gelatin silver print

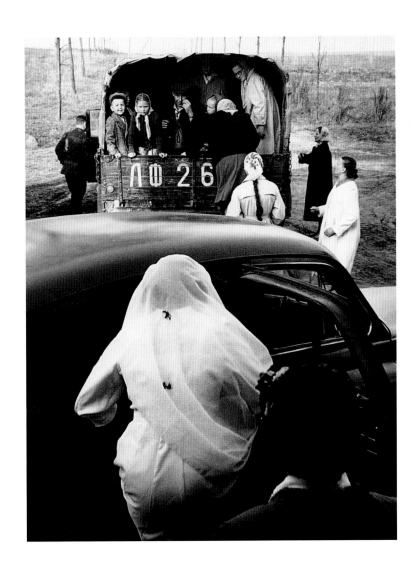

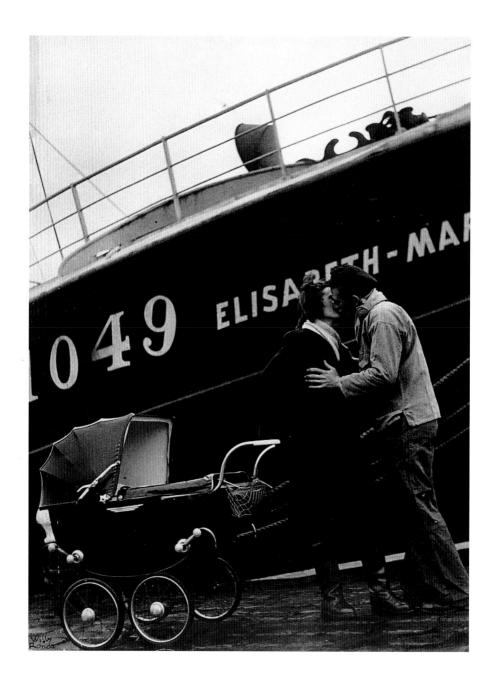

Willy Ronis
Départ au Marin (Sailor's Goodbye), n. d.
Gelatin silver print

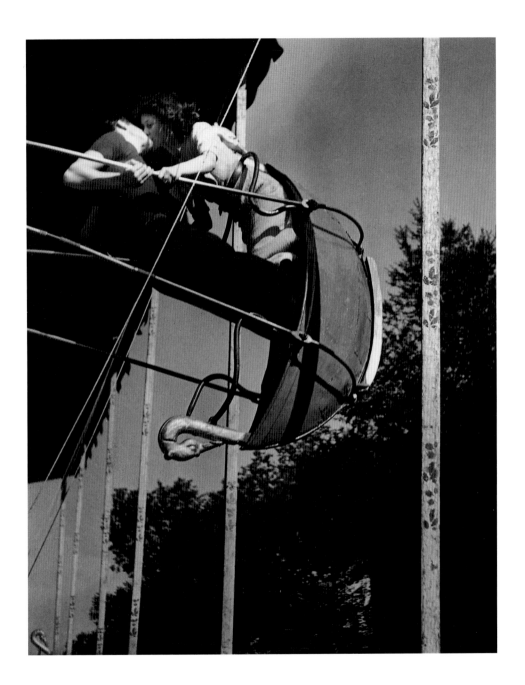

Brassaï
The Swing, Paris, c. 1934
Gelatin silver print

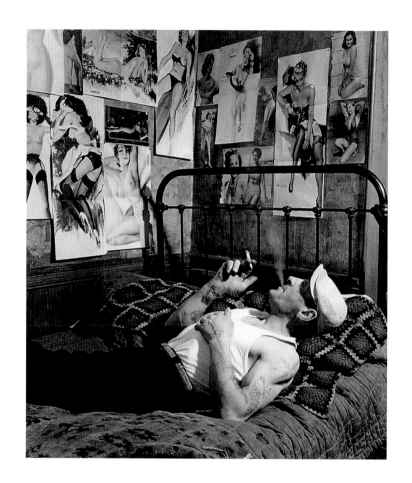

Robert Doisneau
Créatures de rêve (Dream Makers), 1952
Gelatin silver print

Alfred Eisenstadt
Lady of the Evening, Paris, 1929–30
Gelatin silver print

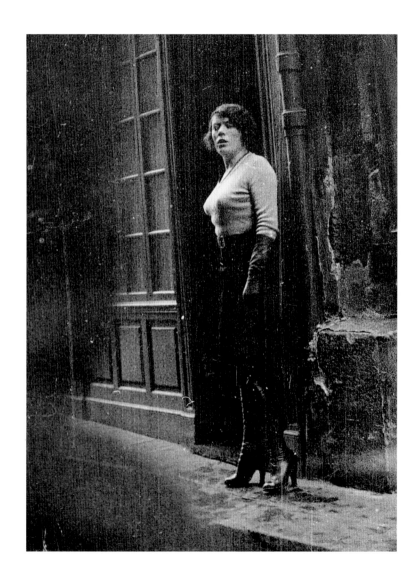

Jakob Tuggener
Ticinese Ball, Grand Hotel Dolder, Zurich, 1949
Gelatin silver print

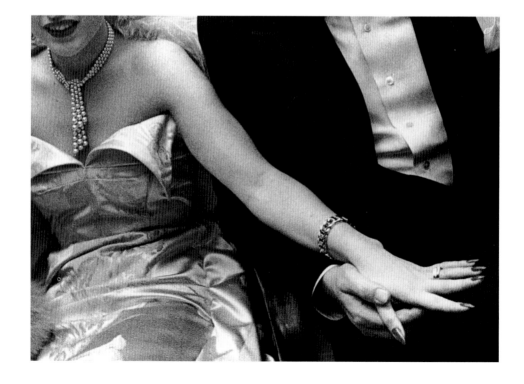

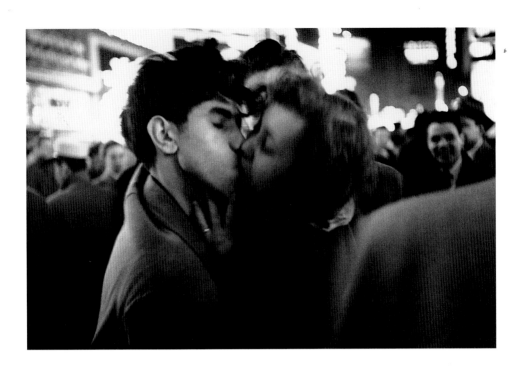

Dan Weiner
New Year's Eve, Times Square,
New York, 1951
Gelatin silver print

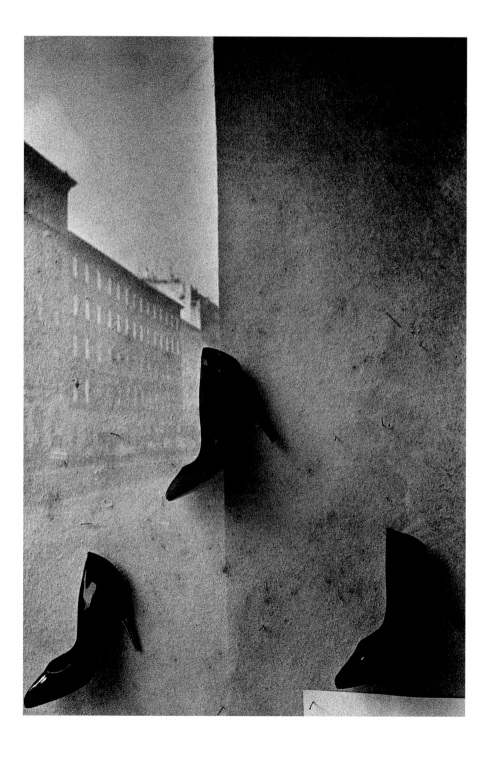

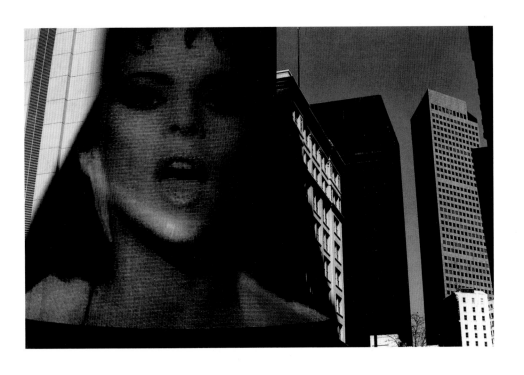

(opposite) **Paul Nozolino**
Vienna, 1995
Gelatin silver print

Harry Callahan
Atlanta, 1985
Gelatin silver print

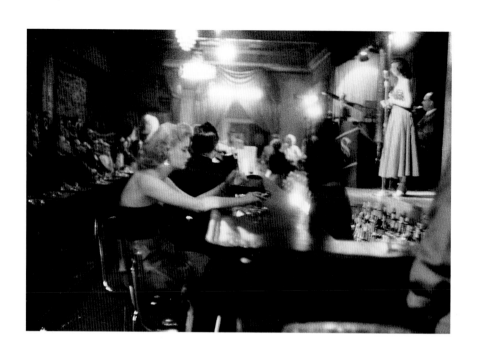

George Zimbel
Bourbon Street, New Orleans, 1955
Gelatin silver print

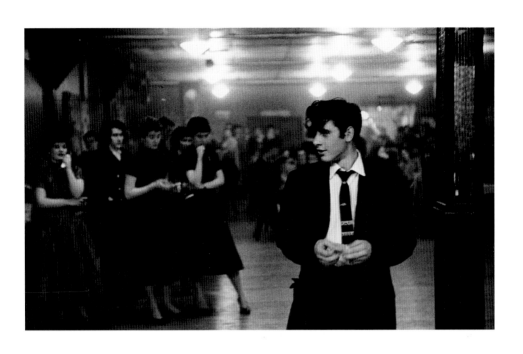

George Zimbel
Irish Dancehall, the Bronx, 1954
Gelatin silver print

(overleaf) **Frank Horvat**
Paris, Le Sphinx, 1956
Gelatin silver print

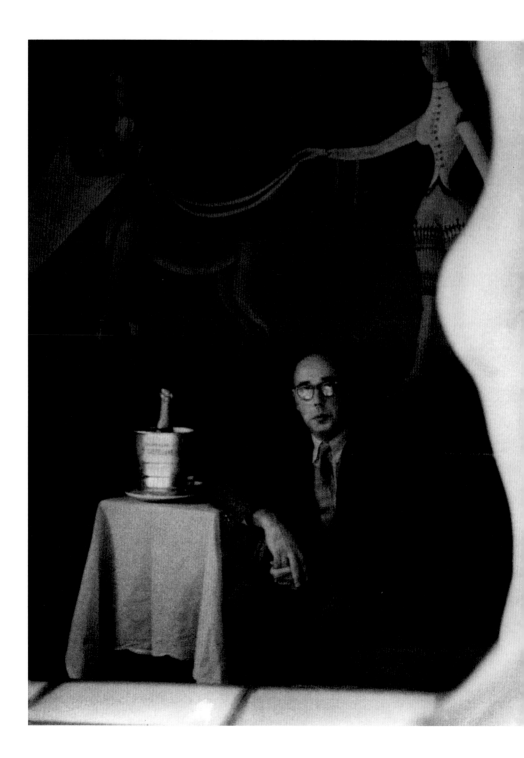

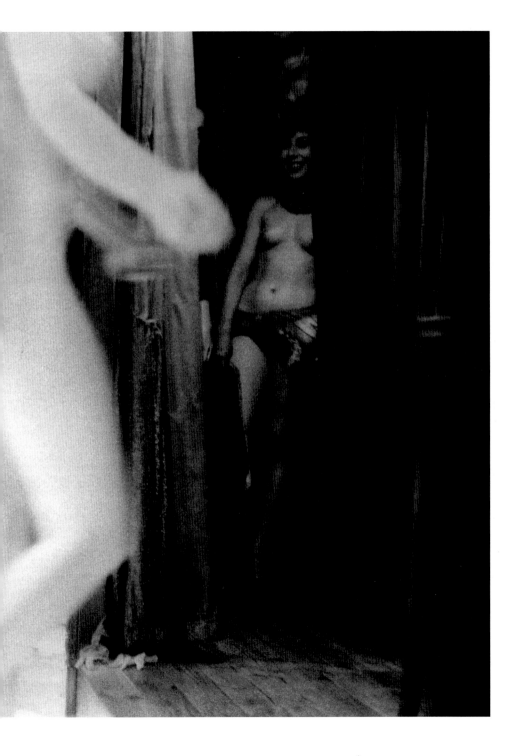

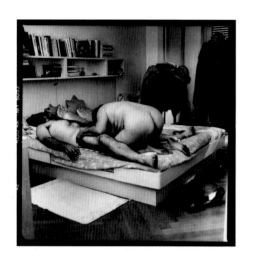 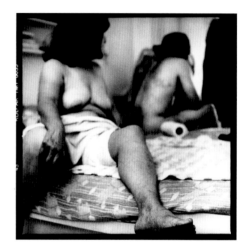

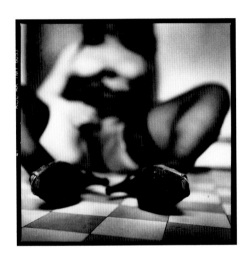 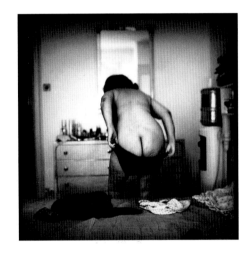

Steeve Iuncker
C'est comme ça (That's How It Is), 1996
Gelatin silver prints

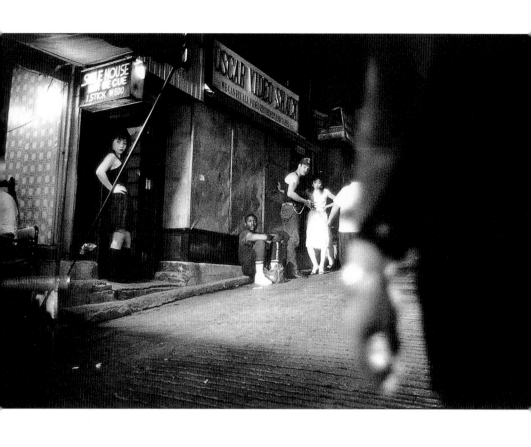

Ed van der Elsken
Untitled, n.d.
Gelatin silver print

(opposite) **Merry Alpern**
From the series *Dirty Windows*, 1994
Gelatin silver print

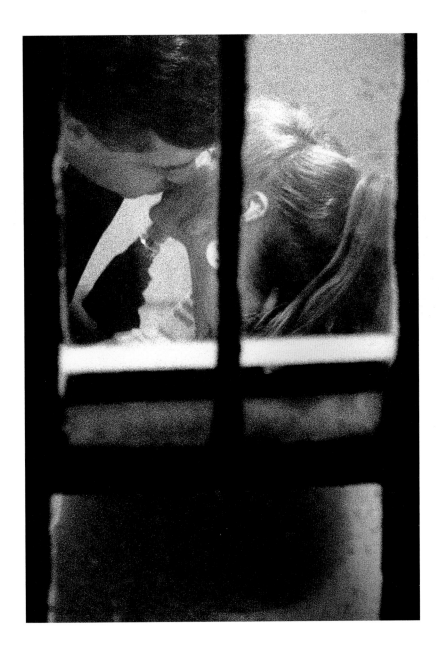

Ralph Steiner
Nehi Esposito, 1929
Gelatin silver print

Yasuhiro Ishimoto
North Avenue Beach, Chicago, 1951
Gelatin silver print

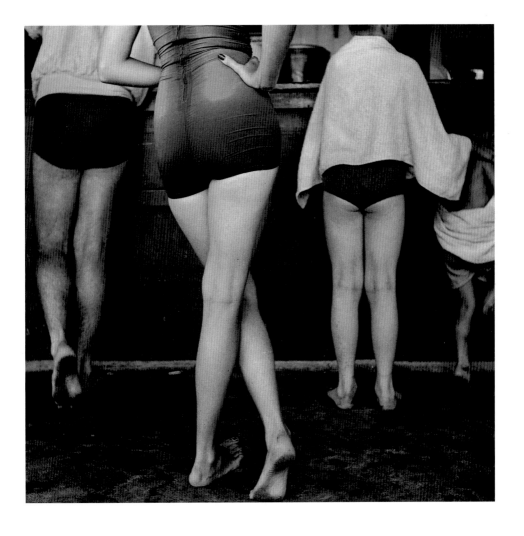

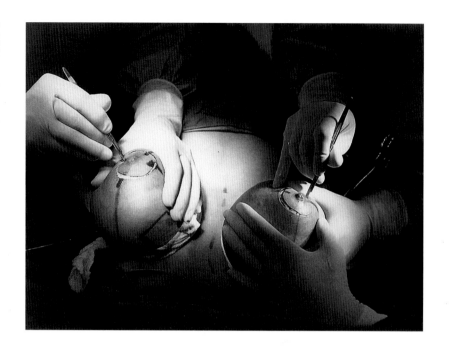

Barbara Gollob
Breast Reduction, 1994–95
Gelatin silver print

Jeff Mermelstein
New York City, 1996
Fujicolor print

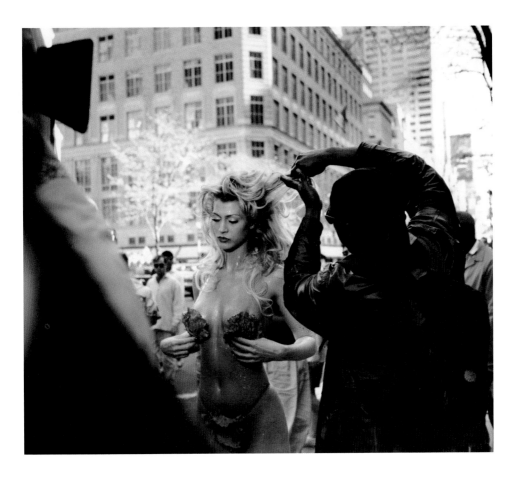

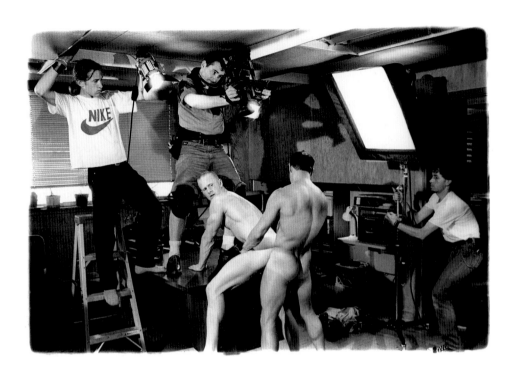

Ken Probst
Crew Battles Low Ceiling, San Francisco, 1996
Gelatin silver print

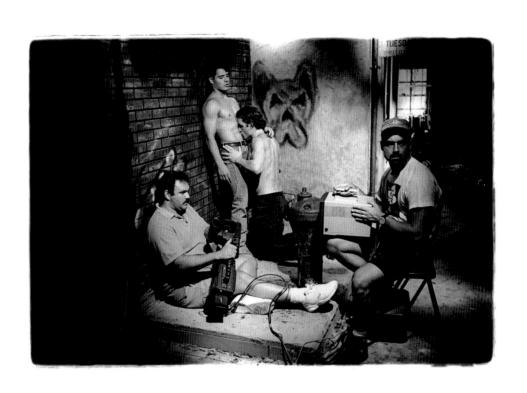

Ken Probst
Troy Kisses Enriqué's Navel, San Francisco, 1994
Gelatin silver print

Jeff Burton
Untitled No. 21, 1995
R-type print

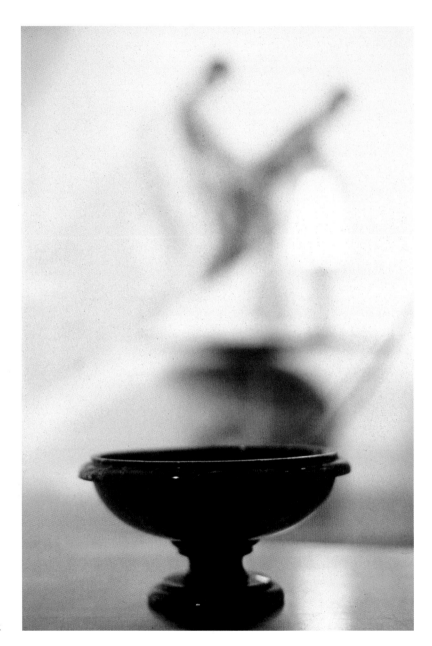

Jeff Burton
Untitled No. 32, 1996
Cibachrome print

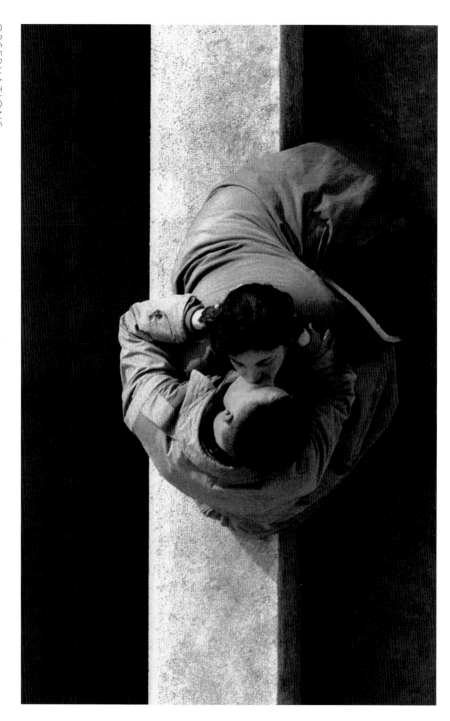

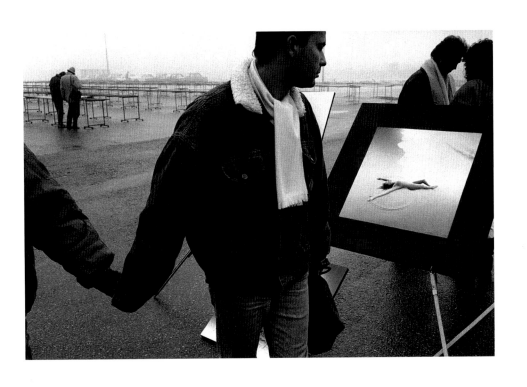

(opposite) **Frank Horvat**
Paris, Quai du Louvre, 1955
Gelatin silver print

Viktor Kolar
Ostrava Market, 1989–90
Gelatin silver print

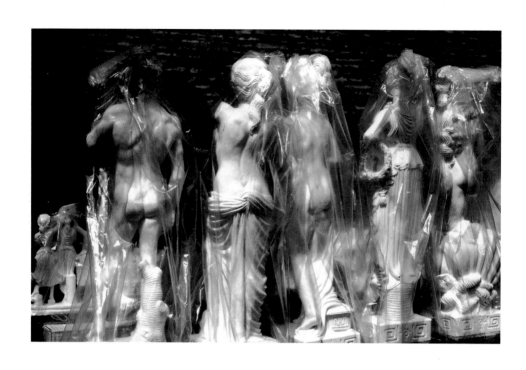

Roberta Sorrentino
David, Venus and the Others, 1985
Cibachrome print

Robert Walker
Backstage, Broadway, New York, 1988
Cibachrome print

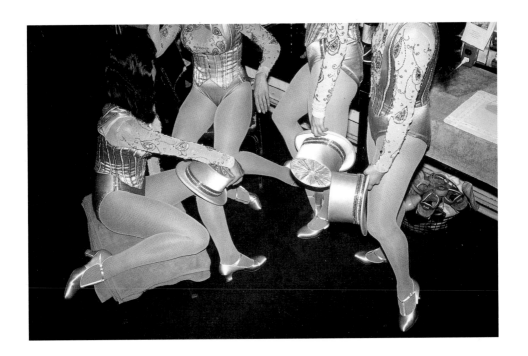

James Friedman
Untitled, 1996
Gelatin silver print

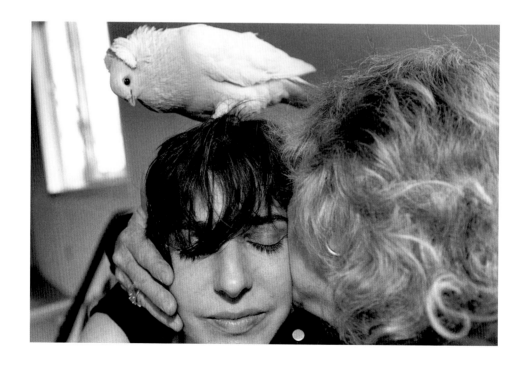

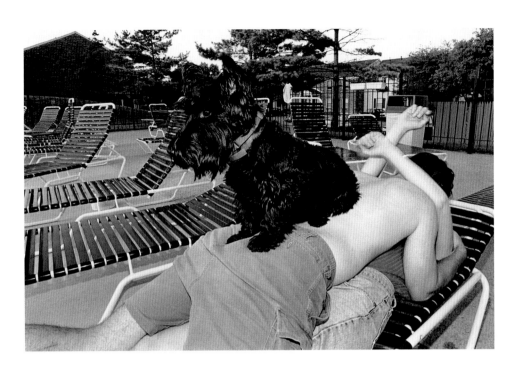

James Friedman
Untitled, 1994
Gelatin silver print

Lauren Greenfield
Mijanou and Friends, 1993
Cibachrome print

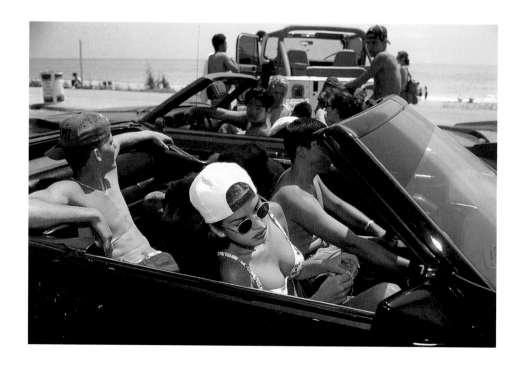

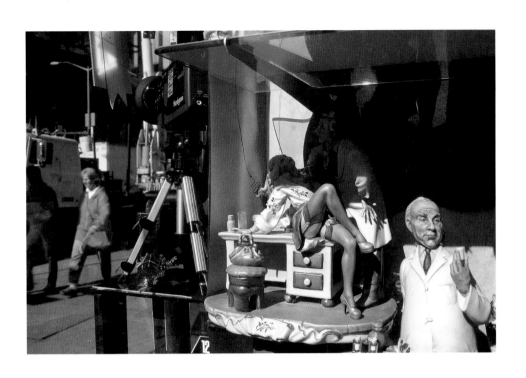

Robert Walker
Times Square, New York, 1988
Cibachrome print

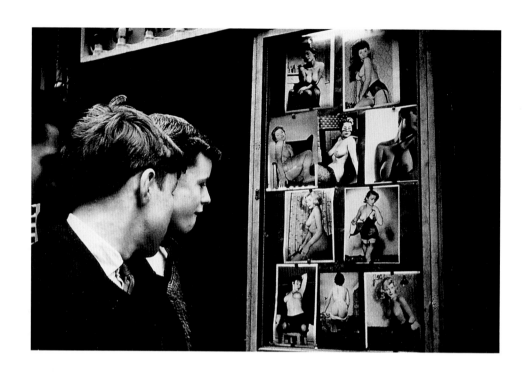

Lutz Dille
London, 1961
Gelatin silver print

Sylvia Plachy
Flea Market Vendor's Daughter,
Route 13, Delaware, 1984
Gelatin silver print

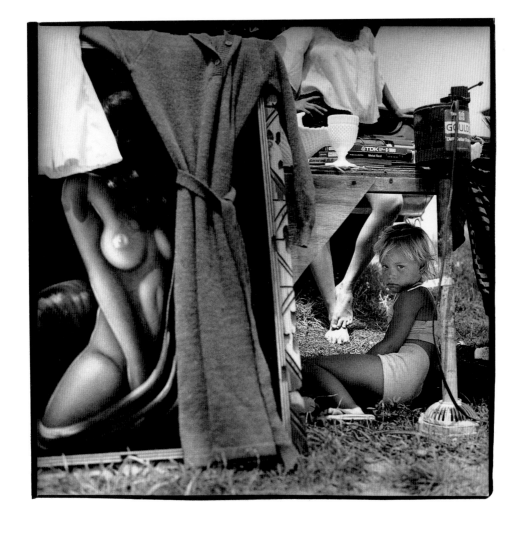

Silvana Reggiardo
Objet télévision (Television Object), Paris, 1995
Chromogenic print

Gérard Musy
Le Palace, 1987
Gelatin silver print

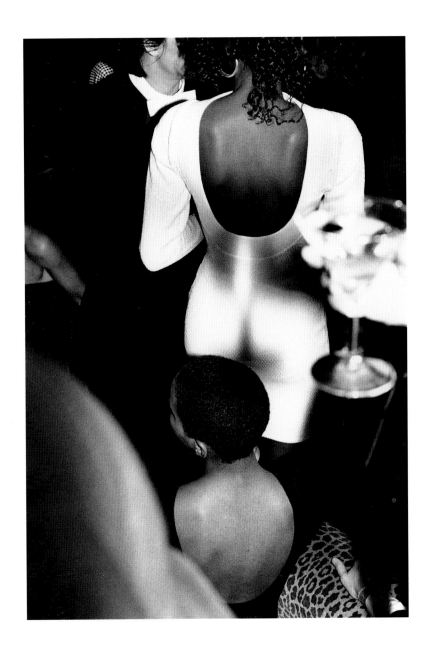

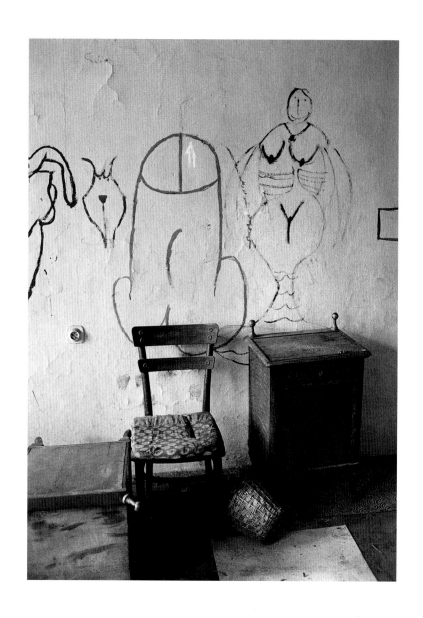

Viktor Kolar
Abandoned Gypsy Residence, Ostrava, 1981–82
Gelatin silver print

Roberta Sorrentino
Lips, c. 1977
Cibachrome print

187

(opposite) **Jane Atwood**
Wood's Hole, Massachusetts, 1983
Gelatin silver print

Sylvia Plachy
Pigeons on Broadway, New York, 1982
Gelatin silver print

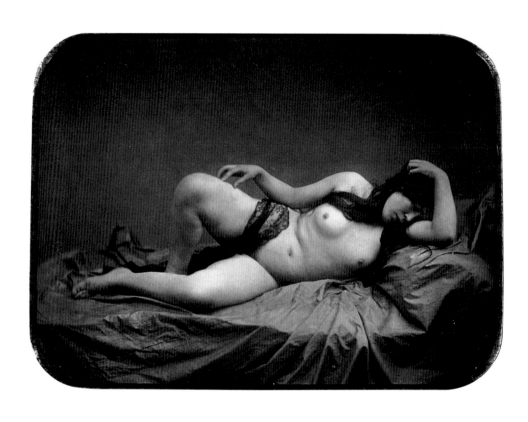

Auguste Belloc
Untitled, c. 1858
Salted paper print

PROPOSITIONS

All photographs are propositions of one form or another. Every photograph is taken to be seen; every photographer seeks to elicit a response from the viewer. Of course the image-maker can never know or control *who* will see his pictures or what the response might be – we may reasonably assume, for example, that Auguste Belloc [194–95] never intended his work to be scrutinized by the Paris police! – so in one sense all photographs betray their *makers'* desires, or at least their makers' ideas of what constitutes desirability.

For whom *are* erotic photographs really made? Sometimes a photographer is compelled to capture on film a moment of deeply private intimacy – the fact that such pictures taken by deceased photographers now appear publicly is no proof that their makers intended them for general consumption [List 193; Wendt 216]. But in most cases public consumption is the aim. The photographer may wish to sell the photograph itself, in the form of as many prints from the negative as possible, as under-the-counter pornography (as we know Belloc did), or openly, as gently *risqué* fare aimed at tourists [203]; or the intention may be to sell a product or service *via* the photographic image [213] in which case the only thing that counts is how often the image is reproduced on billboards and in newspapers and magazines.

In many photographs, however, the 'proposition' is a muddy affair: who is doing the proposing, of what, and to whom? What to make, for instance, of the strange stand-off between a bare-breasted woman and her dapper partner in Josef Breitenbach's *Dr Riegler and J. Greno, Munich* [212]? As if in a game of chess, each seems to be challenging the other to make the first move. The phallic imagery may be obvious, but the title does nothing to clarify the situation. It is hard to believe that any respectable doctor of the 1930s (though we might well wonder, Doctor of what?) would allow himself to be seen, let alone photographed, with a naked woman in a cabaret (as the decor suggests). It is also highly unlikely that he is being photographed unawares. Is the man, therefore, an actor – intended as a stand-in either for the voyeuristic photographer or the viewer-voyeur? Is the image intended as a reflection on the unequal roles of men and women in the photographic enterprise? An early feminist statement (after all, the woman does seem to be holding her own)? Or a

celebration of the status quo? (Titles, incidentally, often contain clues which help uncover buried meaning. For example, *Nu au Jan noir* [Brassaï 217] refers to a French board-game called tric-trac, played on a table split diagonally into two sections, 'jans', named after the two-faced god, Janus. This is a reference to the Surrealist obsession with games of chance.)

Some photographers provoke shock and outrage [Koelbl 221] which sometimes obscures what are in fact very reasonable and relevant propositions: why, for instance, do we continue to deny the male erection a place in mainstream photography? We have no similar reticence regarding female genitalia. Indeed, why not go further and propose the erect penis as an object of great beauty [Mapplethorpe 229]?

Sexuality and sensuality, though hardly poles apart on a continuum, are still very different things. While the goal of many photographers is to trigger sexual desire in their viewers – some are content to titillate while remaining safely within the bounds of middle-class decorum [Mortenson 209] while others clearly intend to provoke lust [Belloc 190; 222] – the goal of others is to share some sensual aspect of their own experience: the smiling face of a South Seas temptress, for example [Henle 215], the essence of ritualized desire that we call 'the dance' [Bruehl 207], or the rich theatricality certain subjects bring with them to the studio [Sinclair 232, 233; Hujar 234, 235].

Theatre is integral to much erotic imagery in another sense. This theatricality is sometimes blatantly obvious [201], on occasion even the essence of a picture's appeal [Elliott 198; Laurent 205]; or it is handled sufficiently skillfully that it never occurs to us that it might have been staged [204; Blum 231]. Whether a set was constructed, models attired, poses arranged, and so on, is finally irrelevant if the resulting image is credible. This is photography's unique strength: seeing really *is* believing.

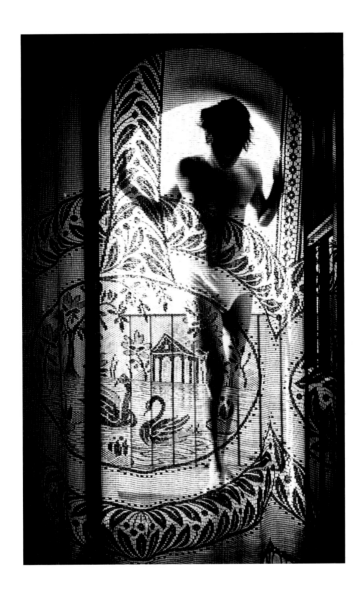

Herbert List
In the Morning, Athens, 1937
Gelatin silver print

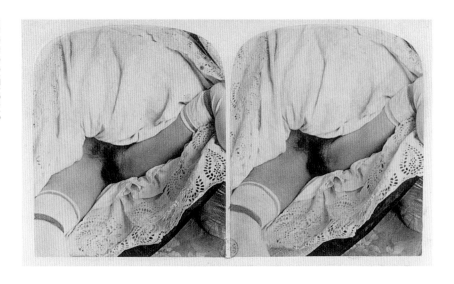

(this page and opposite) **Auguste Belloc**
Untitled, c. 1860
From a series of 95 stereoscopic mounted
albumen prints which were seized
by the Paris police

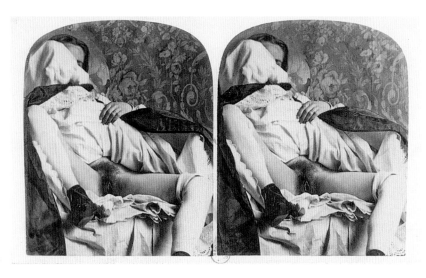

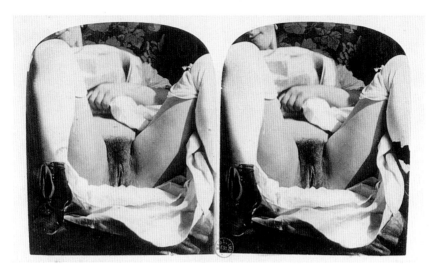

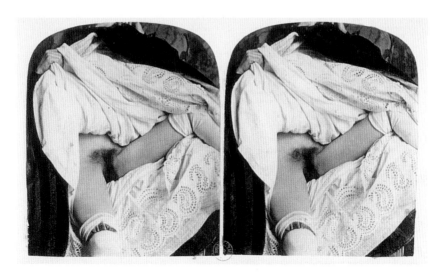

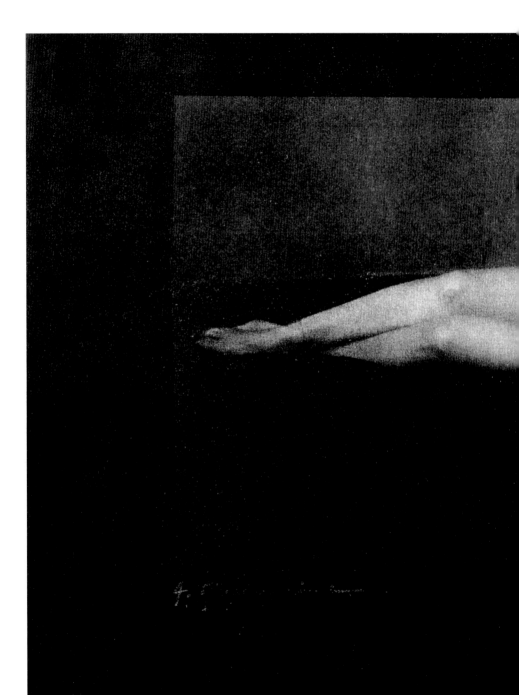

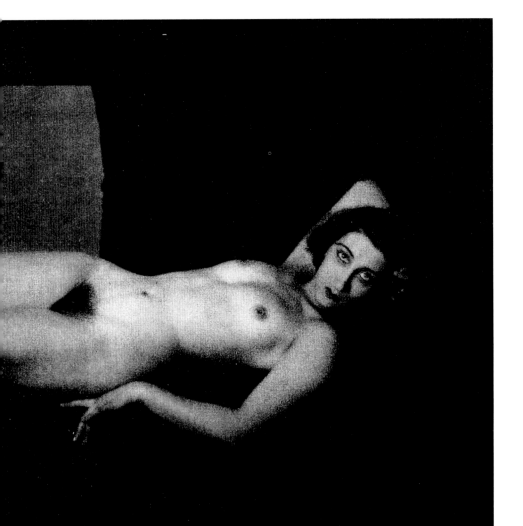

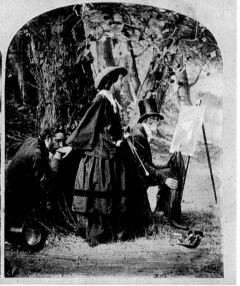

(preceding pages) **Albert Rudomine**
Jeanne Hébuterne
(Modigliani's mistress) *c.* 1917
Gelatin silver print

J. Elliott
Very Pretty Indeed, c. 1865
Stereographic albumen silver
print on card

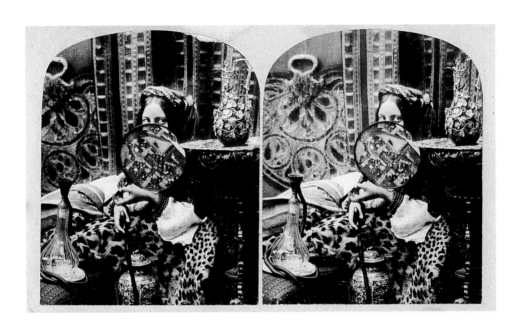

J. Elliott
Untitled, c. 1865
Stereographic albumen silver
print on card

ORIGINAL DEPOSÉ.

Unidentified photographer
Untitled, c. 1865
Albumen silver print mounted
on a *carte-de-visite*

Unidentified photographer
Voilà Deux Jolis Seins ronds et potelés
(Two Pretty Breasts, Round and Plump), c. 1910
Postcard

201

Mlle MONNIER

Une amusante scène de gigolettes
dans l'USINE A FOLIES, aux Folies Bergère

Photos Waléry

Unidentified photographer(s)
*An Amusing Scene of Dancers in the
Folly Factory at the Folies-Bergère, c. 1930*
Tearsheet

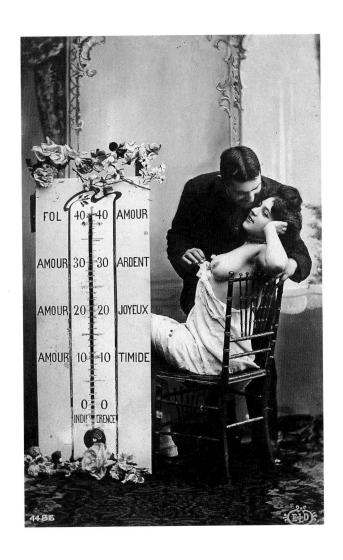

Unidentified photographer
Untitled, c. 1910
Postcard

Unidentified photographer
Untitled, *c.* 1870s
Albumen silver print

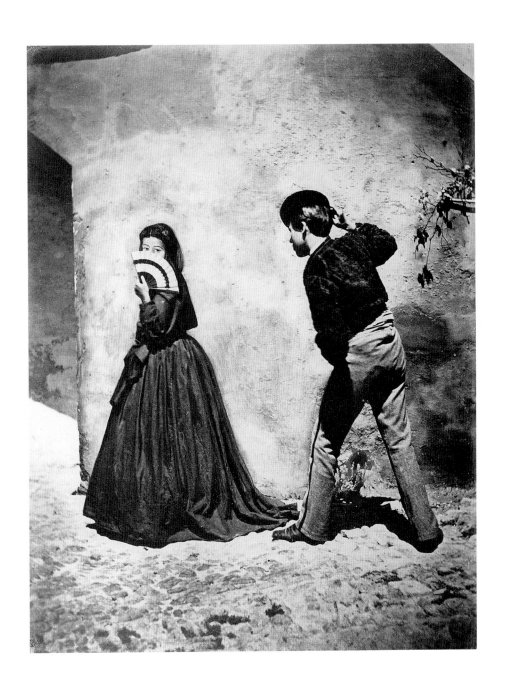

Juan Laurent
Untitled, c. 1870s
Albumen silver print

Isabel Muñoz
Danse orientale (Oriental dance), Cairo, 1993
Gelatin silver print

(opposite) **Anton Bruehl**
Harlem Number, Versailles Café, 1943
Dye-transfer print

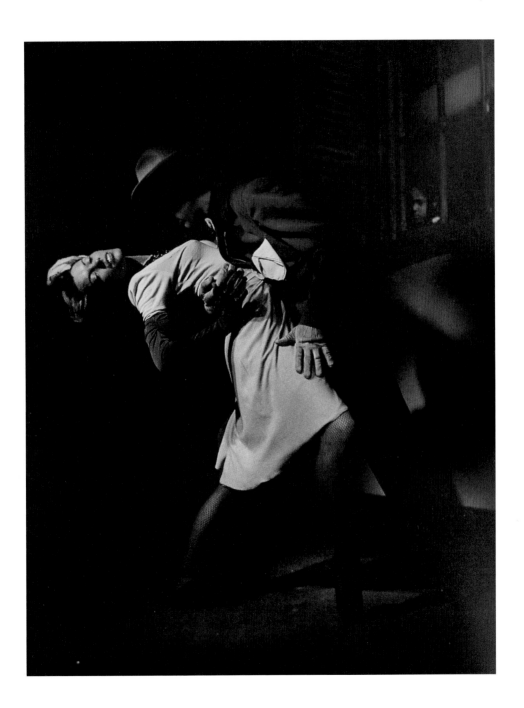

Unidentified photographer
Untitled, c. 1930s
Gelatin silver print

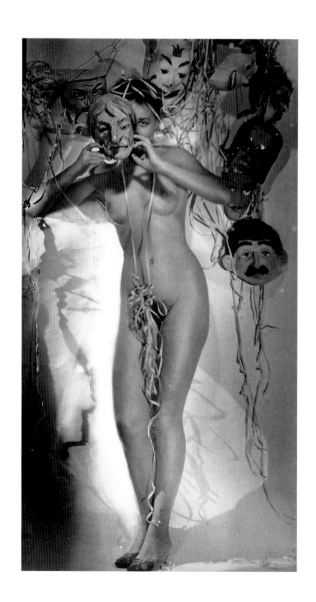

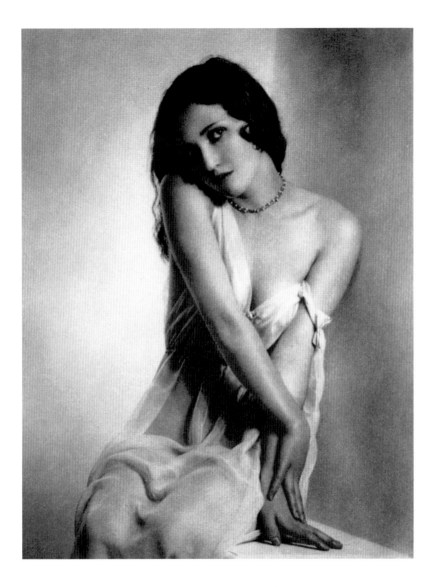

William Mortenson
Myrdith, c. 1935
Gelatin silver print

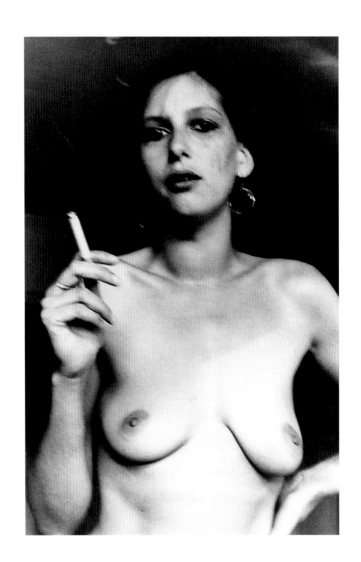

Unidentified photographer
Untitled, n. d.
Gelatin silver print

Unidentified photographer
Untitled, c. 1935
Gelatin silver print

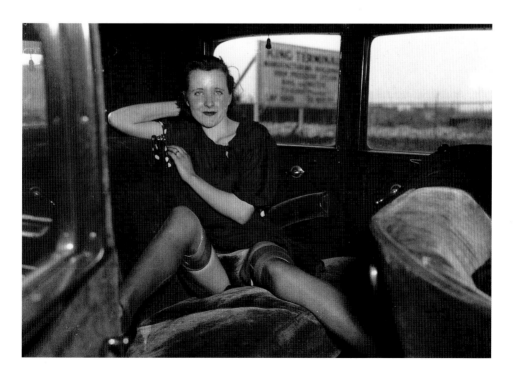

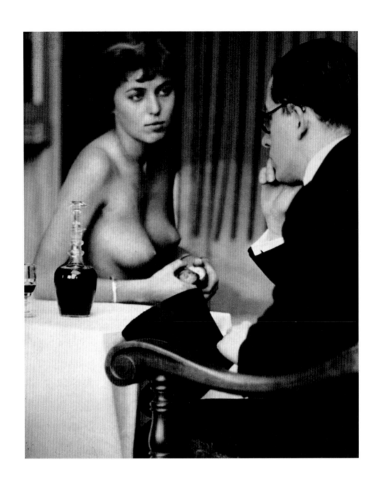

Josef Breitenbach
Dr Riegler and J. Greno, Munich, 1933
Gelatin silver print

Unidentified photographer
Advertisement for Air Express, c. 1950
Gelatin silver print

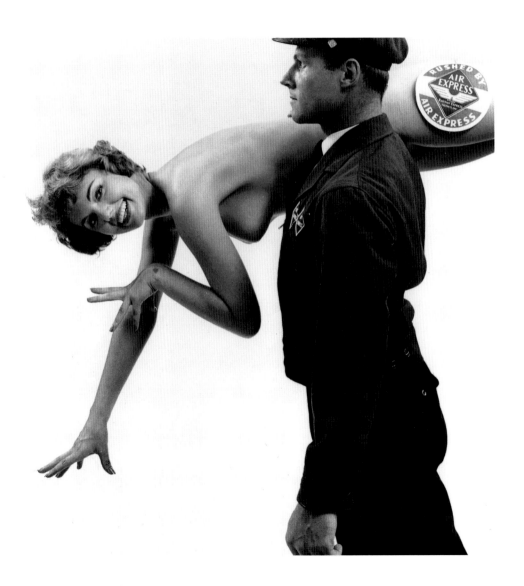

Ralph Steiner
Nude and Mannequin, 1931
Gelatin silver print

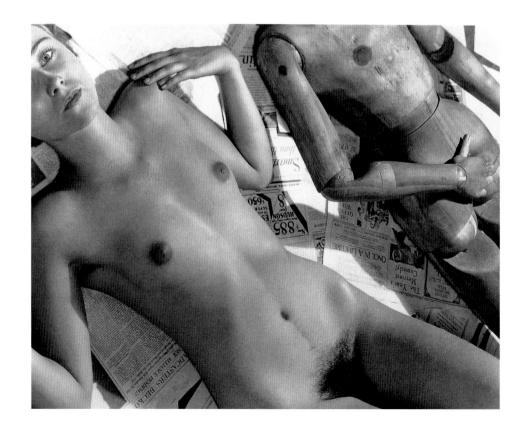

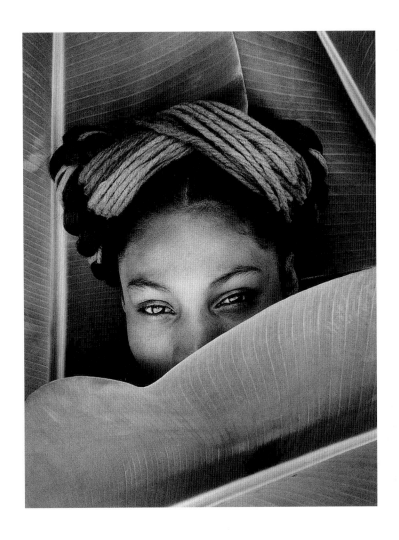

Fritz Henle
Nievis, 1943
Gelatin silver print

215

Lionel Wendt
Untitled, Ceylon, 1939
Toned gelatin silver print

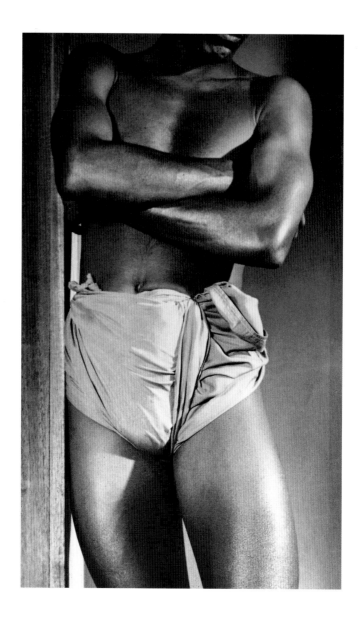

Brassaï
Nu au Jan noir, c. 1952
Gelatin silver print

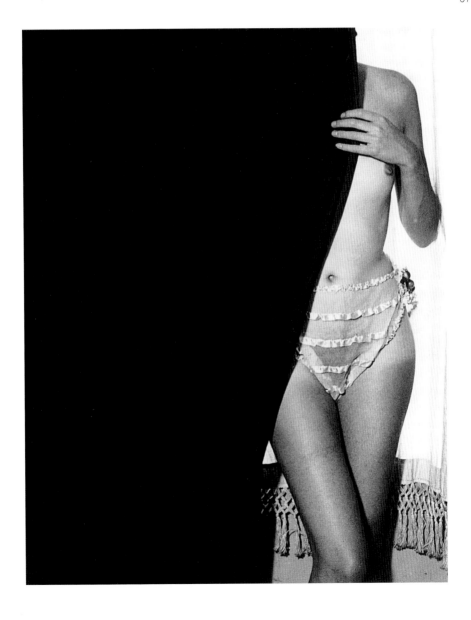

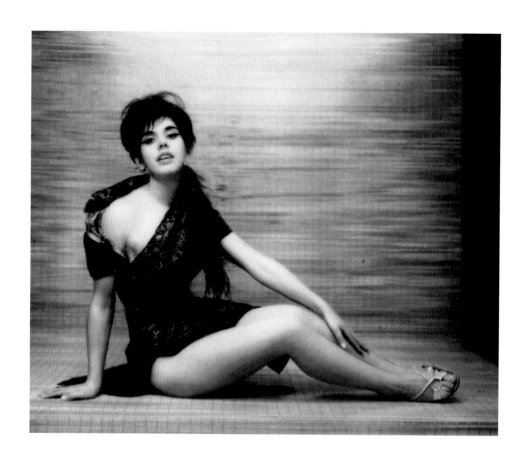

Carlo Mollino
Untitled, c. 1965
Retouched and lacquered Polaroid print

Unidentified photographer
Athletic Model Guild, *c.* 1940
Gelatin silver print

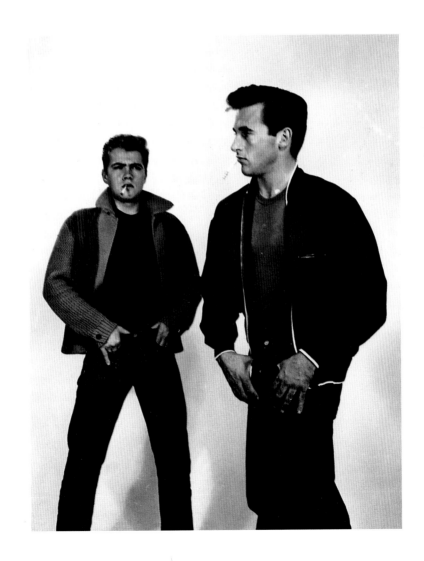

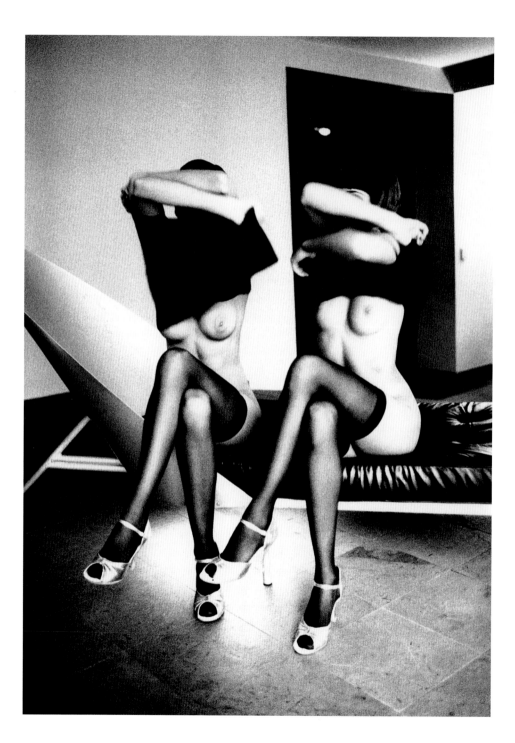

(opposite) **Ellen von Unwerth**
Nudes at the Royalton, 1992
Gelatin silver print

Herlinde Koelbl
André P., 1984
Gelatin silver print

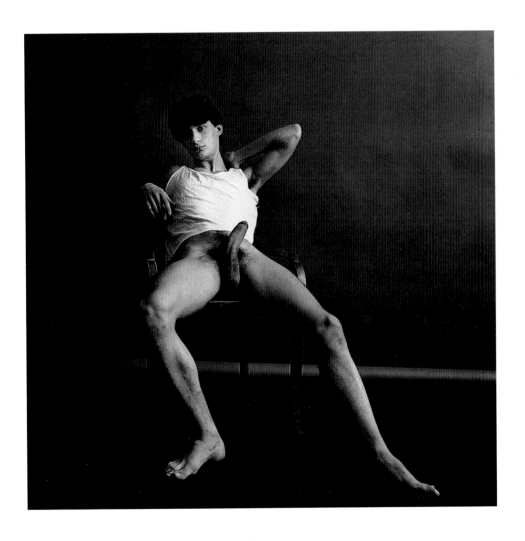

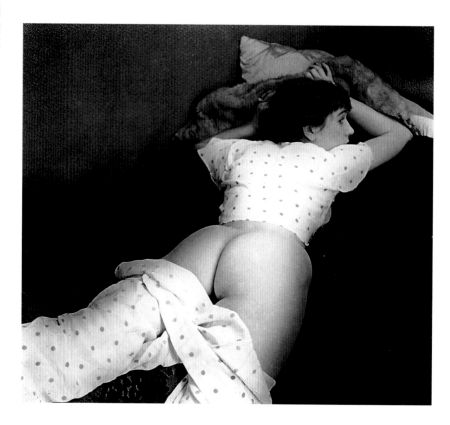

Unidentified photographer
Untitled, c. 1930
Gelatin silver print

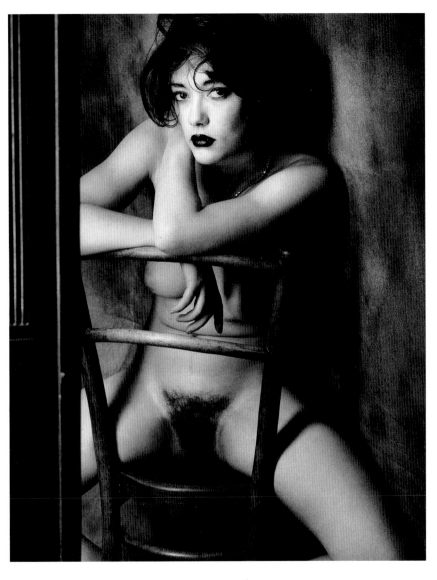

Thomas Karsten
Carmen, Haimhausen, 25.2.1993
Gelatin silver print

(above and opposite)
John Schlesinger
Amateurs, 1993–95
Gelatin silver print

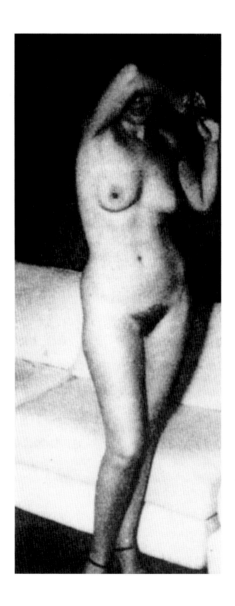

Luzia Simons
Untitled, No 16, 1997
From the series *Camera Obscura*
Gelatine silver print

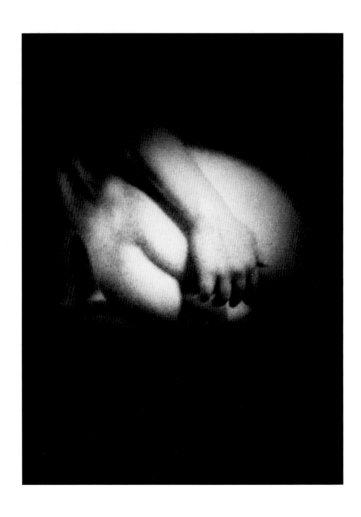

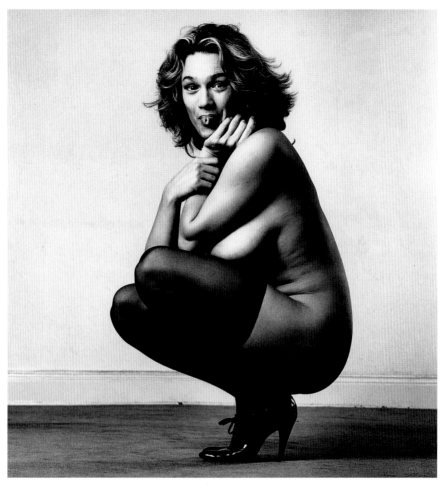

Thomas Karsten
Katherina, Berlin, 8.4.91
Gelatin silver print

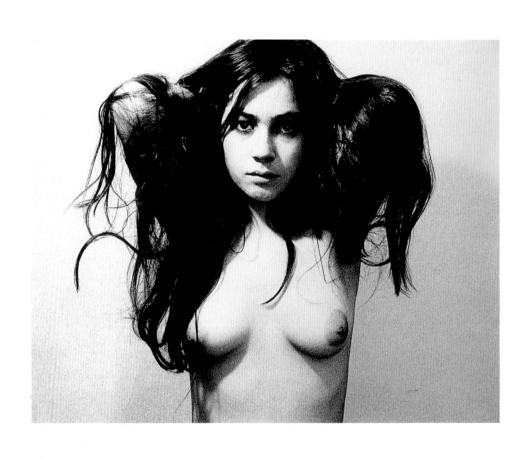

John Max
Untitled, Montreal, c. 1967
Gelatin silver print

Robert Mapplethorpe
Phillip Prioleau, 1980
Gelatin silver print

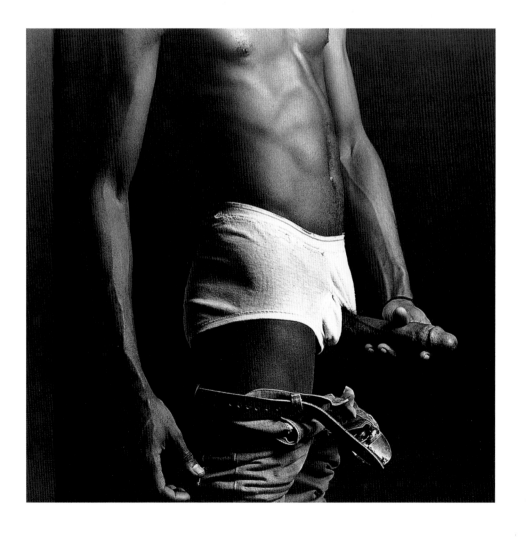

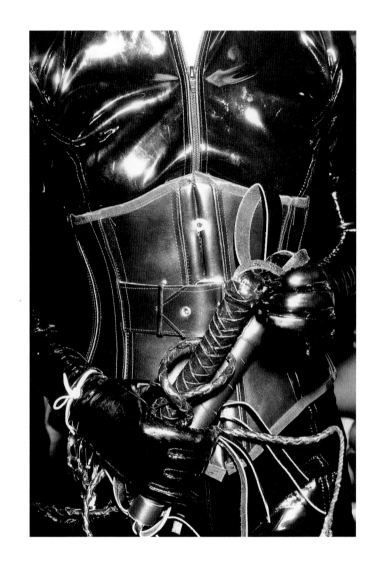

Gérard Musy
Fantastic, 1993
Gelatin silver print

(opposite) **Günther Blum**
Strumpfhalter (Suspenders), 1993
Gelatin silver print

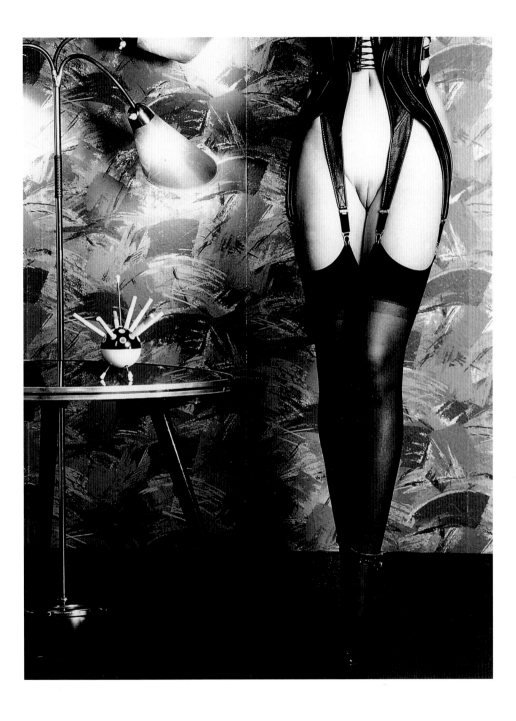

Nicholas Sinclair
Xed Le Head, 1995
Toned gelatin silver print

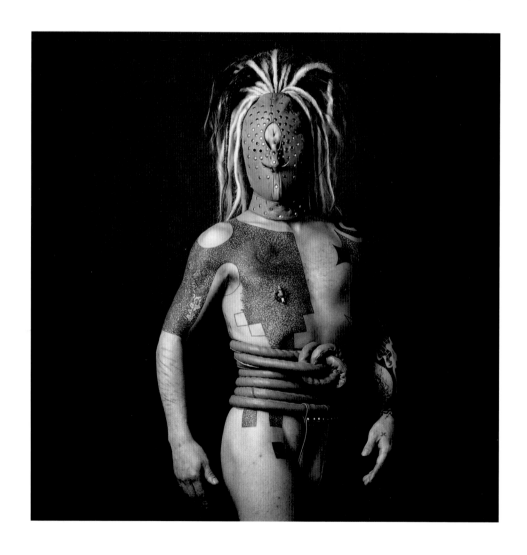

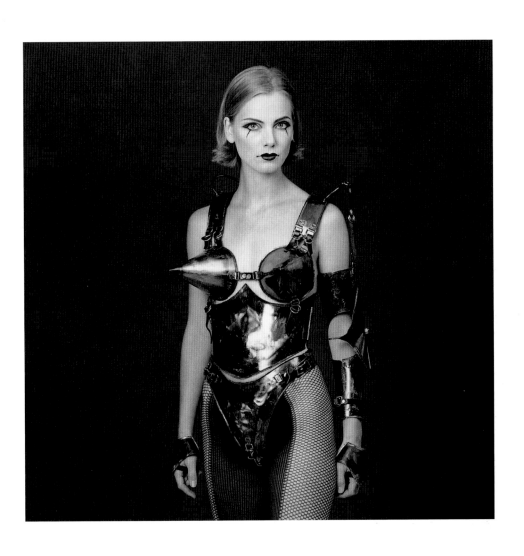

Nicholas Sinclair
Fia Berggren, 1996
Toned gelatin silver print

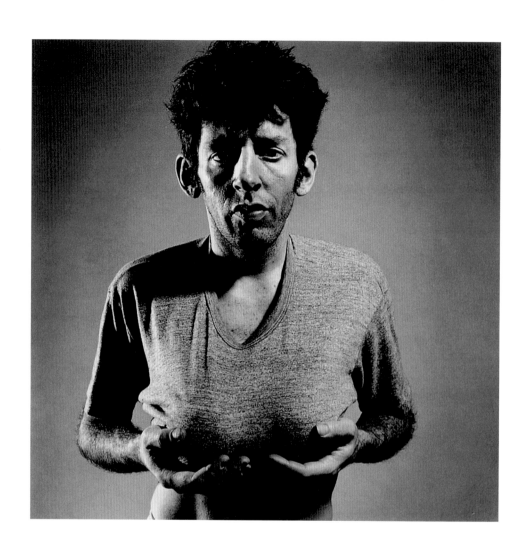

Peter Hujar
Untitled, 1983
Gelatin silver print

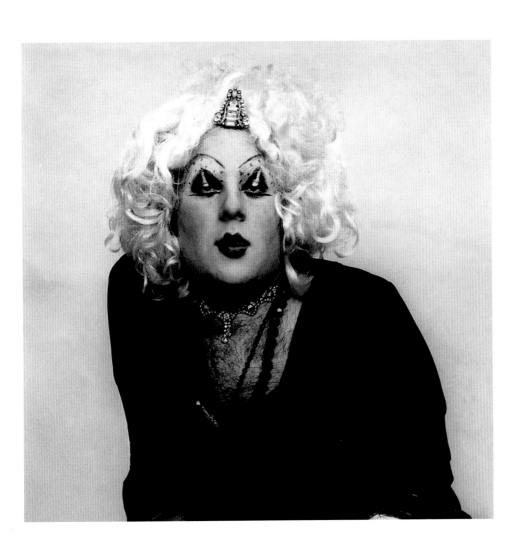

Peter Hujar
Untitled, n.d.
Gelatin silver print

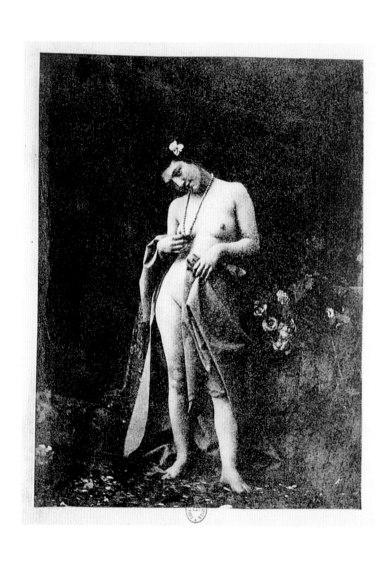

Jacques-Antoine Moulin
Untitled, 1850s
Salt paper print lightly albumenized

TOKENS

We communicate our love and desire for one another through gestures, actions, expressions, words, signs and symbols: outstretched arms, puckered lips, a hug, a kiss, a smile, a come-hither look; the simple words: 'I want you!', 'I love you!; chocolates, hearts, roses... Of all the signs and symbols, the emblems and tokens we have to choose from, none is more favoured than the flower. Since antiquity, and undoubtedly much earlier, real flowers and their representations have served as messengers for our affections. No other token is more versatile in its meaning: what else, for example, can stand as the rose does, for both sacred and profane love [Kells 249; Studio Manassé 260]?

Flowers were a privileged subject of photography from its earliest days. Interestingly, botanical renderings and classically inspired still-lifes were of minor appeal to photographers and their public. The Victorians were far more interested in what they called 'the language of flowers', a complex scheme whereby the type of flowers in bouquets and arrangements, their colour and even their number conveyed subtle meanings which could not be expressed in words [244]. This code was adopted by photography, and floral imagery permeated portraits, greetings cards and photographic keepsakes of weddings, confirmations, birthdays, anniversaries, funerals and so on. Nineteenth-century *cartes-de-visite* showing holly, for example, implied fear of being forgotten, while a photograph of the snapdragon signalled 'presumption' and a dahlia 'thine for ever'. With the arrival of photographic postcards, pictures of bouquets could even be sent in the mail as a poor man's substitute for the real thing [243].

Flowers have long been associated almost exclusively with femininity, and photography continued, extended and reinforced this tradition. But the beauty, fragility and ephemerality of flowers were also seen as attributes which pertained to children, so that the sexual or sensual aspects of flowers which applied to women were, when associated with children, somewhat disturbing [Moulin *opposite*]. Needless to say, this ambiguous symbolism could be cleverly manipulated by unscrupulous photographers [Anthony 241]. Especially beautiful women are often identified with especially rare and beautiful flowers [Beaton 239]. Indeed, in the eyes of some photographers, women could *become* flowers [Park/Gregory 252].

The passion for floral imagery in the photography of love and desire has not abated since Victorian times, though the 'language' has largely fallen into disuse. The turn-of-the-century Pictorialists, for example, could hardly imagine a nude (or for that matter just about any portrait of a woman) *without* floral attributes [Adrien 242; Demachy 247]. Today the flower remains a popular motif in the nude, fashion photography [Meerson 257], portraiture and *self*-portraiture [Schudel-Halm 262–63]. What is somewhat new in recent decades are the associations of flowers with male eroticism [Mapplethorpe 253; Bianchi 264–65]. Until now, the sole male subjects permitted by convention to be associated with flowers were either men who are in the course of giving them as gifts, as we have seen [243]; male artists, who (by conventional wisdom which can be traced back to the Renaissance) are thought to be more in tune with the 'feminine aspects' of their character [Lotti 258–59]; and homosexuals, where the same comment might apply.

And what should we make of the bizarre 'bride' and 'groom' who have chosen to commemorate their marriage in this book [Stezaker 266, 267]? Perhaps the venerable language of flowers so beloved of our ancestors still has the force to express the wishes of Eros, though in a bold new dialect.

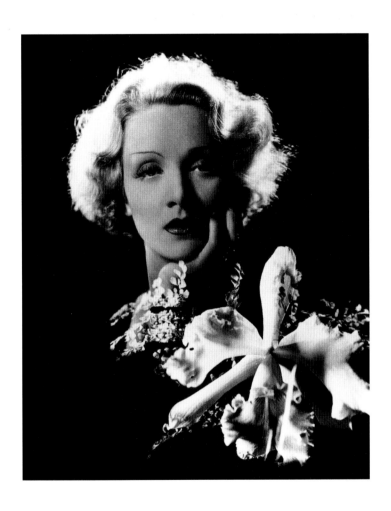

Cecil Beaton
Marlene Dietrich, 1932
Gelatin silver print

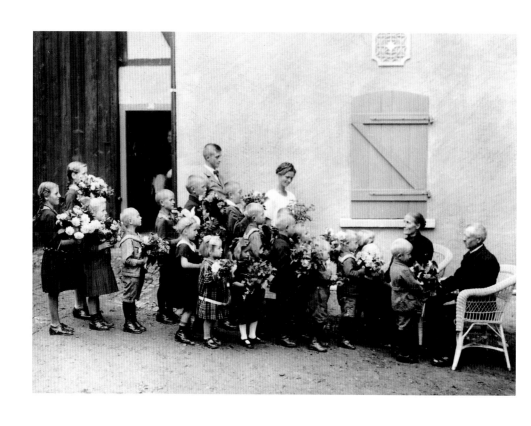

August Sander
Silver Wedding Anniversary, Westerwald, 1932
Gelatin silver print

Mark Anthony
Wildflowers, 1856
Albumen silver print

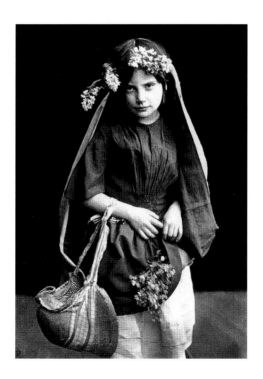

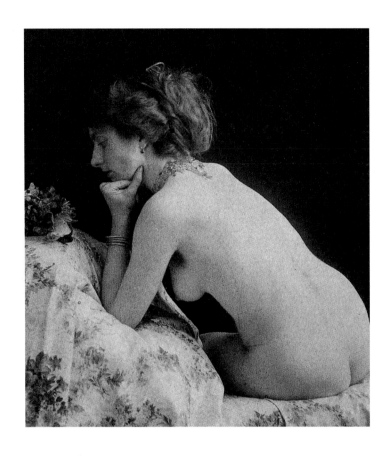

Charles Adrien
Untitled, 1912
Autochrome plate

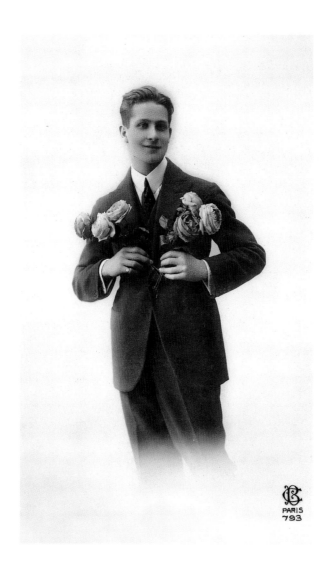

Unidentified photographer
Untitled, c. 1910
Postcard

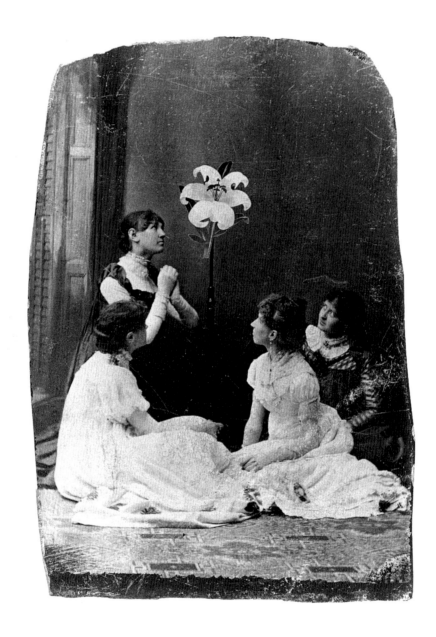

Unidentified photographer
Untitled, c. 1870s
Tintype

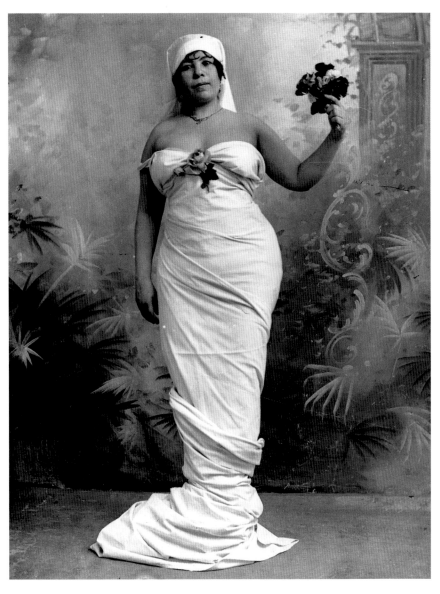

Romualdo Garcia
Untitled, 1905–14
Gelatin silver print

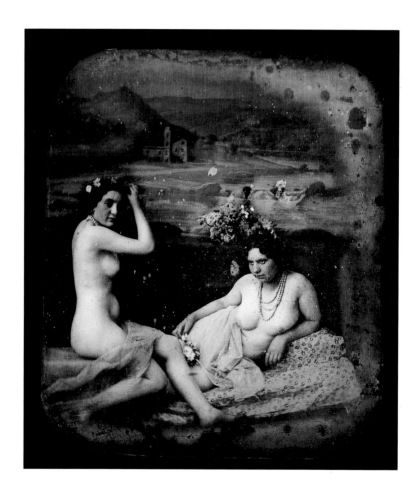

Unidentified photographer
Untitled, c. 1855
Daguerreotype

Robert Demachy
Untitled, c. 1890
Gum bichromate print

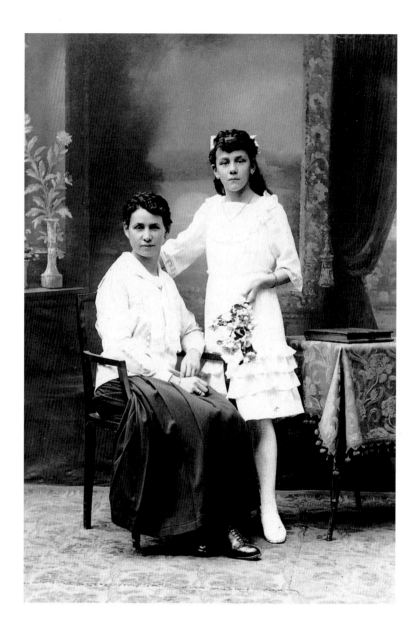

Unidentified photographer
Untitled, c. 1910
Albumen silver print

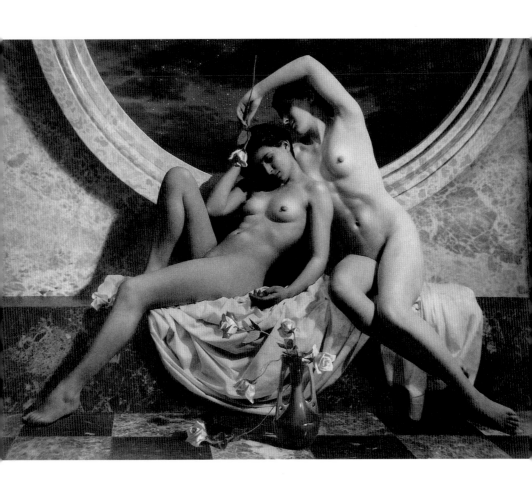

Harold F. Kells
Grecian Nocturne, c. 1935
Gelatin silver print

Paul Cava
Untitled, 1981
Vandyke print on offset lithograph

Tina Collen
Goldenrod Erecta, c. 1988
Chromogenic print

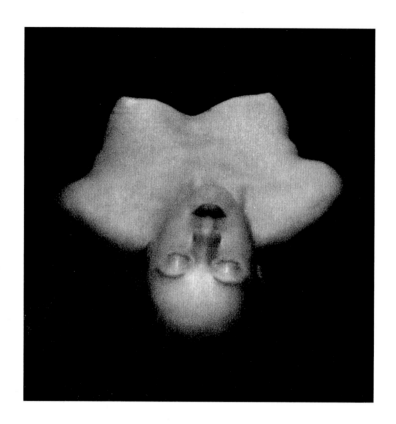

Bertram Park/Yvonne Gregory
Untitled, 1936
Gelatin silver print

Robert Mapplethorpe
Orchid with Hand, 1983
Gelatin silver print

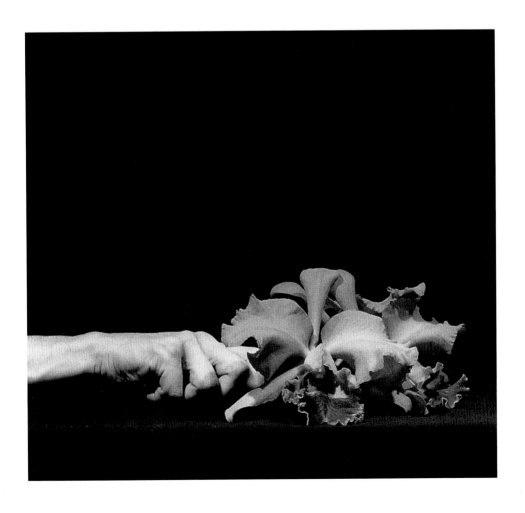

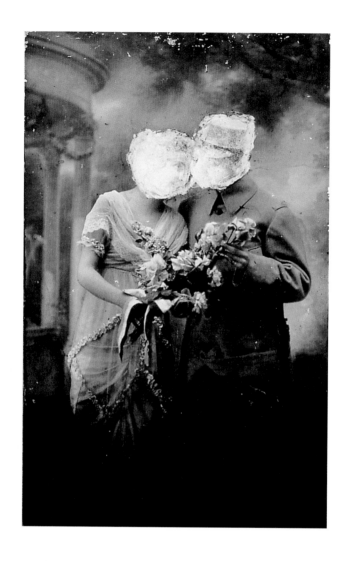

Philippe Bertin
From the series *La Plume et la faux*
(The Pen and the Scythe), 1997–98
Vintage postcard with
intervention by the artist

František Vobecký
Evening Star, 1935–36
Photomontage/gelatin silver print

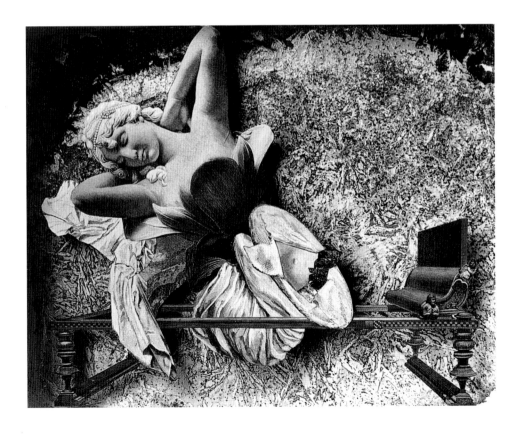

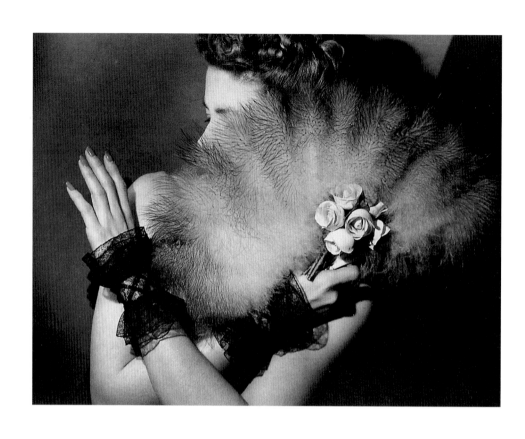

François Kollar
Femmes (Women), 1932
Gelatin silver print

Harry Meerson
Untitled fashion study, c. 1935
Gelatin silver print

(overleaf) **Giorgio Lotti**
La Traviata, Teatro La Scala, Milan; a
Standing Ovation for Riccardo Muti, 1990
Chromogenic print

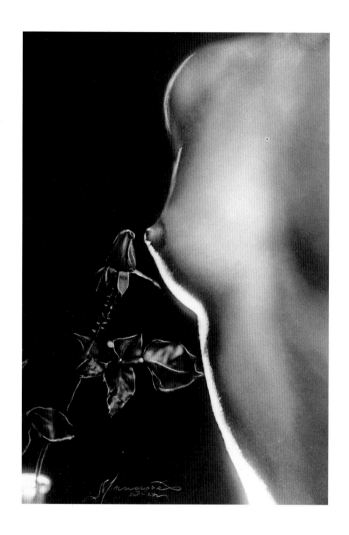

Studio Manassé, Vienna
Untitled, c. 1920
Postcard

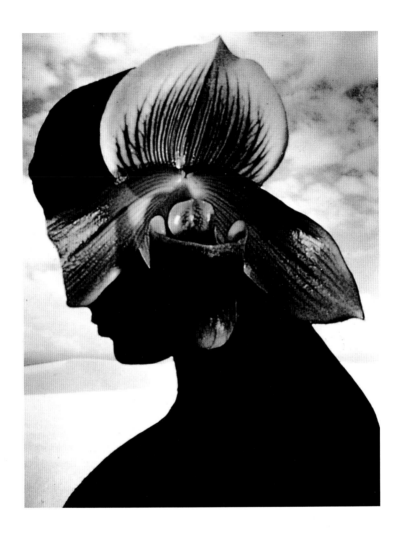

Ruth Thorne-Thomsen
Flora Bella, 1986
Contact gelatin silver print

(overleaf) **Annemarie Schudel-Halm**
Ich (I), 1991
Polaroid SX70 prints

261

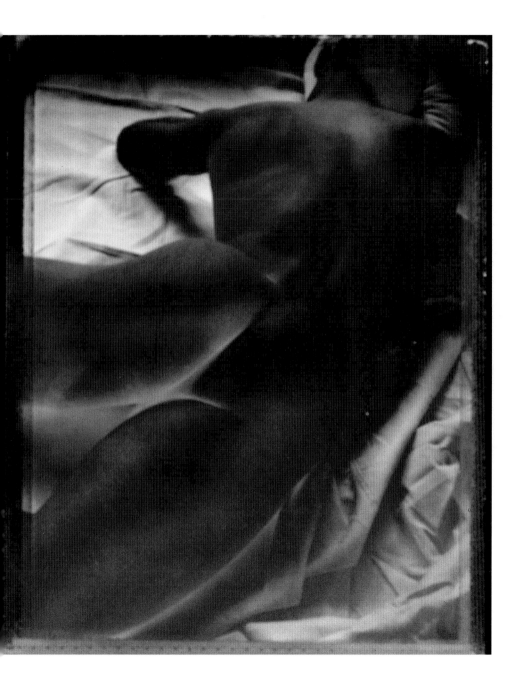

(preceding pages) **Robert Bianchi**
Man and Flowers, Diptych, 1998
Toned gelatin silver print

John Stezaker
(opposite) *Bride*, 1992 / (above) *Groom*, 1992
Collage

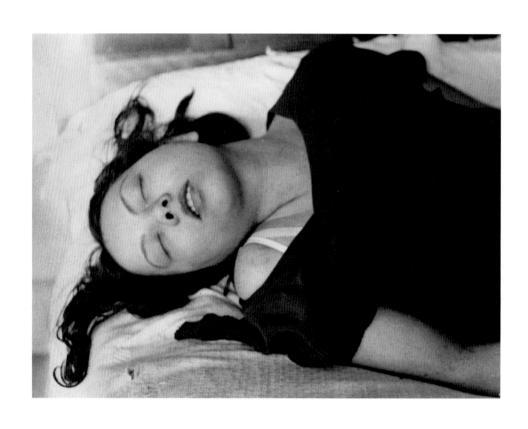

Brassaï
Portrait of Janet, 1932
Gelatin silver print

LIBIDOS

From photography's earliest days, certain practitioners relished the production of sexually explicit material [274]. From a grand total of perhaps five thousand erotic daguerreotypes, just after mid-century, it took only a few decades for production of photographic erotica to reach an industrial scale [272–73]. Today the volume is impossible to fathom but is believed to be in the billions of images annually. And this number leaves out those erotic images seen by more billions of people thanks to the stealthy penetration of explicit sexuality into the domains of advertising and fashion photography. By comparison, the total output of all pre-photographic sexual imagery (paintings, sculptures, engravings, lithographs and so on) could not amount to more than a few months of photography's current production.

Photographs do what erotic drawings and paintings cannot: the latter spring from the imagination of the artist and the viewer knows it; the former are rooted in real life – *real* people, the visual evidence tells us, made love in front of the camera in order for this picture to be taken. Put differently, we turn to erotic drawings (of, say, Picasso or Kokoschka) for an artistic sensibility, but we turn to the photographic pornographer for an unmediated look at 'the real thing' [276].

Photographers who have chosen to serve this market, then as now, know how hard it is to fabricate imagery. For a long time technical obstacles made production difficult. The very fact that it was illicit meant that it had to be studio-generated, and 'natural' outdoor environments had to be concocted indoors [277]. Indoor lighting problems and the consequent slow exposures ruled out truly instantaneous picture-making, which accounts for the artificial, awkward aspect of so much early erotica, indeed, even well into the twentieth century [J.C. 280, 281].

The human element also posed problems for pornographers and, unlike the technical variety, these have never been resolved. Now, as then, photographers strive to convince their clients that what they are looking at is real, but are hamstrung by the fact that it is virtually impossible to photograph sexual activity. Most men and women judge sex to be too intimate an enterprise to allow the presence of a passive (in the participatory sense) observer. Even if they do, the resulting self-consciousness alters the dynamic between the lovers. And since sex acts are fluid and ever-changing, **269**

constant instructions from the photographer to hold still can hardly be conducive to spontaneity. From the beginning, therefore, specialists have been called in to perform or simulate sex: prostitutes, models, out-of-work actors, and the like.

Though sexually explicit imagery is ubiquitous today, it remains formulaic and for the most part artless. The most successful men's magazines do not dare to tamper with what has proved to be a winning formula: well-endowed young women sprawled on rumpled sheets, entirely naked except for the requisite stockings, socks and/or high-heeled shoes, the whole retouched to efface the slightest imperfection visible on the skin, including (especially!) the beauty marks which give a body its individuality. The reader may forgive us for ignoring this vein of imagery in this book, given both its uniformity and its easy availability on every street corner.

A far richer vein of eroticism does bear the imprimatur of its makers. Independent photographers who are not beholden to a commercial market have managed to depict sex in a credible way largely because they have taken pains to forge intimate bonds with their subjects: Larry Clark, who evidently won the trust of his teenage friends and acquaintances [292], and Nan Goldin, who has turned a probing but respectful camera on a wide circle of friends and acquaintances [293], are perhaps the best known of these image-makers, but there are many others who manage to depict sexual activity without the prurient element that characterizes pornography. These photographers know what the pornographers can never seem to grasp: that a tender gesture [Ruben 301] is infinitely more suggestive than a blatant display of genitalia, though this is not to say that polite restraint is required: lust comes through clearly in many of these pictures [Giacomelli 286–87; Barker 288; Fenzy 297].

(opposite) **Mario Testino**
Untitled, 1997
Gelatin silver print

(following pages) **Unidentified photographer**
Pleasures of a Masked Ball, c. 1890
Albumen silver print

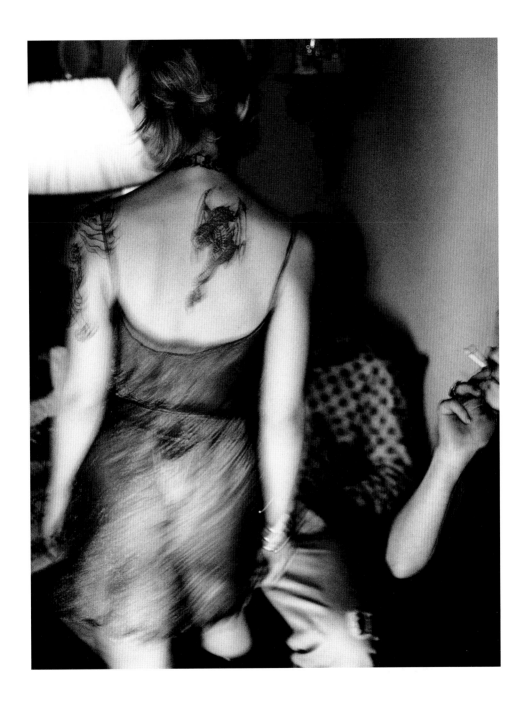

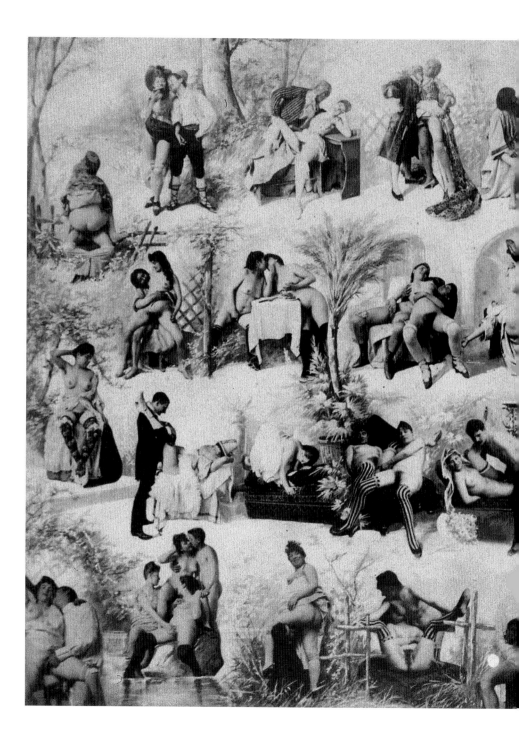

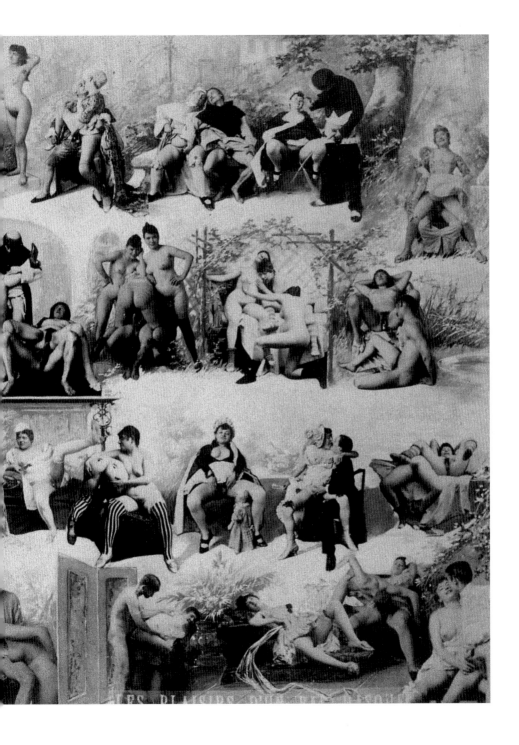

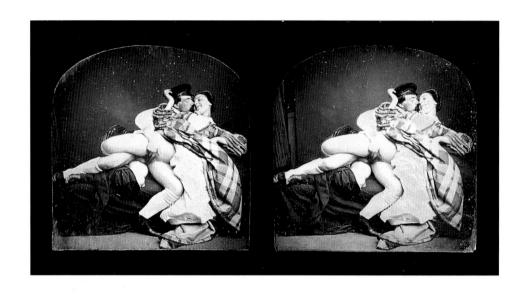

Unidentified photographer
Untitled, c. 1855
Stereoscopic daguerreotype

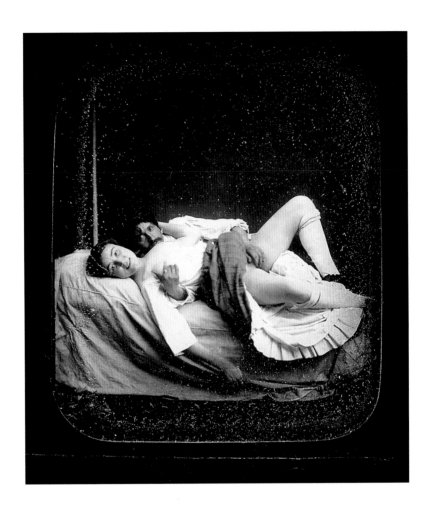

Unidentified photographer
Untitled, c. 1850
Daguerreotype

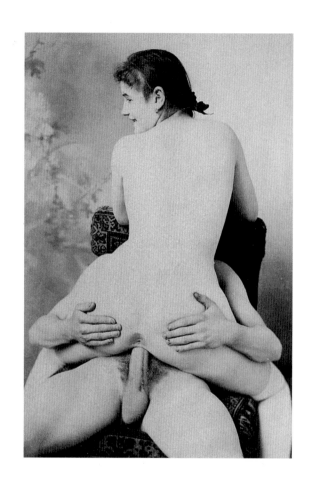

Unidentified photographer
Untitled, c. 1855
Albumen silver print

Unidentified photographer
Untitled, c. 1885
Albumen silver print

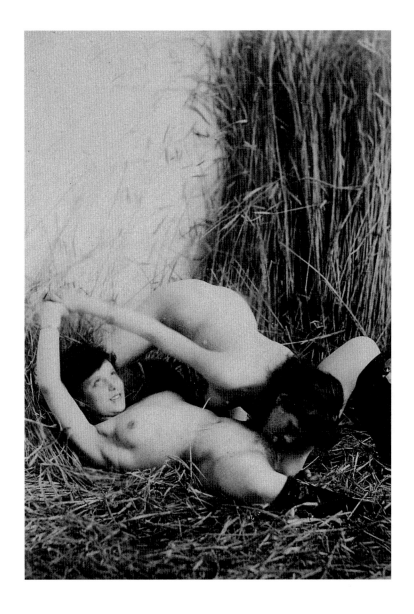

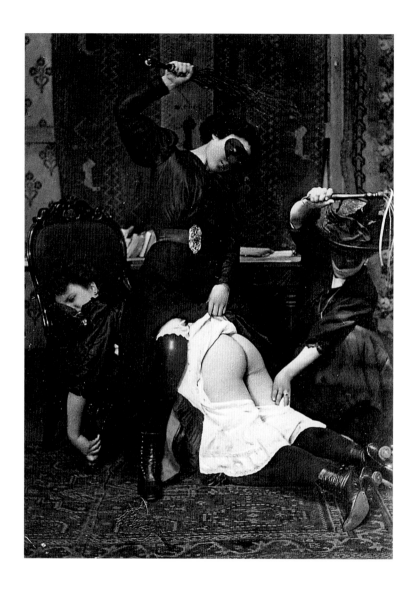

Unidentified photographer
Untitled, c. 1890
Gelatin silver print

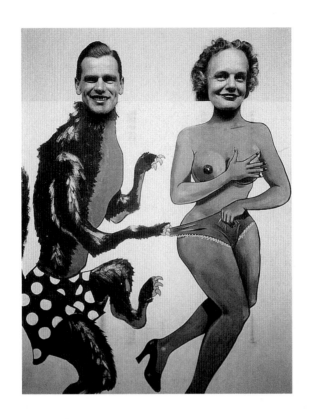

Unidentified photographer
Untitled (Fairground cut-out), c. 1950
Gelatin silver print

(below and opposite)
J. C. (Unidentified photographer)
Untitled, c. 1920s
Gelatin silver prints

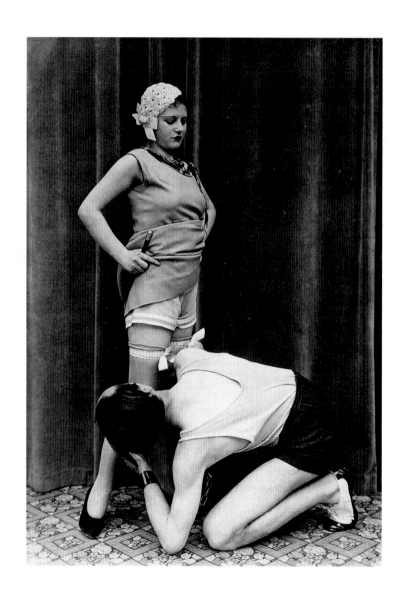

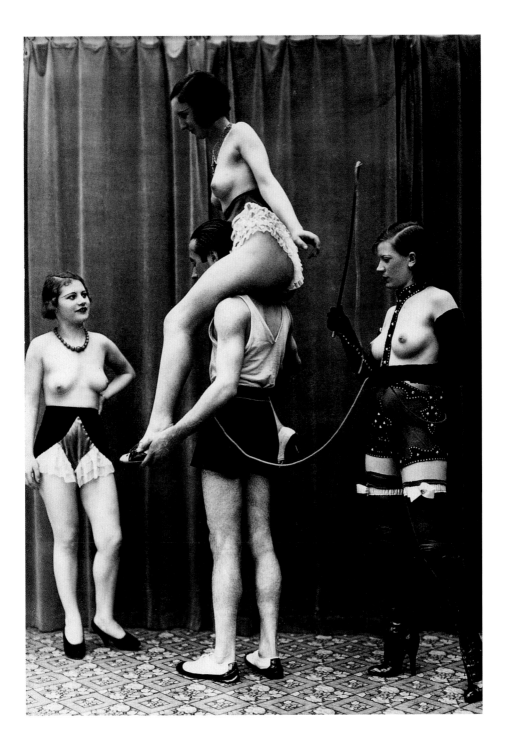

Kris, Chicago
Untitled, c. 1950
Gelatin silver print

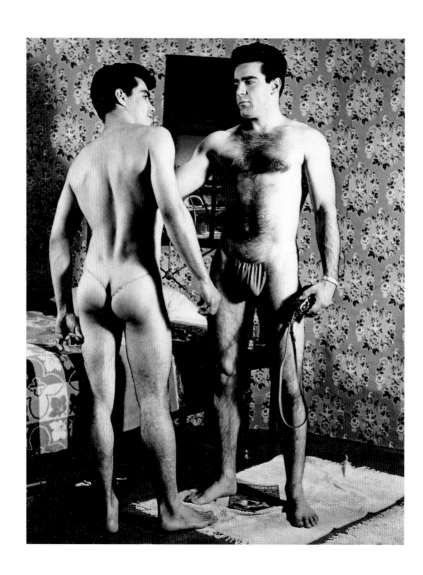

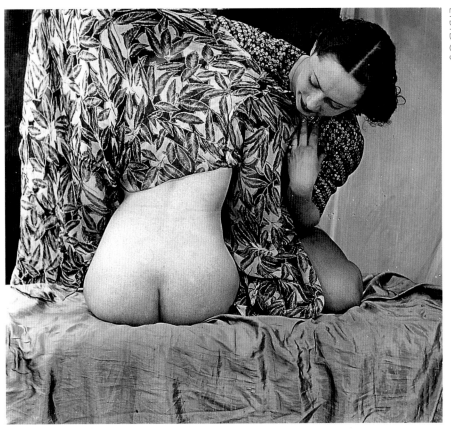

Unidentified photographer
Untitled, *c.* 1920
Gelatin silver print

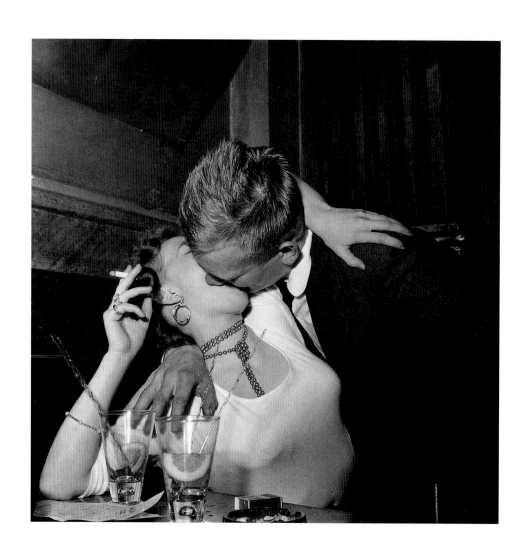

John Firth
At Nalen's, Stockholm: Scandinavia's Most
Popular Dance Club, 1956
Gelatin silver print

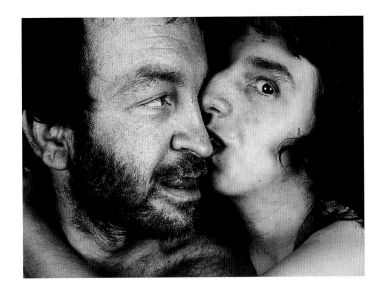

Shelby Lee Adams
The Kiss, 1986
Gelatin silver print

(overleaf) **Mario Giacomelli**
Un homo, una donna, un amore
(A Man, A Woman, A Love), 1960–61
Gelatin silver print

285

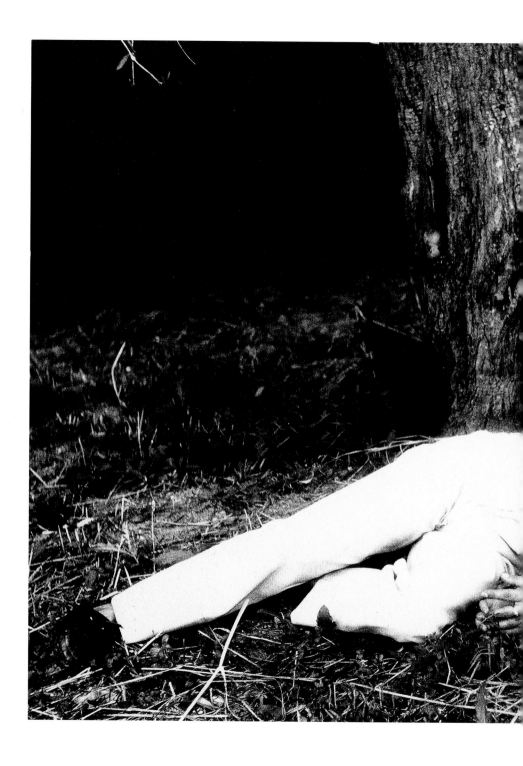

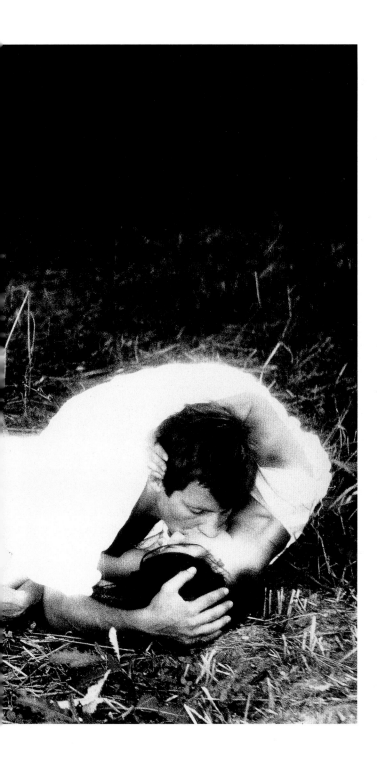

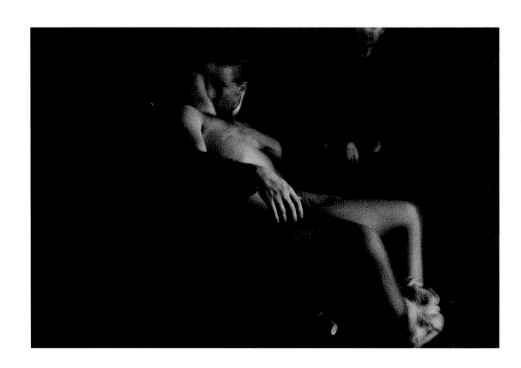

Stephen Barker
Nightswimming, 1994
Toned gelatin silver print

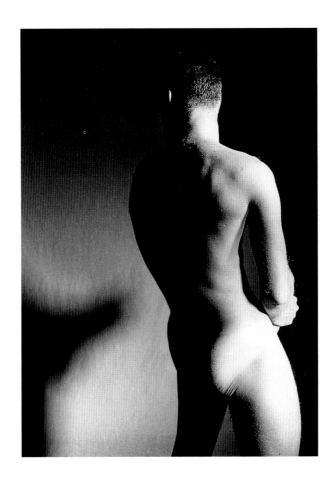

David Lebe
Shadow Play, 1990
Gelatin silver print

(overleaf) **Gérard Musy**
The Vault, 1991
Gelatin silver print

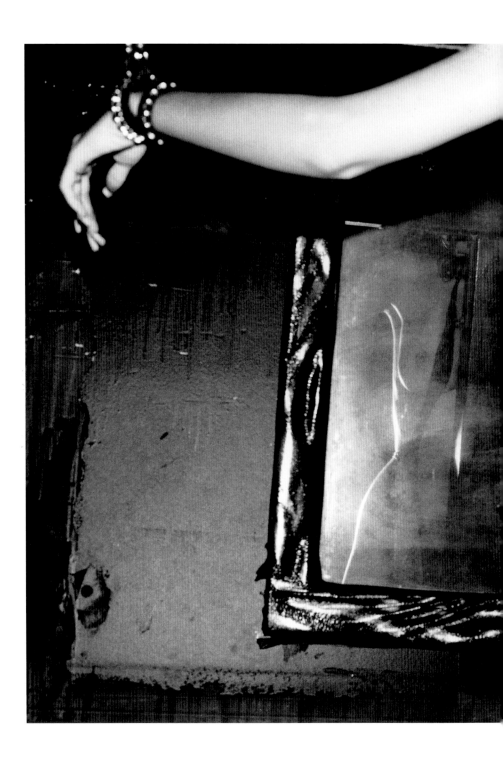

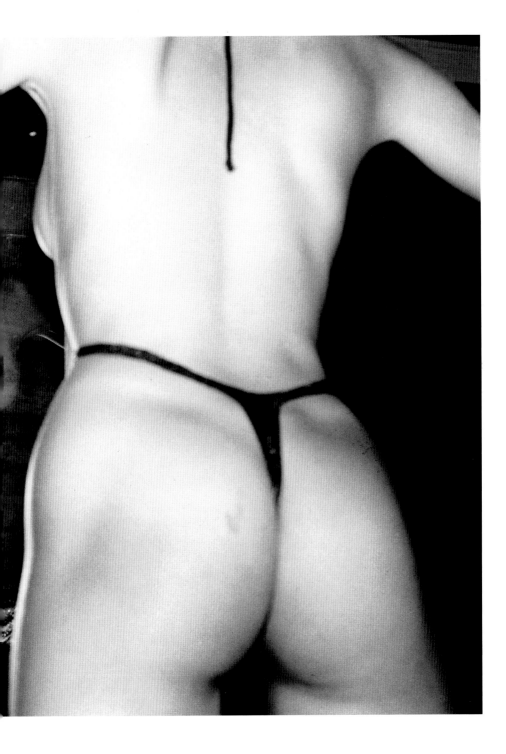

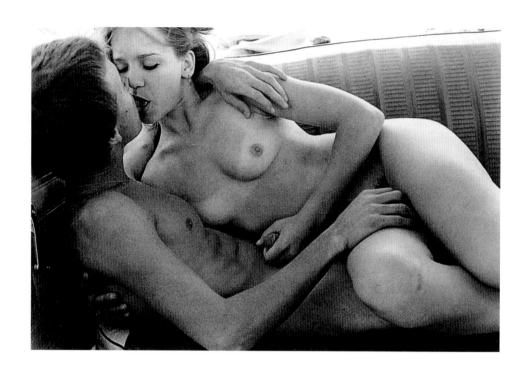

Larry Clark
Untitled, 1972
Gelatin silver print

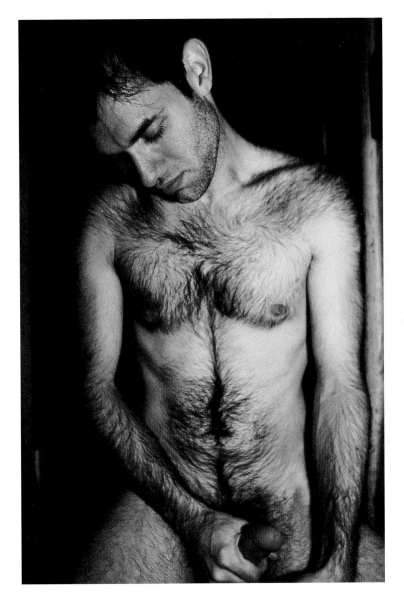

Nan Goldin
Bobby Masturbating, New York, 1980
Gelatin silver print

(overleaf) **Tom Stappers**
Jessica Dancing at Club Exposure,
October 28, 1994
Gelatin silver print

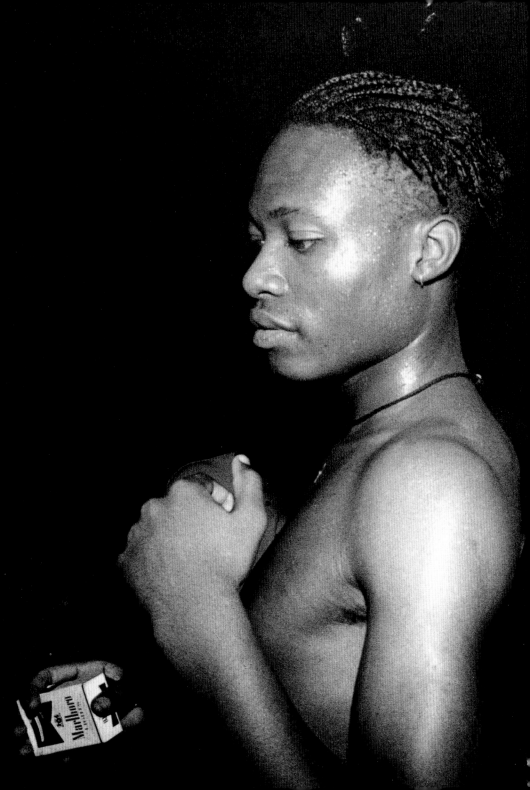

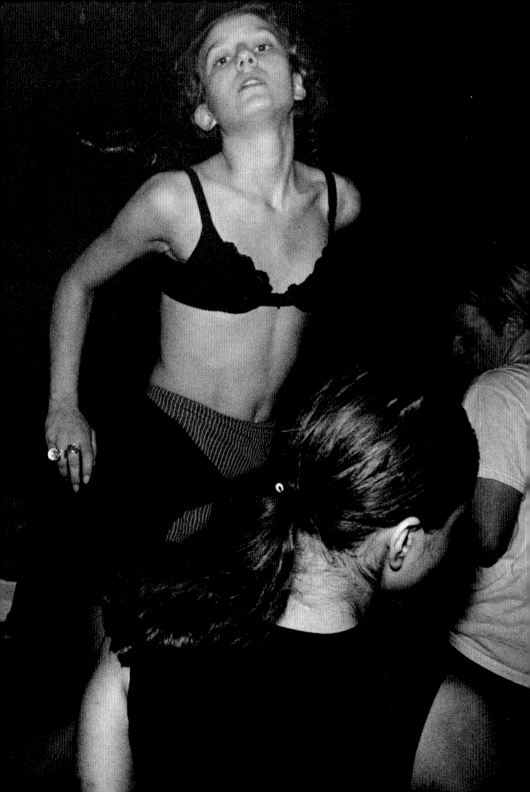

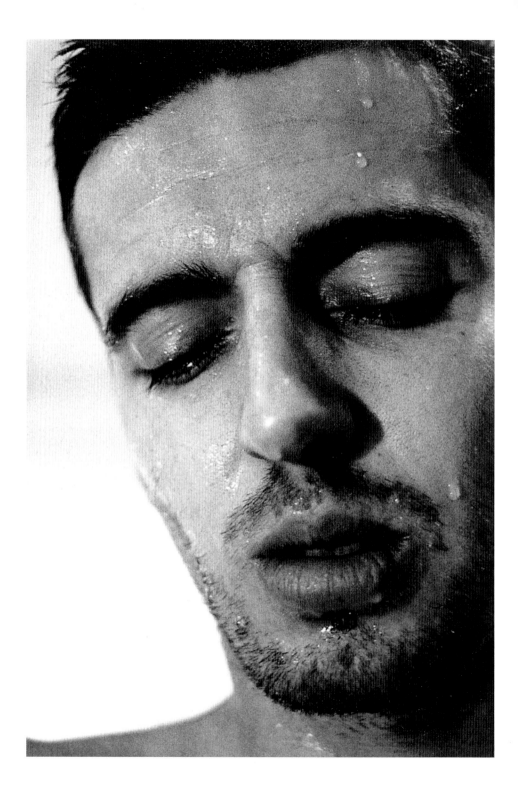

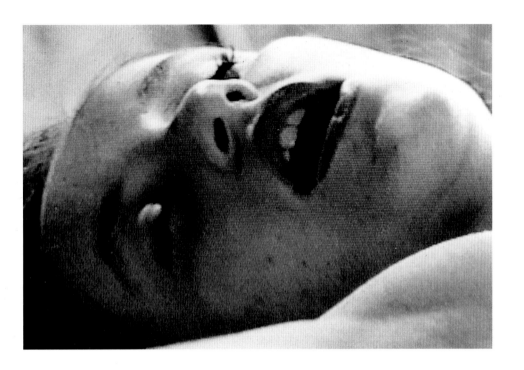

(opposite) **Aura Rosenberg**
T.K., c. 1993
Gelatin silver print

Rémy Fenzy
Les Petites Extases (Little Ecstasies), No. 1, 1996
Gelatin silver print

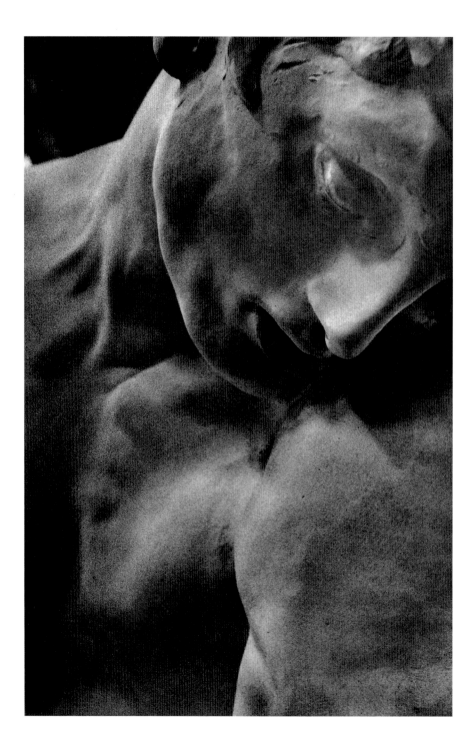

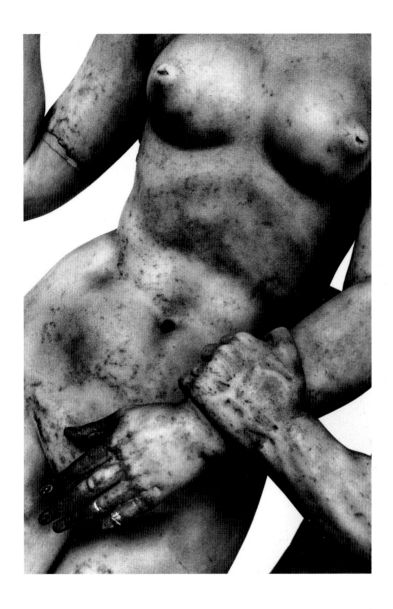

(opposite and above)
Alejandra Figueroa
Untitled, 1997
Gelatin silver prints

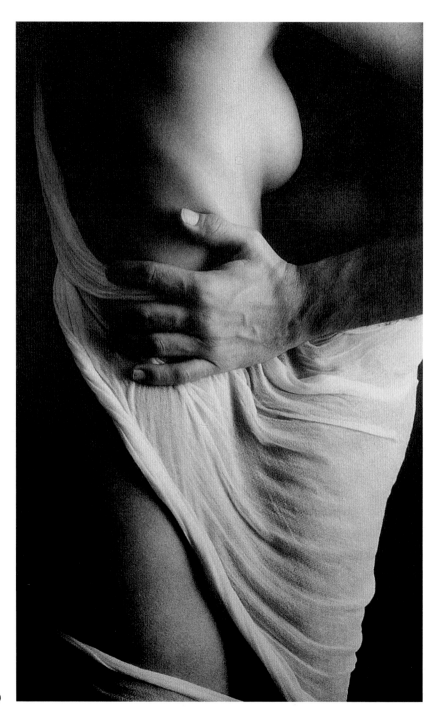

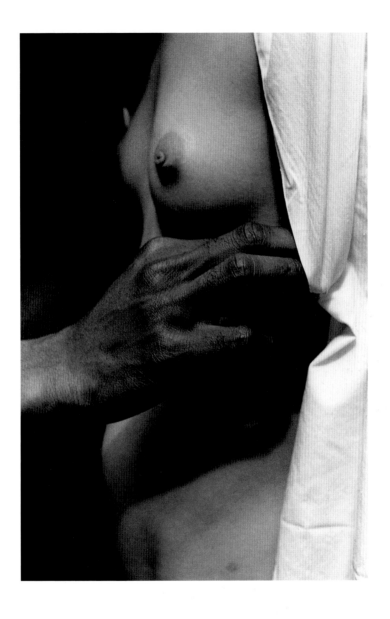

(above) **Ernestine Ruben**
Katinka and Friend, 1983
Gelatin silver print

(opposite) **Isabel Muñoz**
Untitled, *c.* 1990
Gelatin silver print

(overleaf) **Mark Krastof**
Bar, Chicago, 1978
Gelatin silver print

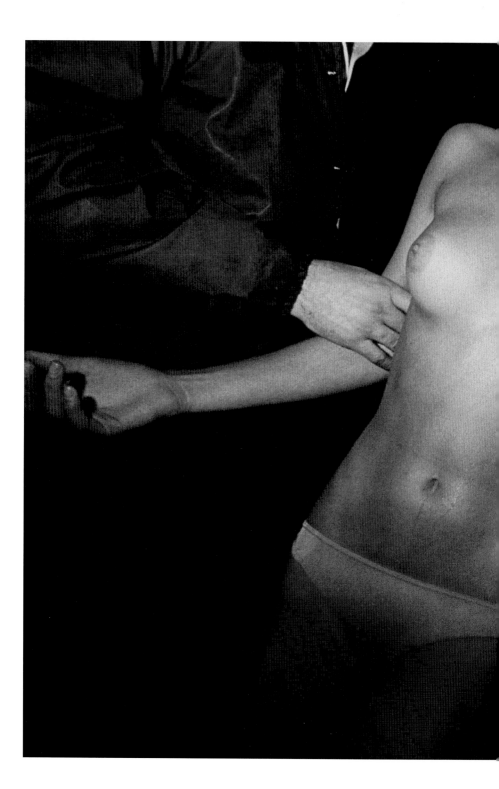

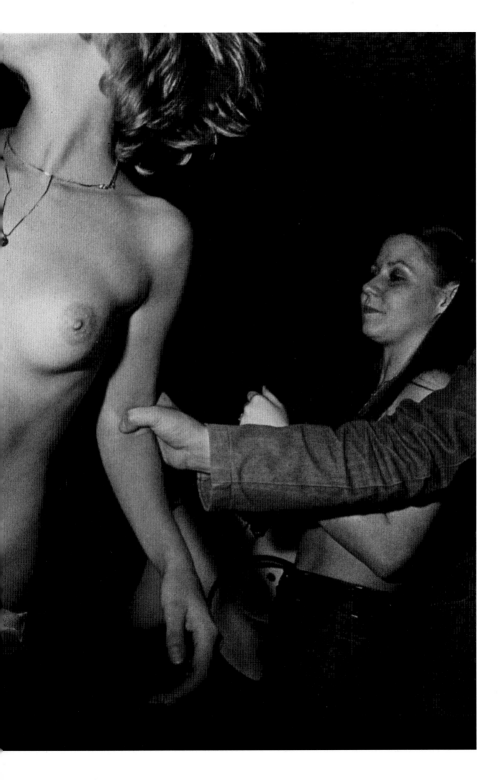

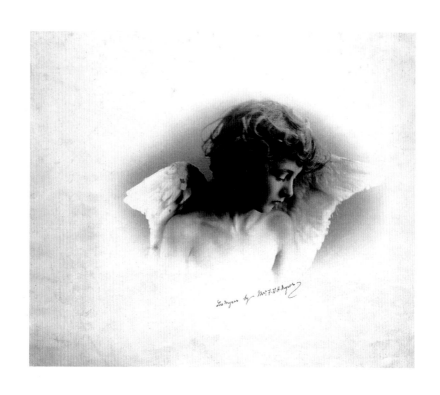

Eveleen Myers
Leo Myers, c. 1890
Platinum print (unverified)

REVERIES

We all have our own theories of love, erotic and platonic, coloured by our own unique experiences in each domain, and we can all conjure up images to conform to them [Myers *opposite*]. But perhaps we can agree on one fundamental difference between love's physical and spiritual manifestations: whereas Eros's arrows strike at will and without warning, bringing anguish as well as joy to his victims, platonic love – selfless and unconditional in its purest form – blesses us with a sense of happiness and well-being which survives the emotional storms that are so characteristic of human nature.

But love in either form is something one has or one hasn't. Desire, by contrast, is a state of unresolved tension; sometimes we know what we want – a person, a thing – and yearn to possess it, but often our longings are vague and indeterminate, and conflated with other desires which by their very nature can never be satiated [308]. When we can we employ our wiles – we charm, we seduce – heady with the challenge but never sure of the result. And once the object of desire *is* attained, the desire dissipates.

Small wonder, then, that love and desire permeate photographers' dreams [Pache 319]. And their daydreams: some photographers see in the reality around them an aspect so dreamlike or surreal that they are compelled to seize and possess it [Lanfranco 320]. They recognize that the man-made world is in itself a distillation of its maker's fantasies, an effort to give tangible form to their desires – for immortality [Atget 310] – or for pure indulgence of the body [Cohen 312]. Often the slightest transformation – effected with lighting, for example – can invest the humblest object with sensuality [Němec 349].

But other photographers prefer a metaphysical approach, judging the world revealed by sight to be a seductive illusion; the true, multifaceted beauty of our universe, they argue, can only be intuited [Mandelbaum 307]. And the phenomena of love and desire are best conveyed obliquely, thus retaining their mystery [Bertin 337].

Fabrications [Boucher 313], theatrical stagings [Garduño 317], darkroom alchemy [Martin 330], computer wizardry [Prince 334, 335]: there is no limit to the conceptual and technical ingenuity brought to bear on the creation of visionary imagery, and perhaps it is foolhardy to pigeon-hole such efforts. How, indeed, to characterize the ambitious project of the photographer Pierre Radisic, who set out **305**

to find (and did!) all the constellations of the heavens as formed by the beauty marks on women's bodies [326, 327, 328, 329]? In so doing he produced a complete atlas of the heavens which can rival any of its medieval counterparts for inventiveness.

Intriguingly, in view of the advanced technology they increasingly utilize, photographers often turn to the past for inspiration, as well as for imagery, and signs and symbols. Classical themes and images from art [Lynes 316; Fontcuberta 346–47], myth and legend [van Lawick and Muller 342, 343] are appropriated by the photographers and combined with other imagery in unorthodox and often unsettling compositions which express that strange human need for transformation.

In recent years, feminist photographers have found such 'appropriations' to be a particularly rich terrain. Kathy Grove mines the history of photography, 'recuperating' the anonymous women who feature prominently in famous photographs by male photographers [340, 341], and entirely subverting our reading of the original. Emmanuelle Purdon locates equally anonymous women interred in paintings of the past, and by reinventing them through photography – as 1940s film stars – invests them with an independence and vitality long denied [332, 333].

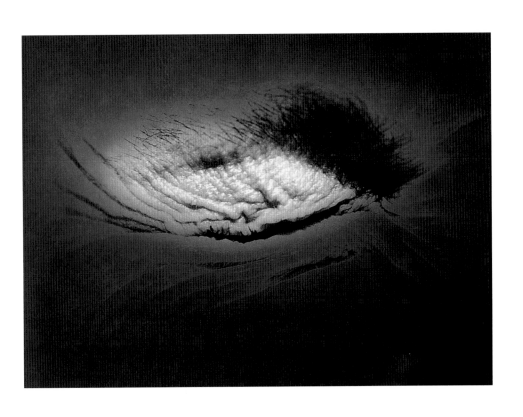

Ann Mandelbaum
Untitled, No. 76, 1995
Gelatin silver print

Unidentified photographer
Die Jungfrau, c. 1900
Postcard

Unidentified photographer
Untitled, c. 1870
Hand-coloured albumen silver print

Eugène Atget
Versailles Park, 1901
Albumen silver print

Guglielmo Marconi
Untitled, c. 1870
Albumen silver printt

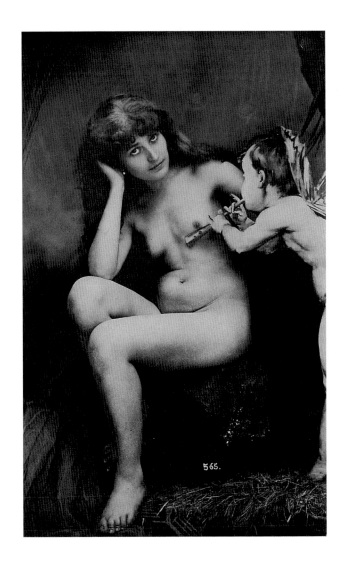

565.

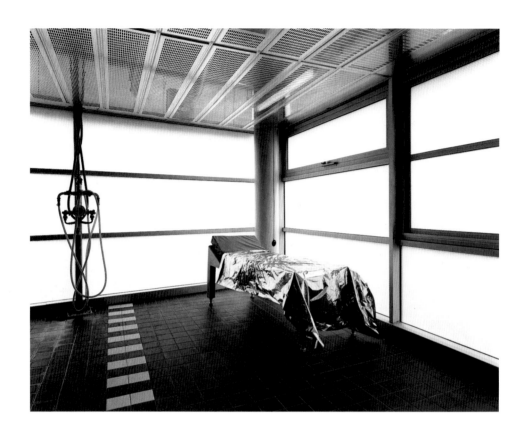

Lynne Cohen
Spa, 1996
Gelatin silver print

(opposite) **Pierre Boucher**
Electra, 1964
Photomontage/gelatin silver print

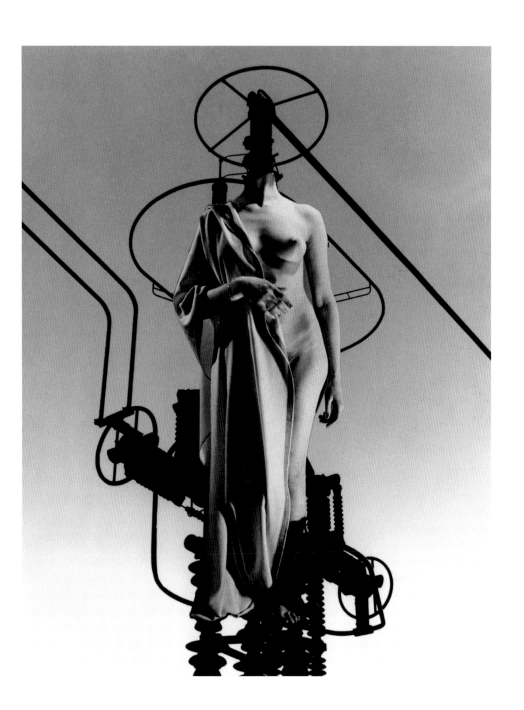

Gary Schneider
Vegetable, 1993
Toned gelatin silver print

Charles Jones
Runner Bean, c. 1900
Toned gelatin silver print

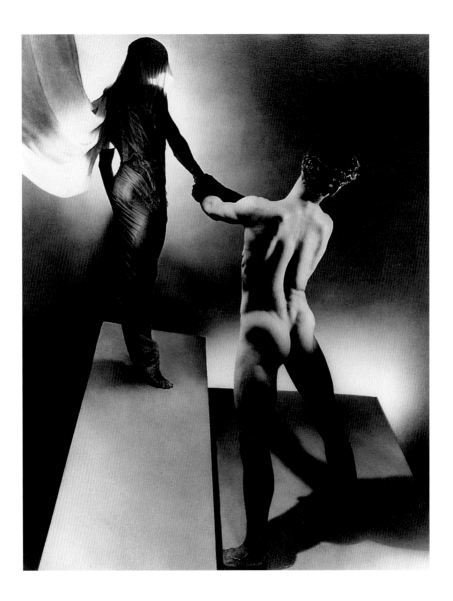

(opposite) **George Platt Lynes**
Orpheus and Eros, c. 1950
Gelatin silver print

Flor Garduño
Dreaming Woman, Pinotepa Nacional,
Mexico, 1991
Gelatin silver print

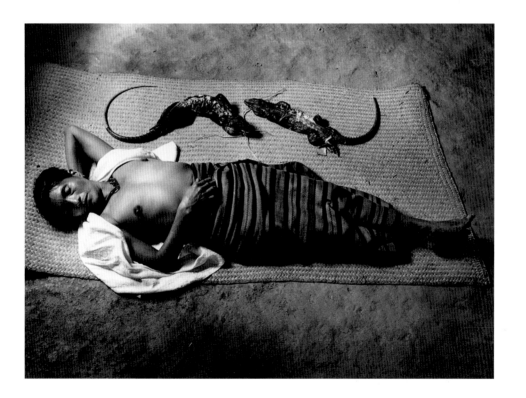

František Drtikol
Stampeding Curves, 1928–29
Pigment print

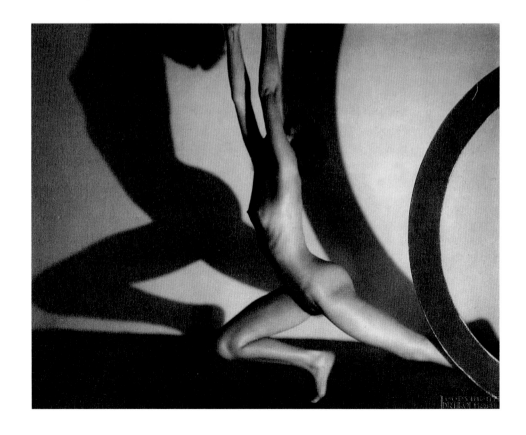

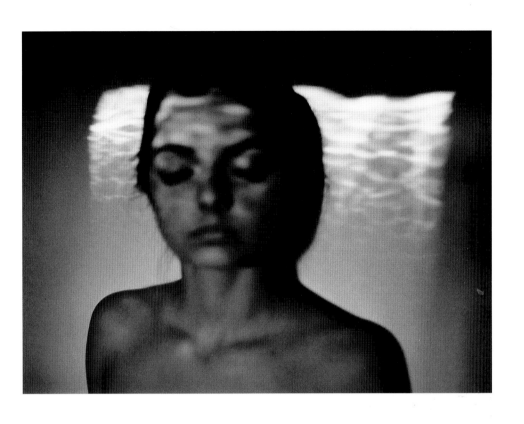

Philippe Pache
Vagues pensées (Thought Waves), 1993
Gelatin silver print

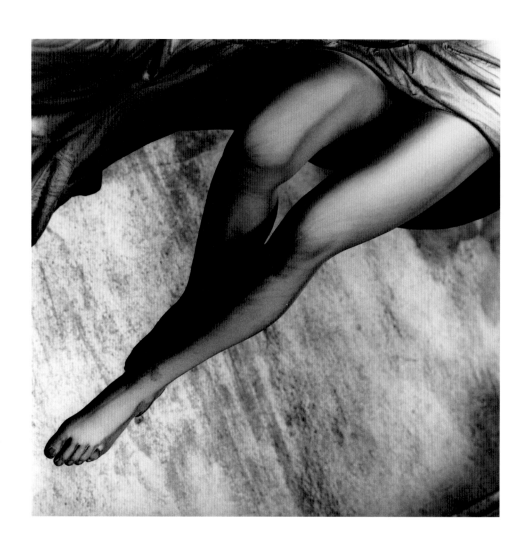

Nanda Lanfranco
Untitled, from the series *des corps*
(bodies), 1983
Gelatin silver print

Erwin Blumenfeld
Untitled, Paris, c. 1937
Solarized gelatin silver print

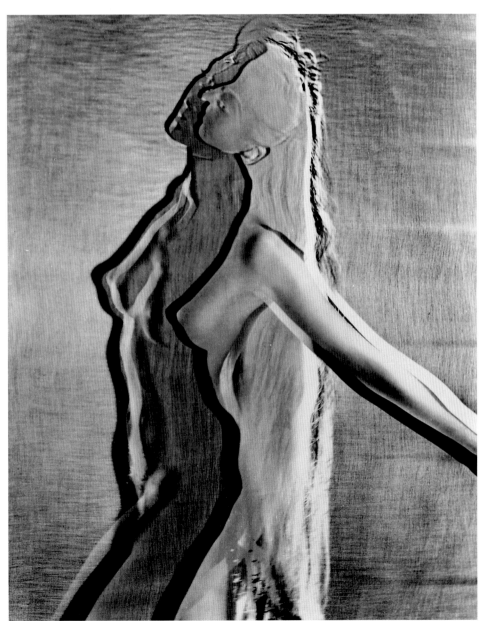

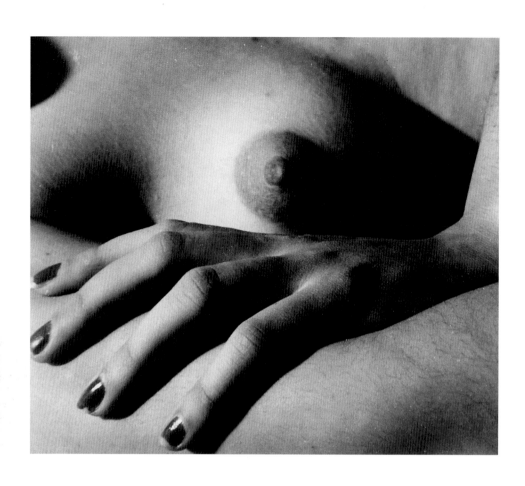

Karel Ludwig
Detail, 1941
Gelatin silver print

Man Ray
Untitled, c. 1936
Gelatin silver print

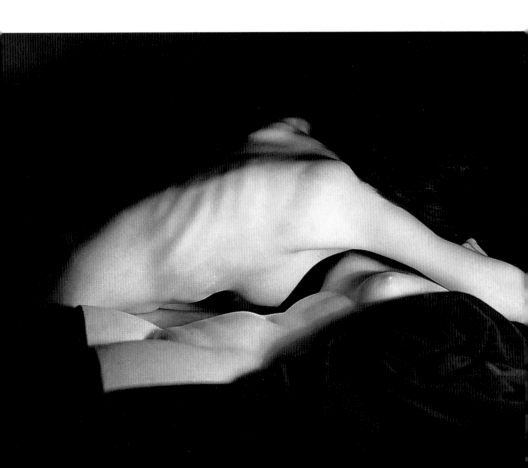

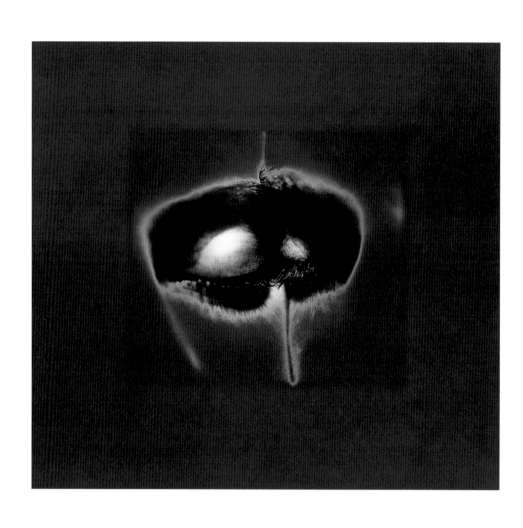

Ann Mandelbaum
Untitled, No. 99, 1995
Gelatin silver print

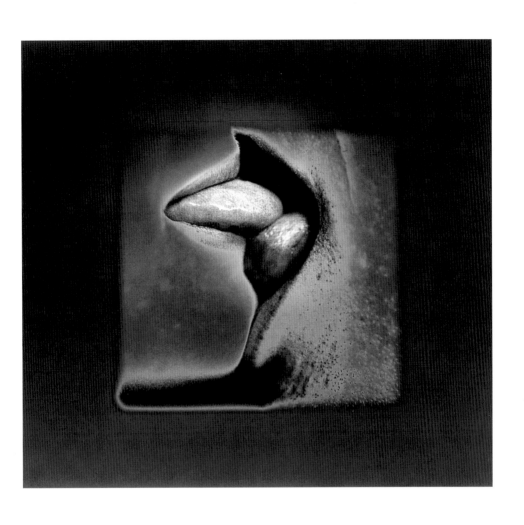

Ann Mandelbaum
Untitled, No. 108, 1996
Gelatin silver print

Pierre Radisic
6.5.94
From the series *Corps célestes*
(Heavenly Bodies)
Gelatin silver print

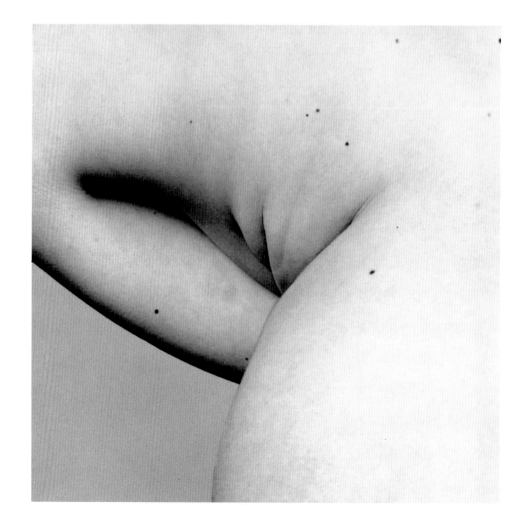

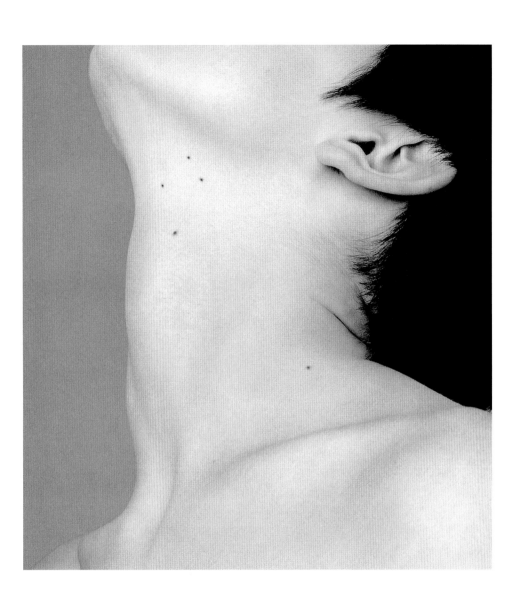

Pierre Radisic
1.1.95
From the series *Corps célestes*
(Heavenly Bodies)
Gelatin silver print

Pierre Radisic
Reticulum, 1994
From the series *Corps célestes*
(Heavenly Bodies)
Gelatin silver print with
computer drawing

Pierre Radisic
Crux, 1995
From the series *Corps célestes*
(Heavenly Bodies)
Gelatin silver print with
computer drawing

Lisa Martin
Arch, 1994
Gelatin silver print

John Bernhard
Nudewood, 1994
Gelatin silver print

Emmanuelle Purdon
Femmes de mystère: From the Painting to the Photo, 1996–97
Gouweloos (top); Brusserat (bottom)
Gelatin silver print

Emmanuelle Purdon
Femmes de mystère: From the Painting to the Photo, 1996–97
Millais (top); Lepage (bottom)
Gelatin silver print

Doug Prince
Body Image 4, 1998
Digital image/inkjet print

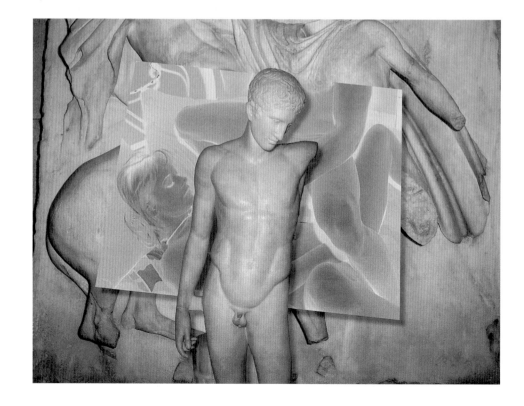

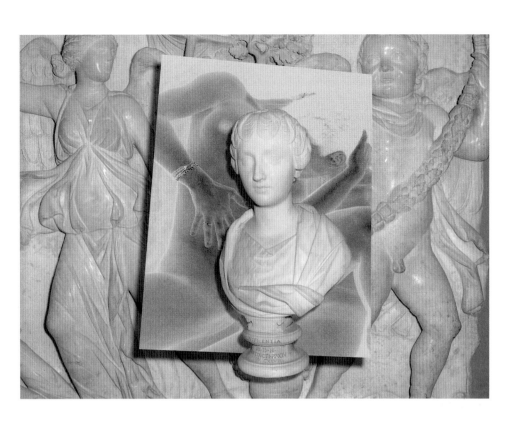

Doug Prince
Body Image 6, 1999
Digital image/inkjet print

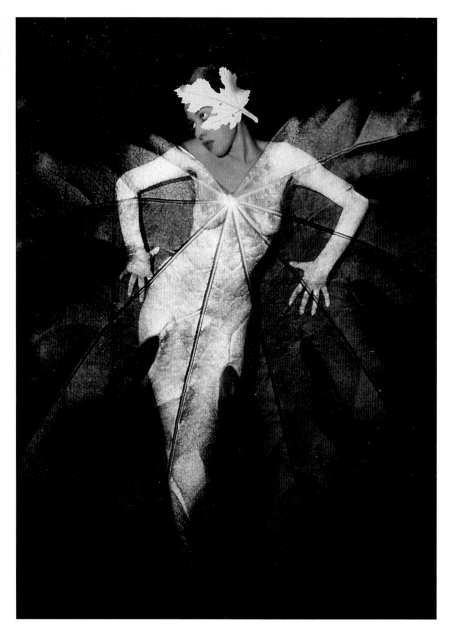

Heinz Hajek-Halke
Das Eva-chanson (The Eva-song), n. d.
Gelatin silver print

Philippe Bertin
From the series *La Plume et la faux*
(The Pen and the Scythe) 1997–98
Vintage postcard, c. 1914, with
intervention by the artist

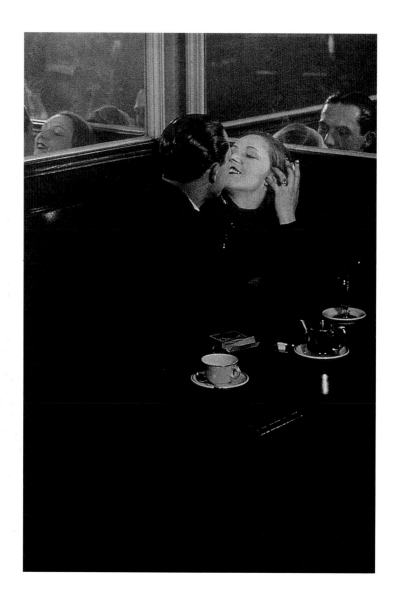

(preceding pages)
Danielle Kwaaitaal
(left) *Ride maltaise (Maltese Ridge)*, 1994
(right) *La Grande Syrte (Surt, Libya)*, 1994
Chromogenic prints on perspex

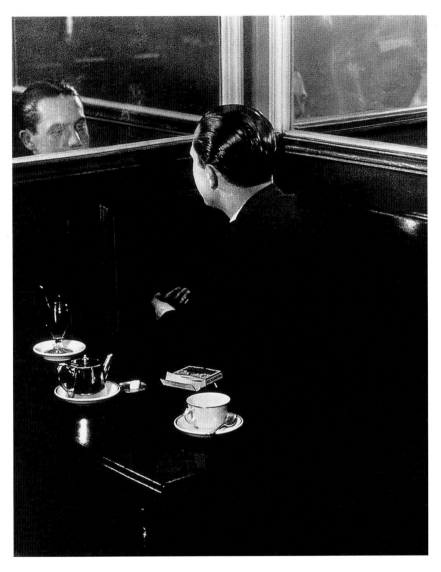

(opposite and above) **Kathy Grove**
After Brassaï, 1994
The Other Series
Altered silver gelatin prints

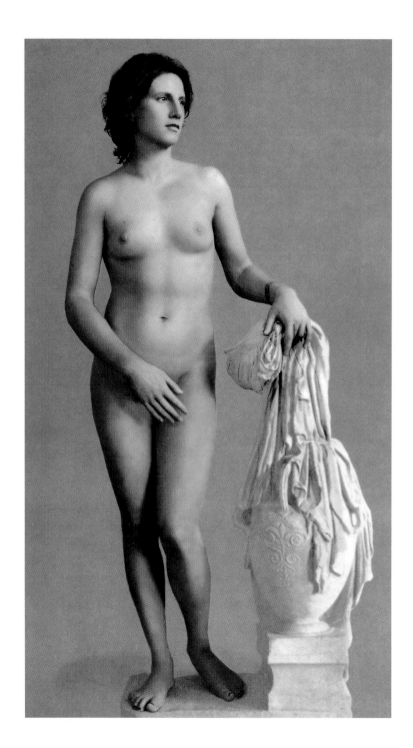

Friedericke van Lawick and Hans Müller
Aphrodite and Eros, 1998
From *the perfectlysupernatural* project
Computer manipulated composites of real people,
combined with *Eros Drawing Bow* (after Lysippus)
and *Cnidian Aphrodite* by Praxiteles

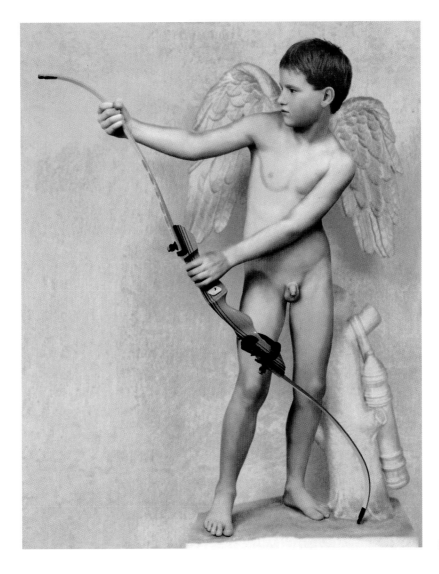

Ernestine Ruben
Black and White with Drapes, 1983
Gelatin silver print

(opposite) **Heinz Hajek-Halke**
Torso, 1932
Gelatin silver print

344

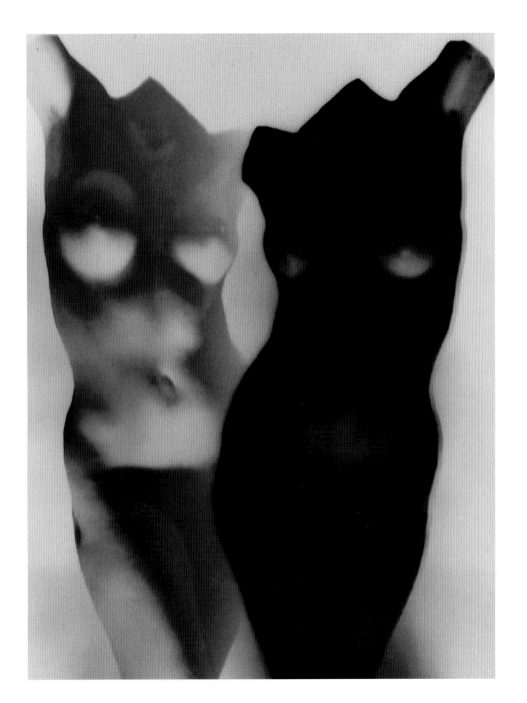

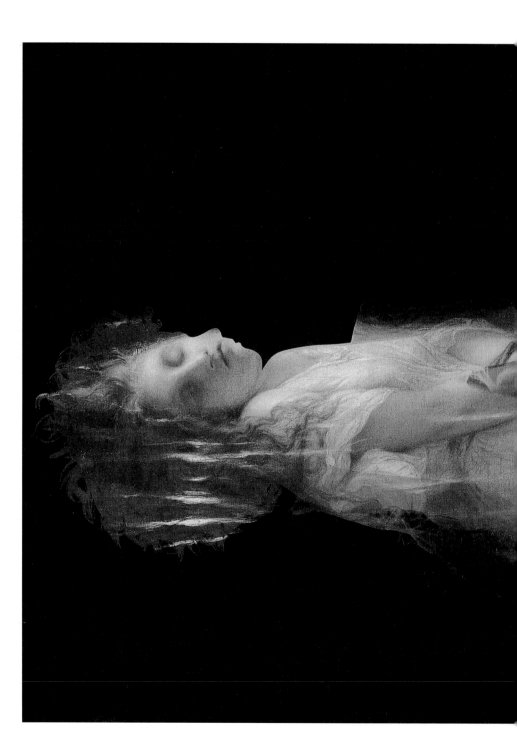

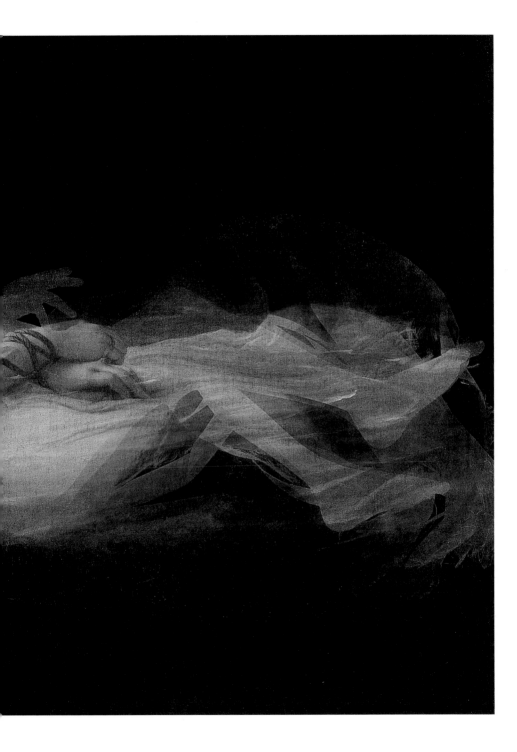

(preceding pages) **Joan Fontcuberta**
Ophelia, 1993
Photogram on reproduction of Delaroche

(above) **Josef Sudek**
Nu à l'escargot (Nude with Snail), 1951
Gelatin silver print

(opposite) **Bohumil Nĕmec**
Untitled advertising photograph, c. 1938
Gelatin silver print

348

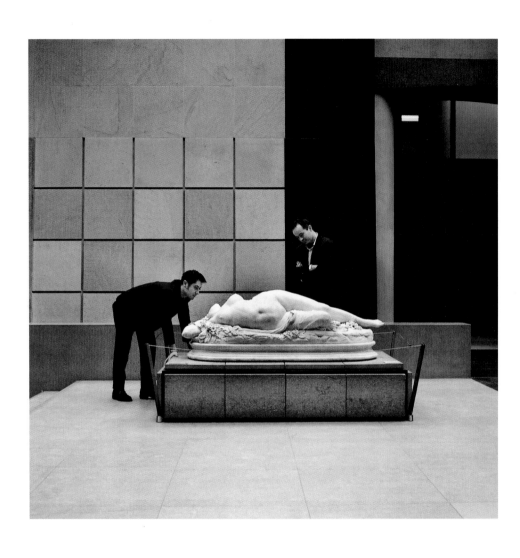

Karen Knorr
Woman Bitten by a Snake, 1998
From the series ACADEMIES
Chromogenic print

(opposite) **Frank Majore**
City of Women, 1996
Cibachrome print

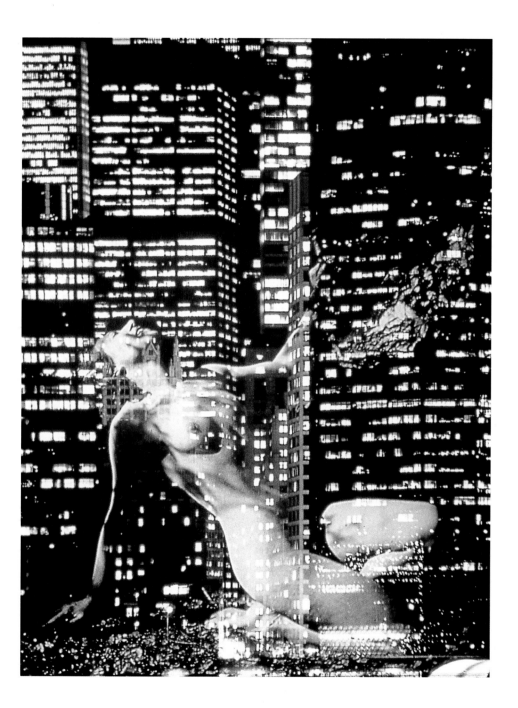

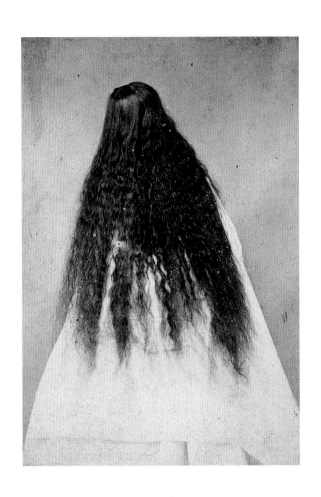

Unidentified photographer
Untitled, c. 1860
Albumen silver print on *carte-de-visite*

OBSESSIONS

For all its rapture, erotic love is often threatened by darker emotions: fear of one's own inadequacy; jealousies that can tear a person apart; festering doubts as to the depth of a partner's commitment; a terror of rejection [Stezaker 382]. Every vision of perfect love carries with it the corresponding nightmare of its loss. And there is something in the human soul which loves to flirt with this danger: the games we play with Eros can get out of hand [Levinthal 356]; the heat of sexual passion can burn those who abandon themselves to it [Rondpierre 6–7, 369]; the shimmering objects we· invest with our desire [Bélin 387] are often shattered before our eyes [Bélin 386].

Photographers (we tend to forget) are vulnerable men and women subject to the same emotional turbulence as we are. Unlike most of us, however, who can only hope that our nocturnal angels will vanquish our demons while we sleep, photographers go into battle with open eyes, wrestling with their phantoms in daylight. In a sense, we, their public, live vicariously through their camera art, hoping for a refractive ray of light (here or there!) to illuminate the darker recesses of our own psyches [Ray 367]. This has always been true of art, of course, but because photographs are, in a fundamental way, fragments of the real world, the medium seems all the more relevant.

While many photographers give voice to their own obsessions [Koeppel 360; Styrský 368; Berticevich 379], and sometimes even act them out, thus retaining their emotional equilibrium [Molinier 359; O'Reilly 363], some are content to witness and record the obsessive and often bizarre behaviour of others [Sinclair 370; Steinmetz Studio 371]. This distinction – between those photographers who stage situations which enact their own fantasies, and those who allow the subjects to express themselves, is important, since at first glance such pictures often have a superficial resemblance [compare Ashton-Harris 372 with Sinclair 370].

Sometimes, however, it is far from clear just whose obsessions are being recorded. Take, for example, an unknown nineteenth-century studio photographer's photograph (one can hardly, in this case, call it a portrait) of the impressive tresses of a young woman or girl [*opposite*]. Who can say whose idea it was to commemorate (rather ghoulishly to modern eyes) her achievement? The girl/woman herself? A parent? Her husband? A lover? Only the photographer can be ruled out with any

degree of certainty, as studio photographers waited for clients to approach them. All that can be said of this mute fragment (no one thought to record her name on the back of the photograph) is that it betrays *someone's* desire to document the phenomenon. Certainly the image, so Victorian in its denial of all other aspects of the body, makes for a fascinating comparison with a late-twentieth-century picture equally obsessed with the significance of hair, though this time the sexual aspect predominates [Dunning 361].

Turbulent dreams, and in the worst case, nightmares, strike us (after the fact, at least) as bizarre amalgams of images and action, surreal in the extreme. Photographers make use of two broad strategies, both of which are well equipped to convey this surreal aspect: the first is theatrical staging involving the performances of real people [Witkin 373] or surrogates in the form of dolls or toys, which when taken out of the childhood context seem grotesque and unnerving [Norfleet 377; Boto 385]; the second is what we might call a *post*-photographic manipulation of already existent imagery (sometimes that which has been produced by the photographer at an earlier time, but more often 'found' imagery) [Stezaker 375]. Collage, essentially a manual technique whereby found photographs and other kinds of imagery are cut up and recombined [O'Reilly 374] is a device particularly well suited to subversive intentions [Buetti 388–89]. Photomontage, essentially a studio or darkroom technique where images are combined in the camera or enlarger, allows for more fluid 'dissolves' of one kind of image into another, such as can be achieved by multiple printing of negatives [Prince 380] and rephotographed projections [Calvin 384]. These are among the wide gamut of creative tactics marshalled by image-makers to illuminate the turbulence which so often comes in the wake of love.

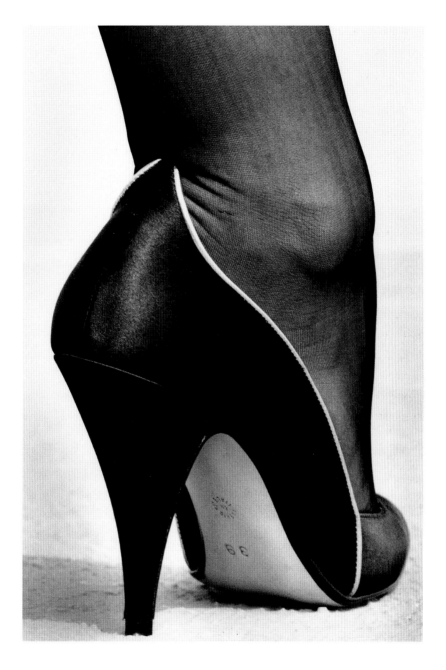

Helmut Newton
Shoe, Monte Carlo, 1983
Gelatin silver print

David Levinthal
American Beauty, 1989
Polaroid print

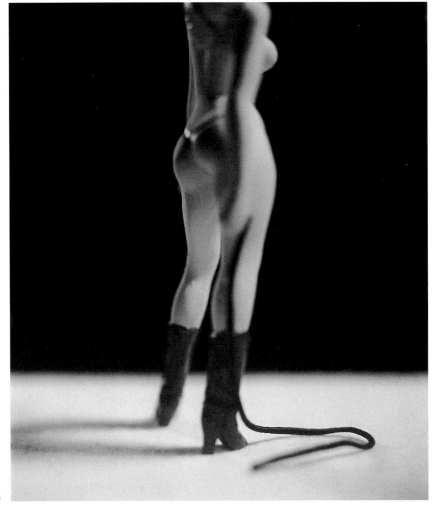

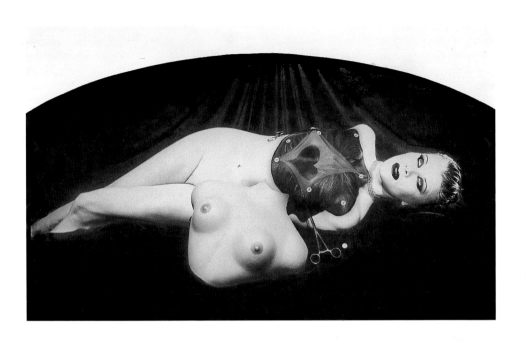

Gilles Berquet
L'Ange anatomique (Anatomical Angel), 1996
Toned gelatin silver print

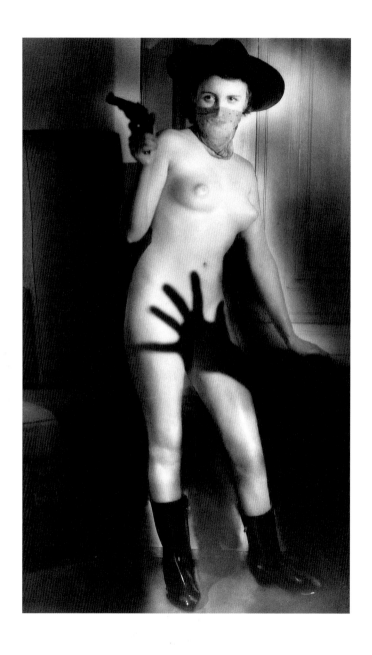

Studio Manassé, Vienna
Untitled, c. 1935
Gelatin silver print

Pierre Molinier
Untitled, c. 1975
Gelatin silver print

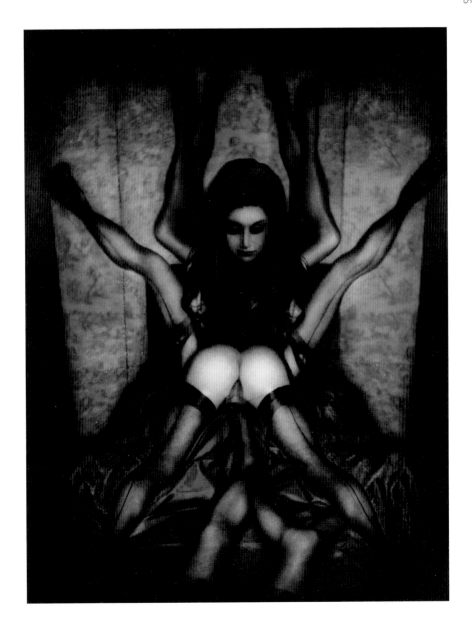

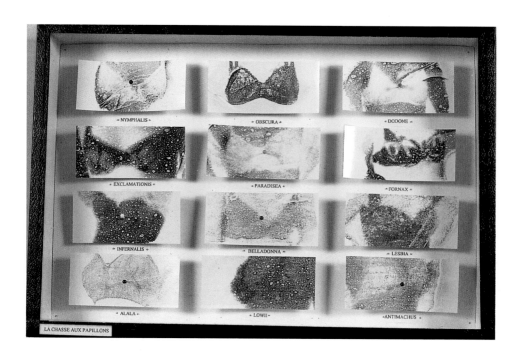

Christian Koeppel
La Chasse aux papillons (Butterfly Hunt), 1997
Pressed images transferred on to bromide paper,
pins and butterfly labels
Cibachrome print

Jeanne Dunning
The Extra Hair 2, 1994
Cibachrome mounted to plexiglass, framed

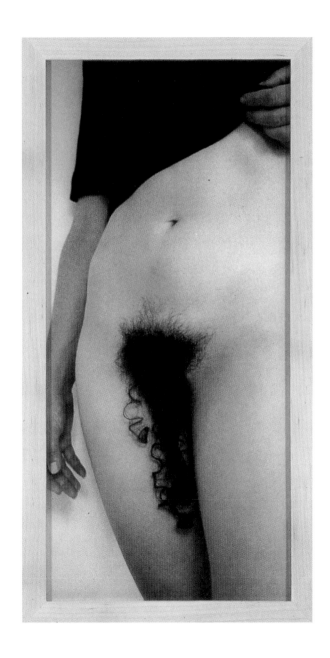

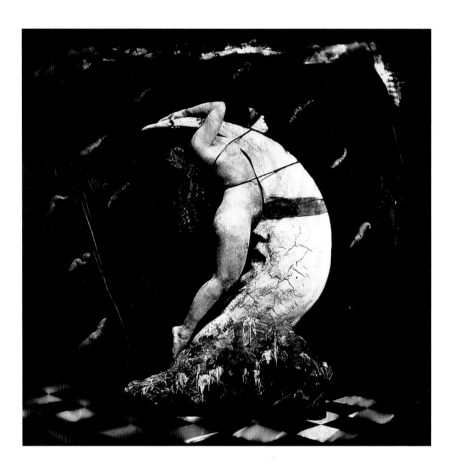

Joel-Peter Witkin
Woman Masturbating on the Moon, New Mexico, 1982
Gelatin silver print

John O'Reilly
Of Benjamin Britten – Death, 1993
Polaroid 107 collage

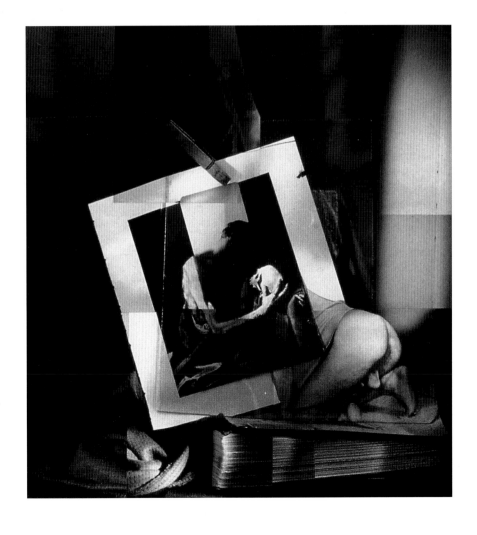

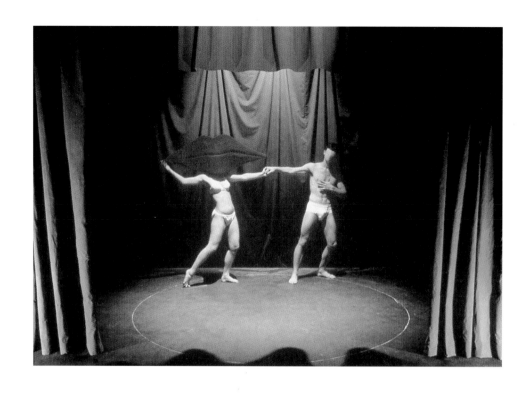

Nic Nicosia
Sex Act No. 6, 1996
Fuji supergloss print

(opposite) **Frank Majore**
Blue Nude, 1998
Cibachrome print

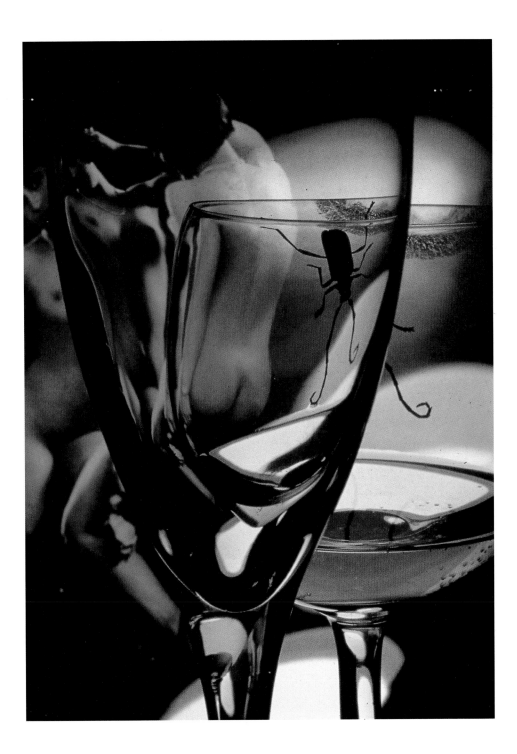

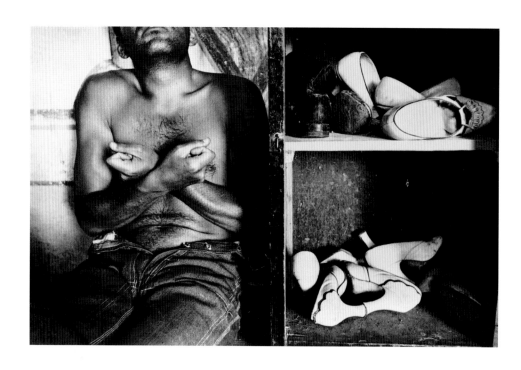

Henri Cartier-Bresson
Santa Clara, Mexico, 1934
Gelatin silver print

Man Ray
Femme aux longs cheveux
(Woman with Long Hair), 1929
Gelatin silver print

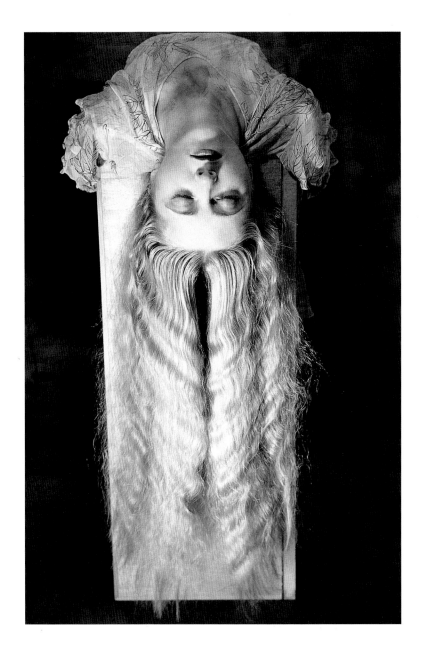

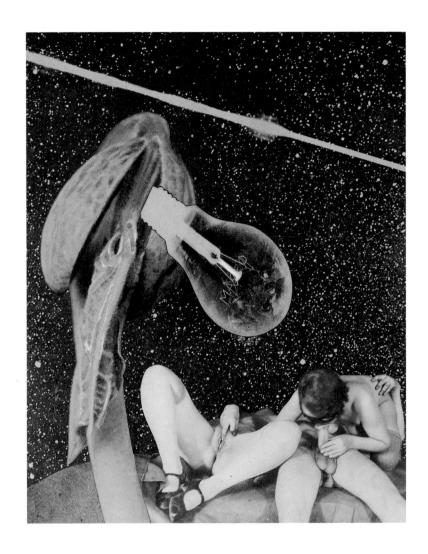

Jindřich Styrský
Collage #8 for Emilie Comes to Me in a Dream, 1933
Collage

Eric Rondpierre
Convulsion
From the series MOIRES, 1996–98
Reprinted deteriorated film still
Chromogenic print

Nicholas Sinclair
Dicky Dick, 1996
Toned gelatin silver print

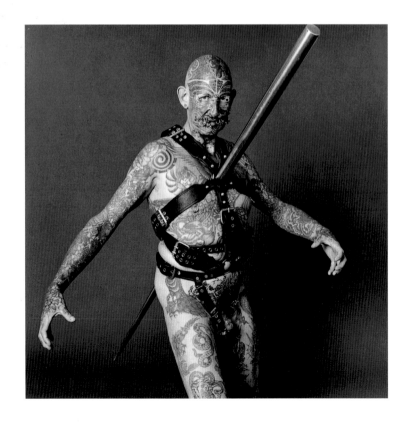

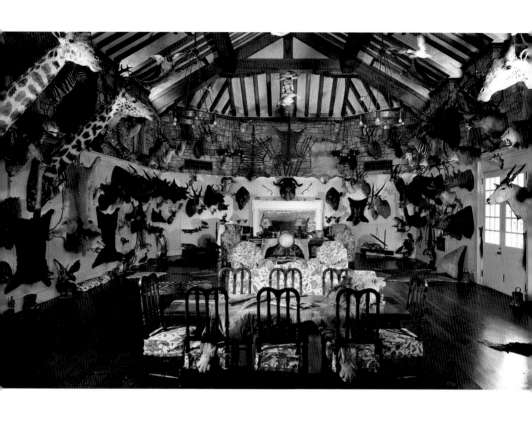

Joe Steinmetz Studio
Phoenixville, Pennsylvania, 1940
Gelatin silver print

Lyle Ashton-Harris
Venus Hottentot 2000, 1994
Polaroid print

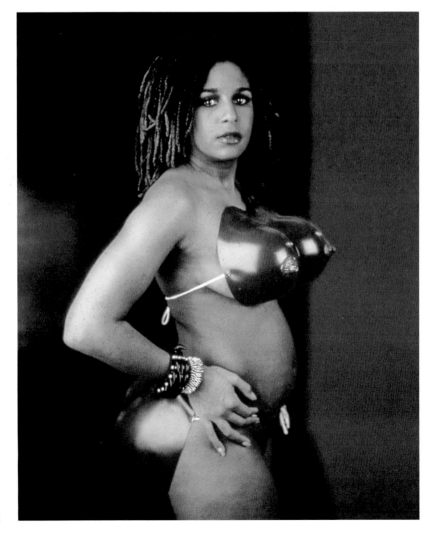

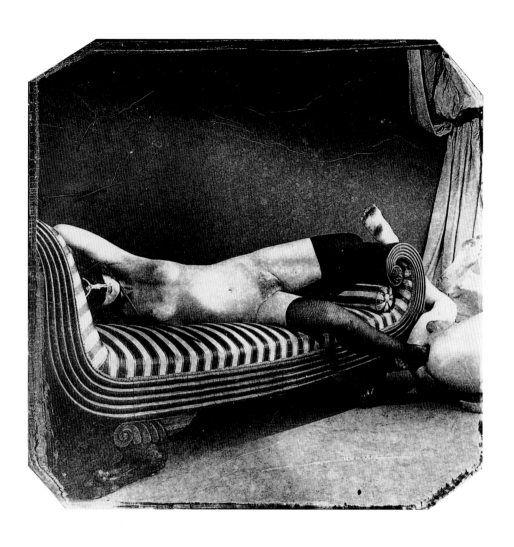

Joel-Peter Witkin
Journeys of the Mask: the History of
Commercial Photography in Juarez,
New York City, 1984
Gelatin silver print

John O'Reilly
French Self and Angel, 1991
Polaroid collage

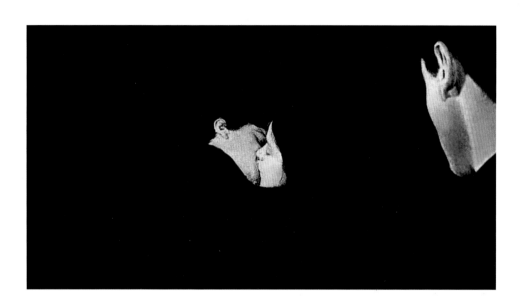

John Stezaker
Untitled, 1976
Collage

Calum Colvin
Mundus Subterraneus IV, 1996
Cibachrome print

Barbara Norfleet
No. 3
From the series *Baby Me*, 1999
Colour-coupler print

377

(opposite) **Gilles Berquet**
Legs in Fishnet, 1987
Toned gelatin silver print

George C. Berticevich
The End, 1982
Photobooth prints

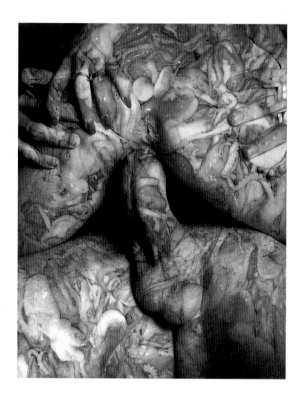

Doug Prince
Earthly Delights, 1996
Multi-negative gelatin silver print

Tina Collen
Untitled, *c.* 1985
Chromogenic print

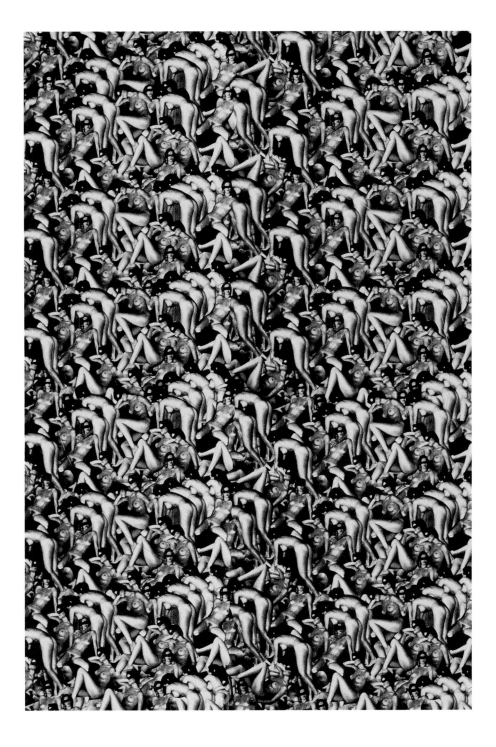

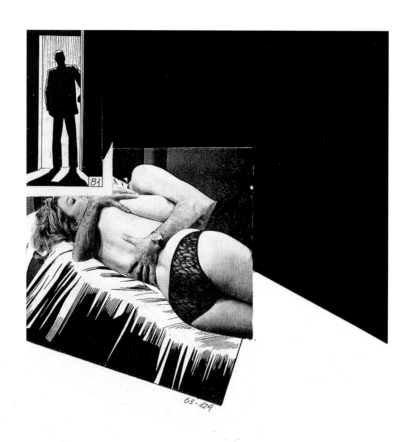

John Stezaker
Untitled, 1979
Collage

(opposite) **Karel Teige**
No. 326, 1947
Collage

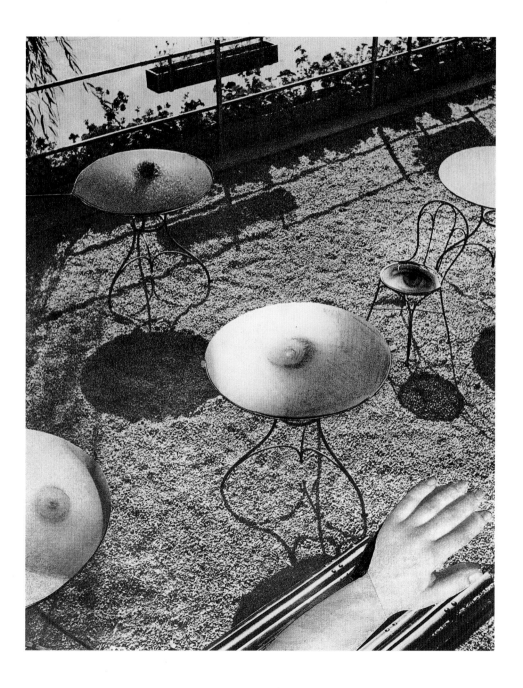

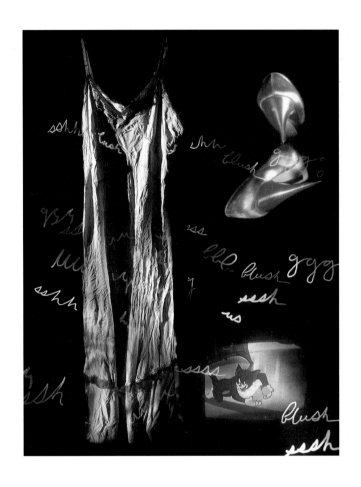

Jane Calvin
Shh, 1997
Chromogenic print

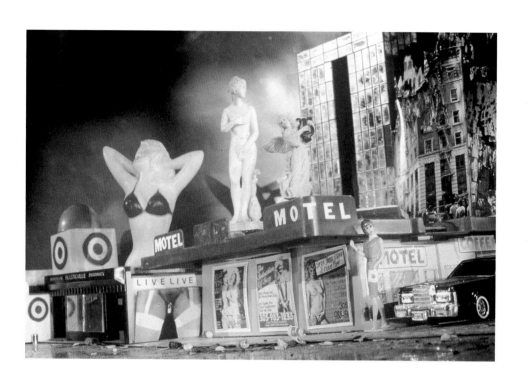

Ken Boto
Motel Venus, 1992
Ektacolor print

Valérie Bélin
(above) Untitled, 1998 / (opposite) Untitled 1997
Gelatin silver prints

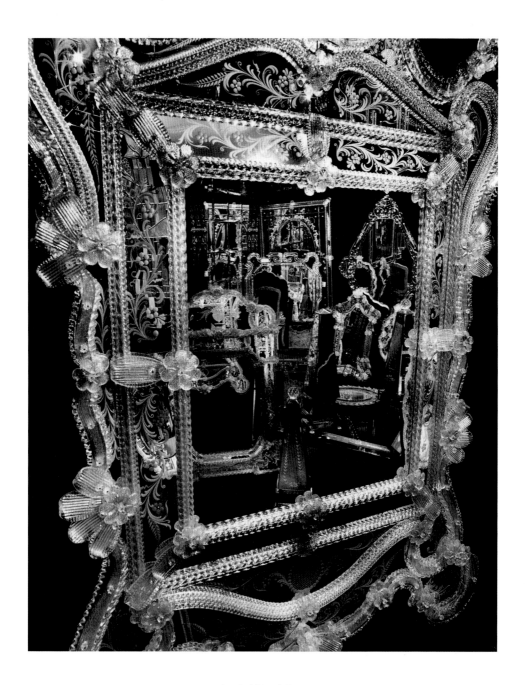

(overleaf) **Daniele Buetti**
Good Fellows, 1996–98
Chromogenic prints from worked tearsheets

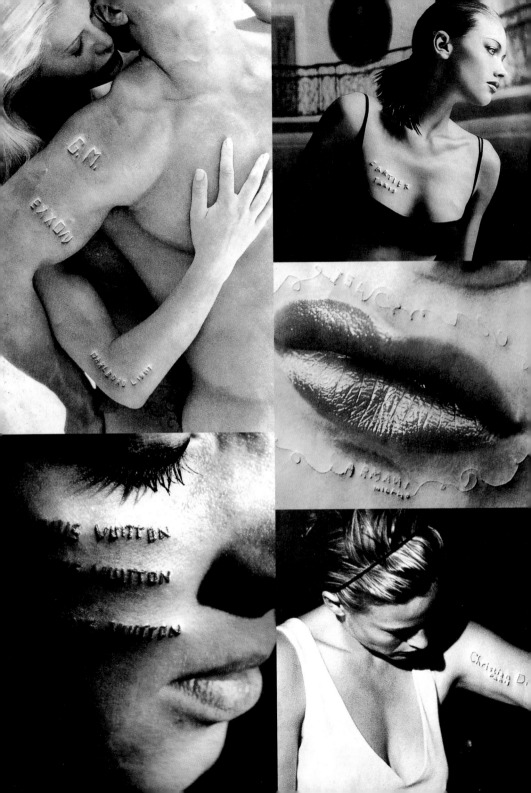

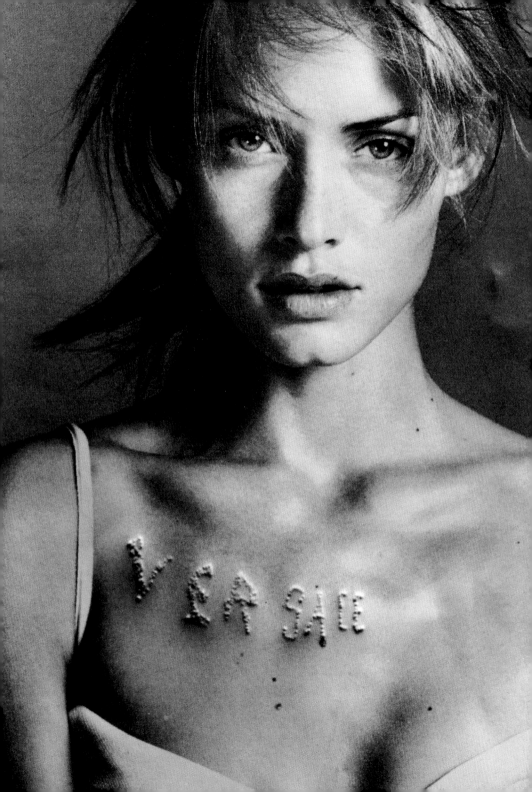

Notes

Abbreviation: *PN* = *Photographic News*, London

1 From *Leaves of Grass*, David McKay, Philadelphia, 1884, pp. 120–29.
2 Philippe Comar, 'Jupon blanc et manteau noir', in Sylvie Aubenas *et al.*, *L'Art du nu au XIXe siècle*, Éditions Hazan/Bibliothèque nationale de France, Paris, 1997, pp. 113–17.
3 Quoted in Gus Macdonald, *Camera: A Victorian Eyewitness*, B. T. Batsford Ltd, London, 1979, p. 22.
4 *PN*, 10 March 1865.
5 'Ghosts, apparitions, wraiths…and their supernatural kindred, have been believed in, more or less, from the days of the Witch of Endor…but it was never supposed that the prosaic art of photography would be able to present a representation of the same individual in two places in one picture – a double, in fact.' (*Ibid.*, 31 March 1865.) The ruse was simple. The photographer would ask the widow if he might see a picture of her husband. He would then surreptitiously make a copy, and by sandwiching the negatives of the two subjects, produce a hybrid image.
6 *PN*, 24 December 1875.
7 *Ibid.*, 6 August 1880.
8 *Ibid.*
9 *The Philadelphia Reporter*, January 1872, p. 51.
10 *PN*, 23 July 1880.
11 *Ibid.*, 29 August 1879.
12 The journal also complained that the new cult of celebrity photography was becoming excessive, in that photographers were now turning up at funerals of the famous to cover the coffins being lowered into the ground: 'One would have thought that photography already pursued public characters sufficiently during their lifetime. Doubtless many of these pictures are sold. They will find plenty of customers, especially in America.' (*Ibid.*, 3 September 1880.)
13 Maria Morris Hambourg *et al.*, *The Waking Dream: Photography's First Century*, Metropolitan Museum of Art/Abrams, New York, 1993, p. 88.
14 Cited in John Szarkowski, *Photography until Now*, Museum of Modern Art, New York, 1989, p. 112.
15 The George Eastman House has in its possession a daguerreotype image of scientific instruments arranged in such a way as to subliminally evoke the phallus. The photohistorian Grant Romer has suggested that such an image displayed in a shop window would have been enough to attract potential customers. (Conversation with the author.)
16 Due to the nature of the direct-positive medium, each image was unique – the only one of its kind – which of course augmented the thrill of possession. It is estimated that the total production of erotic *daguerréotypie*, almost wholly Parisian, never exceeded some four or five thousand images.
17 A contemporary, speaking of daguerreotypes in general, admitted, 'At the outset we did not dare look at the images he [Daguerre] produced. We were intimidated by the clarity of the men portrayed, believing that these small, even tiny faces fixed upon the plates could themselves look back at us…' Cited in Grant Romer's introduction to *Die Erotische Daguerréotypie: Collection of Uwe Scheid*, Weingarten, Freiburg, 1990, p. 9.
18 *Anatomy and Destiny: A Cultural History of the Human Body*, Bobbs-Merrill, Indianapolis, 1975, p. 110.
19 This denial of the body explains the widespread popularity of the pseudo-sciences phrenology and physiognomy.
20 *PN*, 11 August 1885.
21 *Ibid.*, 31 October 1879.
22 *Ibid.*, 11 August 1885.
23 *Ibid.*, 26 November 1858.
24 *Ibid.*, 11 August 1885.
25 Charles Baudelaire, *Salon de 1859. Le Publique moderne et la photographie (Oeuvres complètes II)*, Bibliothèque de la Pléiade, Paris, 1976, p. 617 (author's translation).
26 'The optician/photographer Nicolas-Paymal Lerebours reported in 1843 that "The first *académies* that we did two years ago met with a certain success, and most of them now belong to major artists; we plan to make more directly." ' Cited in Sylvie Aubenas, 'Le Nu académique existe-t-il en daguerréotypie?', in Sylvie Aubenas *et al.* (see note 2), p. 24 (author's translation).
27 *PN*, 26 November 1858.
28 *Ibid.*, 31 October 1879.
29 One photographer of the period explained the trouble he was having finding willing female models: 'I find that models – the female model in all events – object to being photographed. You see, many of these models are quiet, well-conducted girls, and while they do not mind being sketched, they don't like their features and forms reproduced by photography. I fancy they argue that an artist rarely allows a sketch to go out of his possession, but with photography there is no limit to the number of copies which

can be made. Besides, the artist usually idealizes, while photography is remorselessly literal.' (*Ibid.*, 4 January 1880.)

30 'Carroll photographed pre-pubescent girls at a time when the legal definition of childhood in England was under debate. (In 1861 sexual intercourse with a child under 10 was a felony and under 12 a misdemeanor; in 1875 the age of consent was raised to 13, and in 1885 to 16.)' John Pultz, *Photography and the Body*, Weidenfeld & Nicolson, London, 1995, p. 43.

31 Anne Higonnet, *Pictures of Innocence: The History and Crisis of Ideal Childhood*, Thames & Hudson, London, 1998, p. 130.

32 *Ibid.*, p. 122.

33 Further, as the cultural historian Anne Higonnet tells us, 'To a great extent childhood innocence was considered an attribute of the child's body, both because the child's body was supposed to be naturally innocent of adult sexuality, and because the child's mind was supposed to begin blank.' (*Ibid.*, p. 8.)

34 Although the photographic medium was fresh and new, the public had already been conditioned to accept this romanticized, idealized view of childhood innocence through a flood of prints, drawings and popular genre paintings, as Higonnet explains: '…this collective image, Romantic childhood…caught on quickly… Gradually, the visual invention of childhood innocence permeated popular consciousness, swept along by the proliferation of image technologies which generated more diverse and inclusive types of pictures, artists and audiences.' (*Ibid.*, p. 9.) Photography inherited this traditional set of shared conventions, and would quickly build upon it. If today we read into Carroll's images a latent (some would say blatant) sexuality, it is partly because we have come to consider the drives of the unconscious to be as significant in image-making as the declared intentions of the image-maker, perhaps even more so.

35 Julia Margaret Cameron to Sir John F. W. Herschel, 31 December 1864. Reprinted in Colin Ford, *The Cameron Collection*, Wokingham, Berkshire, and Van Nostrand Reinhold, New York, 1975, p. 60.

36 The critics were grudging even in her obituaries: 'If Mrs Cameron's pictures were not perfect, they exercised an interest…any efforts to impart more breadth in camera pictures were welcome.' (*PN*, 10 January 1879)

37 Sylvie Aubenas, 'Le Nu académique…', in Sylvie Aubenas *et al.* (see note 2), p. 52 (author's translation).

38 As 'imprecise contours convey a more natural appearance because things aren't brutally cut off from each other in nature.' Sylvain Morand, 'Une Visite au salon', in *Le Salon de photographie*, Musée Rodin, Paris, 1993, p. 30.

39 The photohistorian Michael Koetzle tells us that some 30,000 people were employed in the manufacture of erotic postcards in France around 1900. Michael Koetzle, *1000 Nudes, The Uwe Scheid Collection*, Taschen, Cologne and London, 1994, p. 310.

40 The system was engineered to be difficult, thus discouraging a desire to do it oneself: 'If the photographer was determined to process his own film, he would involve himself in such complexity that it was sure to immobilize the novice (or 'Kodaker' as the directions called him).' See Elizabeth Brayer, *George Eastman, A Biography*, Johns Hopkins University Press, Baltimore and London, 1996, p. 65, for a full description of the problems the photographer would encounter.

41 Cited in Brayer (see note 40), p. 71.

42 *Ibid.*, p. 72.

43 *Ibid.*, p. 205.

44 Anne Higonnet, *Pictures of Innocence* (see note 31), p. 87.

45 Quoted in Robert Sobieszek, *The Art of Persuasion: A History of Advertising Photography*, Abrams, New York, 1988, p. 31.

46 *Ibid.*, p. 126.

47 *Ibid.*, p. 128.

48 Camille Paglia, *Sexual Personae: Art and Decadence from Nefertiti to Dickinson*, New Haven and London, Yale University Press, 1990, p. 57.

49 '…in the sphere of sexual ethics, it was the Juvenile body with its peculiar charm that was regularly suggested as the "right object" of pleasure. And it would be a mistake to think that its traits were valued because of what they shared with feminine beauty. They were appreciated in themselves or in their juxtaposition with the signs and guarantees of a developing virility. Strength, endurance and spirit also formed part of this beauty…among the Greeks there was a whole moral aesthetics of the boy's body…' Michel Foucault, *The Uses of Pleasure*, Penguin, Harmondsworth, Middx, 1992, p. 200.

50 Ludwig Schrank, in *Photographische Correspondenz*, 1905, quoted in Ulrich Pohlmann, *Wilhelm von Gloeden, Taormina*, Schirmer/Mosel, Munich, 1998, p. 22.

51 Von Gloeden's work did not fare well in Fascist Italy. 1000 negatives and 2000 prints were destroyed. See Ulrich Pohlmann (note 50).

52 *The Male Nude*, Taschen, Cologne and London, 1998, p. 260.

Sources of Photographs

2–3 © 1961 Mario Giacomelli; Courtesy Musée de l'Elysée, Lausanne **6–7** © 1998 Eric Rondpierre; Courtesy the Photographer, Paris **12** Courtesy Fotomuseum in Münchner Stadtmuseum, Munich **15** Courtesy The National Gallery of Canada, Ottawa **17** Courtesy The National Gallery, Warsaw **21** Courtesy Bibliothèque nationale de France, Paris **22, 24** Courtesy Uwe Scheid Collection, Überherrn **27** Courtesy Private Collection, London **30** Courtesy Fotomuseum in Münchner Stadtmuseum, Munich **33** Courtesy Lehnert & Landrock Archives, Cairo/Musée de Elysée, Lausanne **35** © 1987 Rafael Goldchain; Courtesy Stephen Bulger Gallery, Toronto **37** Courtesy Zabriskie Gallery, New York **38, 43** Courtesy Fotomuseum in Münchner Stadtmuseum, Munich **45** © 1998 Melanie Manchot; Courtesy the Photographer, London **48–49** © 1999 Duane Michals; Courtesy the Photographer, New York **50** Courtesy The National Gallery of Canada, Ottawa (purchased 1977 © NGC/MBAC) **52** © 1978 Phil Bergerson; Courtesy Stephen Bulger Gallery, Toronto **54–55** Courtesy Private Collection, London **56** Courtesy Robert Koch Gallery, San Francisco **57** Courtesy Private Collection, London **58** Courtesy Private Collection, Lausanne **59–60** Courtesy Private Collection, London **61** Courtesy The National Gallery of Canada, Ottawa (purchased 1968 © NGC/MBAC) **62** Courtesy Private Collection, London **63** © The Estate of Imogen Cunningham; Courtesy the Estate, Berkeley, California **64** Courtesy Collection Jean Henry, Paris **65** Courtesy Private Collection, London **66** © 1986 Andrea Modica; Courtesy Edwynn Houk Gallery, New York **67** © 1990 Gérard Lüthi; Courtesy the Photographer, Moutier, Switzerland **68** © 1992 Sally Mann; Courtesy Edwynn Houk Gallery, New York **69** © The Estate of Leon Levenstein; Courtesy Howard Greenberg Gallery, New York **70** © The Estate of W. Eugene Smith; Courtesy the Estate, New York **71** © 1998 Shelby Lee Adams; Courtesy Stephen Bulger Gallery, Toronto **72** © 1997 Nicholas Nixon; Courtesy Zabriskie Gallery, New York **73** © 1993 Shelby Lee Adams; Courtesy Stephen Bulger Gallery, Toronto **74** © 1994 Sandi Fellman; Courtesy Edwynn Houk Gallery, New York **75** © 1997 Sally Gall; Courtesy Julie Saul Gallery, New York **76** © 1986 Nicholas Nixon; Courtesy Zabriskie Gallery, New York **77** © Ministère de la Culture, Paris (A.F.D.P.P.) **78** © 1994 Bill Jacobson; Courtesy Julie Saul Gallery, New York **79** © The Estate of Ed van der Elsken; Courtesy The Netherlands Photo Archives, Rotterdam **80** Courtesy The Photography Collection, Carpenter Center, Harvard University, Cambridge, Massachusetts **81** Courtesy Private Collection, New York **82** © 1994 Elinor Carucci; Courtesy Ricco/Maresca Gallery, New York **83** © 1989 Larry Sultan; Courtesy Janet Borden Gallery, New York **84** © 1958 David Heath; Courtesy The National Gallery of Canada, Ottawa (purchased 1974) **85** © 1990 Sally Mann; Courtesy Edwynn Houk Gallery, New York **86–87** © 1996 Florence Paradeis; Courtesy the Photographer, Paris **88–89** Courtesy Ricco/Maresca Gallery, New York **90** © 1994 Phil Bergerson; Courtesy Stephen Bulger Gallery, Toronto **91** © 1994 Rineke Dijkstra; Courtesy Paul Andriesse Gallery, Amsterdam **92** © 1998 Nicholas Nixon; Courtesy Zabriskie Gallery, New York **93** © 1993 John Dugdale; Courtesy Wessel + O'Connor Gallery, New York **94** Courtesy Ricco/Maresca Gallery, New York **95** © 1984 Sandi Fellman; Courtesy Edwynn Houk Gallery, New York **96** Courtesy The National Gallery of Canada, Ottawa (purchased 1968 © NGC/MBAC) **99** © 1996 Giannetto Bravi; Courtesy the Photographer, Cislago, Italy **100** Courtesy Bibliothèque nationale de France, Paris **101** Courtesy Uwe Scheid Collection, Überherrn **102** Courtesy Private Collection, London **103–04** Courtesy Uwe Scheid Collection, Überherrn **105** Courtesy Fotomuseum in Münchner Stadtmuseum, Munich **106** Courtesy Vince Aletti Collection, New York **107** © 1980 Arthur Elgort; Courtesy the Photographer, New York **108** Courtesy Uwe Scheid Collection, Überherrn **109** Courtesy Vince Aletti Collection, New York **110** © 1996 George Holz; Courtesy Fahey/Klein Gallery, Los Angeles **111** Courtesy Vince Aletti Collection, New York **112–13** Courtesy The Photography Collection, Carpenter Center, Harvard University, Cambridge, Massachusetts **114** Courtesy Uwe Scheid Collection, Überherrn **115** Courtesy Vince Aletti Collection, New York **116** Courtesy Villa Grisebach, Berlin **117** Courtesy The National Gallery of Canada, Ottawa (purchased 1990) **118** Courtesy Private Collection, New York **119** Courtesy Monas Hierogliphica, Milan

Ton Peek Gallery, Utrecht **217** © Gilberte Brassaï, Paris; Courtesy Edwynn Houk Gallery, New York **218** Courtesy Galerie Ulrich Fiedler, Cologne **219** Courtesy Vince Aletti Collection, New York **220** © 1992 Ellen von Unwerth; Courtesy the Photographer, New York **221** © 1984 Herlinde Koelbl; Courtesy the Photographer, Munich **222** Courtesy Uwe Scheid Collection, Überherrn **223** © 1993 Thomas Karsten; Courtesy the Photographer, Vierkirchen, Germany **224–25** © 1995 John Schlesinger; Courtesy the Photographer, New York **226** © 1997 Luzia Simons; Courtesy the Photographer, Paris **227** © 1991 Thomas Karsten; Courtesy the Photographer, Vierkirchen, Germany **228** © 1967 John Max; Courtesy Stephen Bulger Gallery, Toronto **229** © The Estate of Robert Mapplethorpe; Courtesy The Robert Mapplethorpe Foundation, New York **230** © 1993 Gérard Musy; Courtesy the Photographer, Paris **231** © The Estate of Günther Blum; Courtesy Sylvie Blum-Neubauer, Lambsheim, Germany **232** © 1995 Nicholas Sinclair; Courtesy the Photographer, Brighton **233** © 1996 Nicholas Sinclair; Courtesy the Photographer, Brighton **234–35** © 1987 The Estate of Peter Hujar; Courtesy James Danziger Gallery, New York **236** Courtesy Bibliothèque nationale de France, Paris **239** © The Estate of Cecil Beaton; Courtesy Sotheby's, Ltd, London **240** © The Estate of August Sander, Sinzig, Germany **241** Courtesy The Royal Photographic Society, Bath **242** Courtesy Société française de photographie, Paris **243** Courtesy the Author, Lausanne **244** Courtesy Palmquist Collection, Arcata, California **245** Courtesy Private Collection, New York **246** Courtesy Uwe Scheid Collection, Überherrn **247** Courtesy The Royal Photographic Society, Bath **248** Courtesy Private Collection, Lausanne **249** Courtesy The National Gallery of Canada, Ottawa (purchased 1972 © NGC/MBA) **250** © 1981 Paul Cava; Courtesy Marcuse Pfeiffer Collection, New York **251** © 1988 Tina Collen; Courtesy Museum Ludwig, Cologne **252** Courtesy Uwe Scheid Collection, Überherrn **253** © The Estate of Robert Mapplethorpe; Courtesy The Robert Mapplethorpe Foundation, New York **254** © 1998 Philippe Bertin; Courtesy the Photographer, Paris **255** Courtesy Galerie Moravia, Brno **256** Courtesy Zabriskie Gallery, New York **257** Courtesy Private Collection, London **258–59** © 1990 Giorgio Lotti; Courtesy Laura Leonelli, Bergamo **260** Courtesy Uwe Scheid Collection,

Überherrn **261** © 1986 Ruth Thorne-Thomsen; Courtesy the Photographer, Philadelphia **262–63** © 1991 Annemarie Schudel-Halm; Courtesy the Photographer, Zurich **264–65** © 1998 Robert Bianchi; Courtesy the Photographer, New York **266–67** © 1992 John Stezaker; Courtesy the Photographer, London **268** Courtesy The National Gallery of Canada, Ottawa (public domain/purchased 1990) **271** © 1998 Mario Testino; Courtesy coromandel express, Paris and New York **272–78** Courtesy Uwe Scheid Collection, Überherrn **279** Courtesy Private Collection, San Francisco **280–81** Courtesy Private Collection, London **282** Courtesy Vince Aletti Collection, New York **283** Courtesy Uwe Scheid Collection, Überherrn **284** © 1986 Hulton Getty **285** © 1986 Shelby Lee Adams; Courtesy Stephen Bulger Gallery, Toronto **286–87** © 1961 Mario Giacomelli; Courtesy Musée de l'Elysée, Lausanne **288** © 1994 Stephen Barker; Courtesy Thomas Healy Gallery, New York **289** © 1990 David Lebe; Courtesy the Photographer, Philadelphia **290–91** © 1991 Gérard Musy; Courtesy the Photographer, Paris **292** © 1972 Larry Clark; Courtesy Luhring Augustine Gallery, New York **293** © 1980 Nan Goldin; Courtesy Matthew Marks Gallery, New York **294–95** © 1994 Tom Stappers; Courtesy the Photographer, Voorburg, Holland **296** © 1993 Aura Rosenberg; Courtesy the Photographer, New York **297** © 1996 Rémy Fenzy; Courtesy the Photographer, Marseilles **298–99** © 1997 Alejandra Figueroa; Courtesy the Photographer, Paris **300** © 1990 Isabel Muñoz; Courtesy Agence VU, Paris **301** © 1983 Ernestine Ruben; Courtesy the Photographer, New York **302–03** © 1978 Mark Krastof; Courtesy the Photographer, Chicago **304** Courtesy Private Collection, London **307** © 1995 Ann Mandelbaum; Courtesy the Photographer, New York **308** Courtesy Walter Binder, Zurich **309** Courtesy Uwe Scheid Collection, Überherrn **310** Courtesy The National Gallery of Canada, Ottawa (purchased 1974) **311** Courtesy Uwe Scheid Collection, Überherrn **312** © 1996 Lynne Cohen; Courtesy P.P.O.W. Gallery, New York **313** © 1964 Pierre Boucher; Courtesy Musée Nicéphore Niépce, Chalon-sur-Saône **314** © 1993 Gary Schneider; Courtesy P.P.O.W. Gallery, New York **315** Courtesy Sean Sexton Collection, London **316** © The Estate of George Platt Lynes, New York; Courtesy the Estate of George Platt Lynes **317** © 1991 Flor Garduño; Courtesy Musée de l'Elysée, Lausanne

318 Courtesy Museum of Decorative Arts, Prague 319 © 1993 Phillippe Pache; Courtesy the Photographer, Lausanne 320 © 1983 Nanda Lanfranco; Courtesy the Photographer, Genoa 321 © The Estate of Erwin Blumenfeld; Courtesy Kathleen and Henry Blumenfeld, Paris 322 Courtesy Uwe Scheid Collection, Überherrn 323 © 1994 Artists Rights Society (ARS), New York/ADAGP/Man Ray Trust, Paris 324 © 1995 Ann Mandelbaum; Courtesy the Photographer, New York 325 © 1996 Ann Mandelbaum; Courtesy the Photographer, New York 326–29 © 1995 Pierre Radisic; Courtesy the Photographer, Brussels 330 © 1994 Lisa Martin; Courtesy the Photographer, New York 331 © 1994 John Bernhard; Courtesy the Photographer 332–33 © 1999 Emmanuelle Purdon; Courtesy the Photographer, Paris 334 © 1998 Doug Prince; Courtesy the Photographer, Portsmouth, New Hampshire 335 © 1999 Doug Prince; Courtesy the Photographer, Portsmouth, New Hampshire 336 Courtesy The Estate of Heinz Hajek-Halke, Cologne 337 © 1998 Philippe Bertin; Courtesy the Photographer, Paris 338–39 © 1994 Danielle Kwaaitaal; Courtesy Bloom Gallery, Amsterdam 340–41 © 1994 Kathy Grove; Courtesy the Photographer, New York 342–43 © 1998 Friedericke van Lawick and Hans Müller; Courtesy the Photographers, Kirchheim/Teck, Germany 344 © 1983 Ernestine Ruben; Courtesy the Photographer, New York 345 © The Estate of Heinz Hajek-Halke; Courtesy the Estate, Cologne 346–47 © 1993 Joan Fontcuberta; Courtesy the Photographer, Barcelona 348 © The Estate of Josef Sudek, Prague; Courtesy Musée de l'Elysée, Lausanne 349 Courtesy Moravian Gallery, Brno 350 © 1998 Karen Knorr; Courtesy Maureen Paley Interim Art, London 351 © 1996 Frank Majore; Courtesy Janet Borden Gallery, New York 352 Courtesy Private Collection, London 355 © 1983 Helmut Newton; Courtesy the Photographer, Monaco 356 © 1989 David Levinthal; Courtesy Janet Borden Gallery, New York 357 © 1996 Gilles Berquet; Courtesy the Photographer, Paris 358 Courtesy Uwe Scheid Collection, Überherrn 359 © 1994 Artists Rights Society (ARS), New York/SPADEM, Paris; Courtesy Musée nationale d'art moderne, Centre Georges Pompidou, Paris 360 © 1997 Christian Koeppel; Courtesy the Photographer, Paris 361 © 1994 Jeanne Dunning; Courtesy Feature Gallery, New York 362 © 1982 Joel-Peter Witkin; Courtesy PaceWildensteinMacGill, New York 363 © 1993 John O'Reilly; Courtesy Howard Yezerski Gallery, Boston, and Bonni Benrubi Gallery, New York 364 © 1996 Nic Nicosia; Courtesy P.P.O.W. Gallery, New York 365 © 1998 Frank Majore; Courtesy Janet Borden Gallery, New York 366 © 1934 Henri Cartier-Bresson/Magnum, Paris 367 © 1994 Artists Rights Society (ARS), New York/ADAGP/Man Ray Trust, Paris 368 Courtesy UBU Gallery, New York 369 © 1998 Eric Rondpierre; Courtesy Galerie Michelle Chomette, Paris 370 © 1996 Nicholas Sinclair; Courtesy the Photographer, Brighton 371 Courtesy The Photography Collection, Carpenter Center, Harvard University, Cambridge, Massachusetts 372 © 1994 Lyle Ashton-Harris; Courtesy Galerie Analix Forever, Geneva 373 © 1994 Joel-Peter Witkin; Courtesy PaceWildensteinMacGill, New York 374 © 1993 John O'Reilly; Courtesy Howard Yezerski Gallery, Boston, and Bonni Benrubi Gallery, New York 375 © 1976 John Stezaker; Courtesy the Photographer, London 376 © 1996 Calum Colvin; Courtesy the Photographer, Edinburgh 377 © 1999 Barbara Norfleet; Courtesy Robert Klein Gallery, Boston 378 © 1987 Gilles Berquet; Courtesy the Photographer, Paris 379 © 1982 George C. Berticevich; Courtesy the Photographer, Tiburon, California 380 © 1996 Doug Prince; Courtesy the Photographer, Portsmouth, New Hampshire 381 © 1985 Tina Collen; Courtesy Museum Ludwig, Cologne 382 © 1979 John Stezaker; Courtesy the Photographer, London 383 Courtesy Museum of Czech Literature, Prague 384 © 1997 Jane Calvin; Courtesy the Photographer, Chicago 385 © 1992 Ken Boto; Courtesy Robert Koch Gallery, San Francisco 386–87 © 1998 Valérie Bélin; Courtesy Galerie Xippas, Paris 388–89 © 1999 Daniele Buetti; Courtesy the Photographer, Zurich

Acknowledgments

A book of this scope is only possible through the combined enthusiasm of many people: the living photographers themselves, photographers' estates and trusts, private collectors, museum curators and gallery owners. I am hugely indebted to all those who have contributed to this publication with pictures or valuable information. First of all I wish to thank the following photographers and artists, and the following estates and trusts, who have generously contributed work to this book: Shelby Lee Adams, Merry Alpern, Lyle Ashton-Harris, Jane Atwood, Stephen Barker, Vanessa Beecroft, Valérie Bélin, Phil Bergerson, John Bernhard, Gilles Berquet, George Berticevich, Philippe Bertin, Robert Bianchi, Mario de Biasi, Ken Boto, Pierre Boucher, Uldis Braun, Giannetto Bravi, Daniele Buetti, Nancy Burson, Jeff Burton, Jane Calvin, Cornell Capa, Richard Carling, Paul Cava, Larry Clark, Lynne Cohen, Tina Collen, Calum Colvin, Rineke Dijkstra, John Dugdale, Jeanne Dunning, Arthur Elgort, Louis Faurer, Sandi Fellman, Rémy Fenzy, Alejandra Figueroa, Joan Fontcuberta, James Friedman, Sally Gall, Flor Garduño, Mario Giacomelli, Rafael Goldchain, Nan Goldin, Barbara Gollob, Robert Graham, Lauren Greenfield, Kathy Grove, Clara Gutsche, David Heath, Frank Horvat, Yasuhiro Ishimoto, Steeve Iuncker, Bill Jacobson, Thomas Karsten, Karen Knorr, Herlinde Koelbl, Christian Koeppel, Viktor Kolar, David Kramlich, Mark Krastof, Danielle Kwaaitaal, Nanda Lanfranco, Friedericke van Lawick, David Lebe, David Levinthal, Giorgio Lotti, Gérard Lüthi, Frank Majore, Melanie Manchot, Ann Mandelbaum, Sally Mann, Lisa Martin, John Max, Jeff Mermelstein, Duane Michals, Andrea Modica, Hans Müller, Isabel Muñoz, Gérard Musy, Helmut Newton, Nic Nicosia, Nicholas Nixon, Barbara Norfleet, Paul Nozolino, John O'Reilly, Philippe Pache, Florence Paradeis, Sylvia Plachy, Doug Prince, Ken Probst, Emmanuelle Purdon, Pierre Radisic, Silvana Reggiardo, Herb Ritts, Eric Rondpierre, Aura Rosenberg, Ernestine Ruben, John Schlesinger, Gary Schneider, Annemarie Schudel-Halm, Jeanloup Sieff, Luzia Simons, Nicholas Sinclair, Roberta Sorrentino, Tom Stappers, John Stezaker, Larry Sultan, Mario Testino, Ruth Thorne-Thomsen, Ellen von Unwerth, Robert Walker, Joel-Peter Witkin, George Zimbel, and the many unidentified photographers. The Estates of Hans Baumgartner, Zurich; Cecil Beaton, London; Günther Blum, Lambsheim; Erwin Blumenfeld, Paris; Brassaï, Paris; Anton Bruehl, New York; Imogen Cunningham, Berkeley, California; Lutz Dille, Toronto; Ed van der Elsken, Rotterdam; Heinz Hajek-Halke, Cologne; Peter Hujar, New York; Leon Levenstein, New York; Herbert List, Hamburg; George Platt Lynes, New York; Robert Mapplethorpe, New York; August Sander, Sinzig, Germany; W. Eugene Smith, New York; Josef Sudek, Prague; Dan Weiner, New York; Lionel Wendt, Utrecht.

I am deeply grateful for the assistance and support I have received from my professional acquaintances in galleries, museums, libraries and the like. Without their knowledge, generosity and enthusiasm the project would never have been possible: Vince Aletti, Paul Andriesse, Susan Arthur, Timothy Baum, Bonni Benrubi, Walter Binder, Vladimir Birgus, Sylvie Blum-Neubauer, Kathleen Blumenfeld, Pierre Bonhomme, Janet Borden, Adam Boxer, Gilberte Brassaï, Stephen Bulger, Susan Campbell, Claudia Cargnel, Julie Castellano, Sadie Coles, James Danziger, Larissa Dryansky, David Fahey, Ulrich Fiedler, Philippe Garner, Martin Gasser, Howard Greenberg, Suzanne Greenberg, Thomas Healy, Jenni Holder, Edwynn Houk, Bill Hunt, Kaori Ikeuchi-Feldman, Ken Jacobson, Penny Jacobson, Robert Koch, Stephen Koch, Hans P. Kraus, Jr., James Lavender, Laura Leonelli, Gregory Leroy, Michelle Maccarone, Peter MacGill, Matthew Marks, Daniela Martorana, David Mellor, Arielle Meyerowitz, Nicholas Monti, Wendy Olsoff, Maureen Paley, Elizabeth Partridge, Priska Pasquer, Jeffrey Peabody, Ton Peek, Peter Pfunder, Penny Pilkington, Ulrich Pohlmann, Anise Richey, Pam Roberts, Grant Romer, Michael Ruetz, Julie Saul, Uwe Scheid, Max Scheler, Alissa Schoenfeld, Sean Sexton, Ann Thomas, Sandra Weiner, Anna Winand, Taki Wise, Virginia Zabriskie.

I wish to thank the following agencies, museums, libraries, galleries and collectors for their generous help in locating imagery and arranging permissions for reproduction: Agence Rapho, Paris; Agence VU, Paris; Bibliothèque nationale de France, Paris; Bloom Gallery, Amsterdam; The Bokelberg Collection, New York; Bonni Benrubi Gallery, New York;

Carpenter Center for the Visual Arts/The Photography Collection, Cambridge, Massachusetts; Collection Jean Henry, Paris; coromandel express, Paris and New York; Edwynn Houk Gallery, New York; Fahey/Klein Gallery, Los Angeles; Fondation Select, Lausanne; Fotomuseum in the Münchner Stadtmuseum, Munich; Galerie Analix Forever, Geneva; Galerie Ulrich Fiedler, Cologne; Galerie Xippas, Paris; Howard Greenberg Gallery, New York; Howard Yezerski Gallery, Boston; Hulton Getty, London; Imogen Cunningham Trust, Berkeley, California; International Center of Photography, New York; Jakob Tuggener Stiftung, Zurich; James Danziger Gallery, New York; Janet Borden Gallery, New York; Jo Brunenberg Collection, Weert, Netherlands; Josef Breitenbach Trust, New York; Julie Saul Gallery, New York; L. A. Gallery, Frankfurt; Luhring Augustine Gallery, New York; Marcuse Pfeiffer Collection, New York; Matthew Marks Gallery, New York; Maureen Paley Interim Art, London; Ministère de la culture, Paris; Mission du Patrimoine Photographique, Paris; Monas Hierogliphica, Milan; Moravian Gallery, Brno; Musée de l'Elysée, Lausanne; Musée Nicéphore Niépce, Chalon-sur-Saône; Museum of Czech Literature, Prague; Museum of Decorative Arts, Prague; Museum Ludwig, Cologne; The National Gallery of Canada, Ottawa; The National Gallery, Warsaw; The Netherlands Photo Archives, Rotterdam; PaceWildensteinMacGill, New York; Paul Andriesse Gallery, Amsterdam; Photo Gallery International, Tokyo; P.P.O.W. Gallery, New York; Rheinisches Bildarchiv, Cologne; Ricco/Maresca Gallery, New York; Robert Klein Gallery, Boston; Robert Koch Gallery, San Francisco; Robert Mapplethorpe Foundation, New York; The Royal Photographic Society, Bath; Sadie Coles HQ, London; Société française de photographie, Paris; Sotheby's, Ltd, London; Stephen Bulger Gallery, Toronto; Stephen Cohen Gallery, Los Angeles; Swiss Foundation for Photography, Zurich; Thomas Healy Gallery, New York; Ton Peek Gallery, Utrecht; UBU Gallery, New York; Uwe Scheid Collection, Überherrn; Verlag Claudia Gehrke, Tübingen; Villa Grisebach, Berlin; Vince Aletti Collection, New York; Wessel + O'Connor Gallery, New York; Zabriskie Gallery, New York; and a number of private collectors who wish to remain anonymous.

I also wish to thank the staff of the Musée de l'Elysée, who contributed in many ways to the realization of this project. In particular I wish to acknowledge Daniel Girardin, Christophe Blaser, Nathalie Herschdorfer, Marie-Claude Bouyal, Christine Giroud and Jean Clivaz.

Lastly, my profound thanks to my wife, Clare, who was deeply involved in many aspects of the book from conception to completion, and shared my moments of euphoria and doubt.